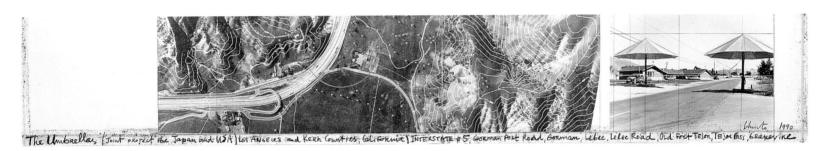

The Umbrellas (Joint project for Japan and USA) Los Angeles and Kern Counties (California) INTERSTATE #5, Gorman Post Road, Gorman, Lebec, Lebec Road, Old Fort Tejon, Tejon Pass, Grapevine

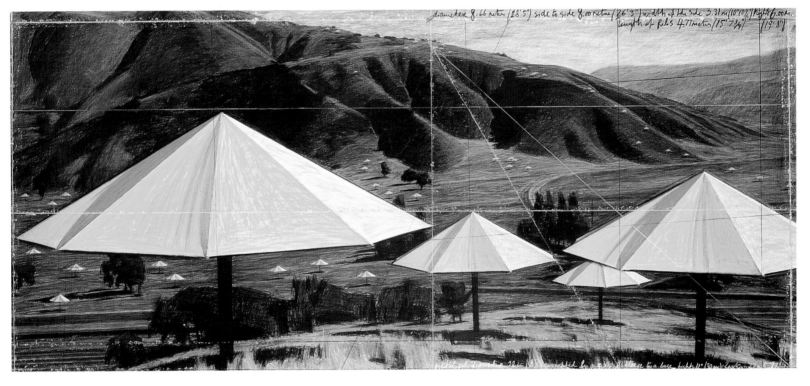

The Umbrellas, Joint Project for Japan and USA

Drawing 1990. Two parts: 38 x 244 cm (15 x 96 in) and 106.6 x 244 cm (42 x 96 in)

Pencil, charcoal, crayon, pastel, enamel paint, photograph, fabric sample and map

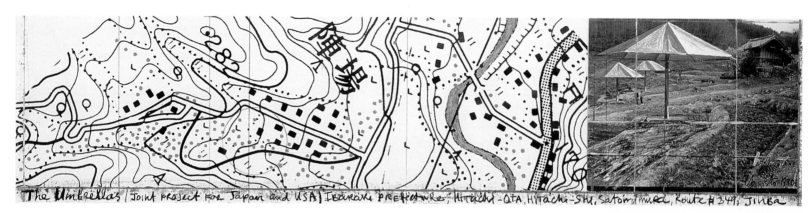

The Umbrellas / Joint Project for Japan and USA / Ibaraki Prefecture, Hitachi-Ota, Hitachi-Shi, Satomi-mura, Route #349, Jinba

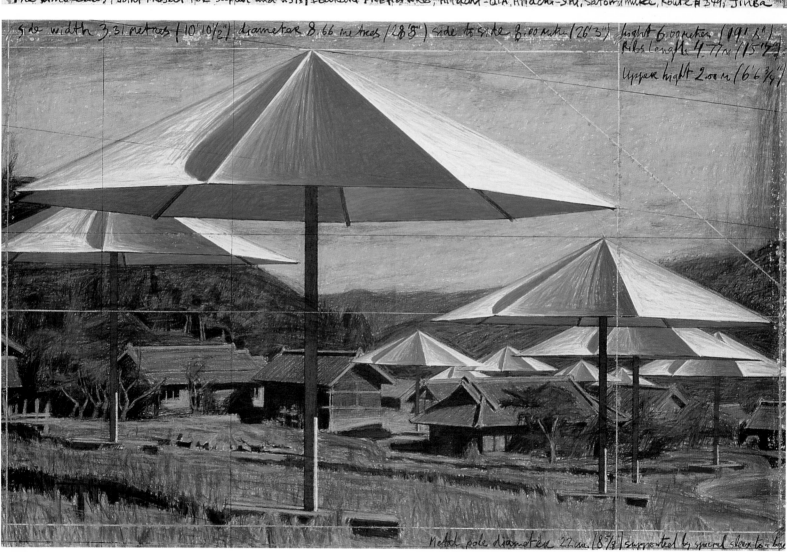

side width 3.31 metres (10'10½") diameter 8.66 metres (28'5") side to side 8.00 mtr. (26'3") hight 6.00 meter (19'8")
Ribs length 4.77 m (15'7")
Upper hight 2.00 m (6'6¾")

Metal pole diameter 22 cm (8⅝") supported by special sleeve to base

The Umbrellas, Joint Project for Japan and USA
Drawing 1990. Two parts: 38 x 165 cm (15 x 65 in) and 106.6 x 165 cm (42 x 65 in)
Pencil, pastel, charcoal, photograph, crayon, enamel paint and map

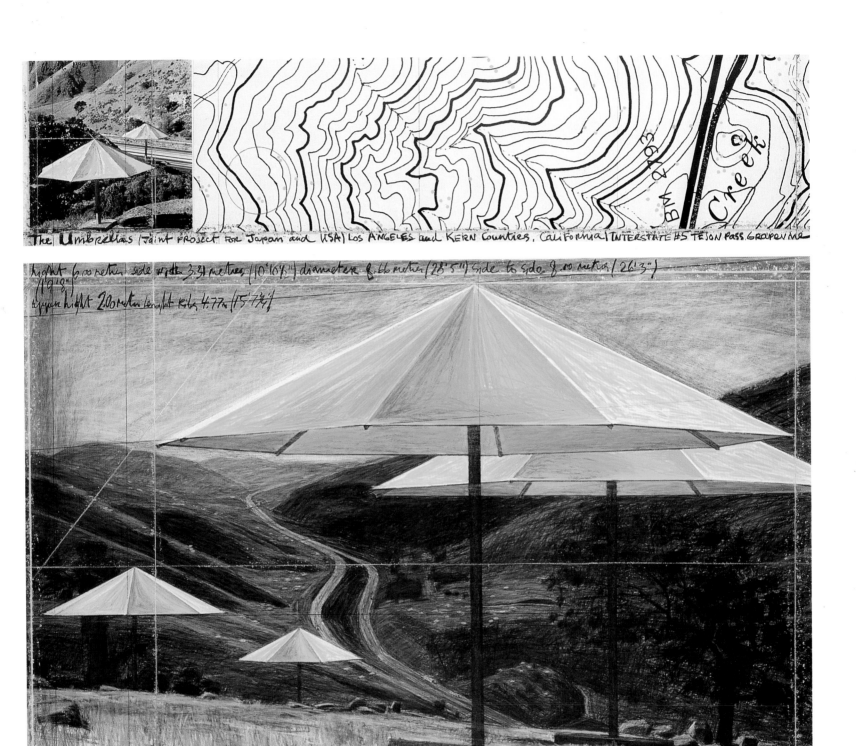

The Umbrellas (Joint Project for Japan and USA) Los Angeles and Kern Counties, California Interstate #5 Tejon Pass Grapevine

The Umbrellas, Joint Project for Japan and USA

Drawing 1990. Two parts: 38 x 165 cm (15 x 65 in) and 106.6 x 165 cm (42 x 65 in)

Pencil, pastel, charcoal, photograph, crayon, enamel paint and map

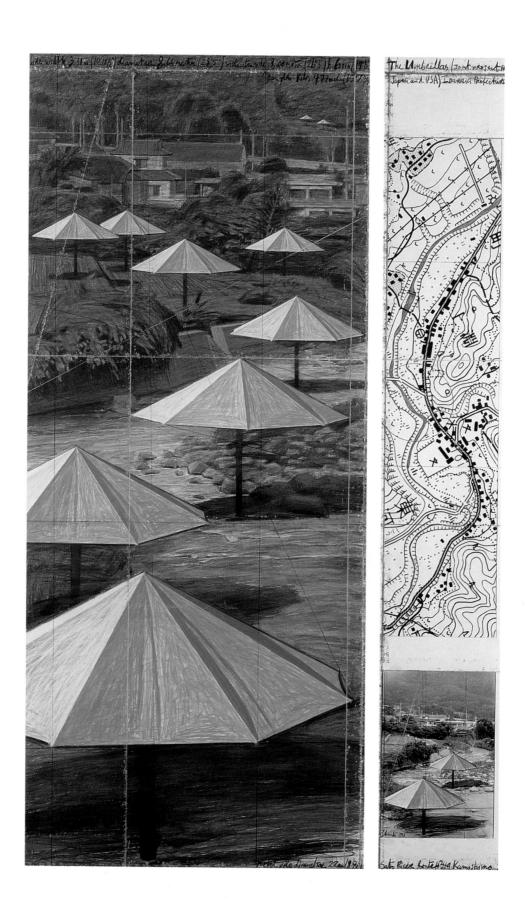

The Umbrellas, Joint Project for Japan and USA

Drawing 1990. Two parts: 244 x 106.6 cm (96 x 42 in) and 244 x 38 cm (96 x 15 in)

Pencil, charcoal, photograph, pastel, crayon and map with enamel paint

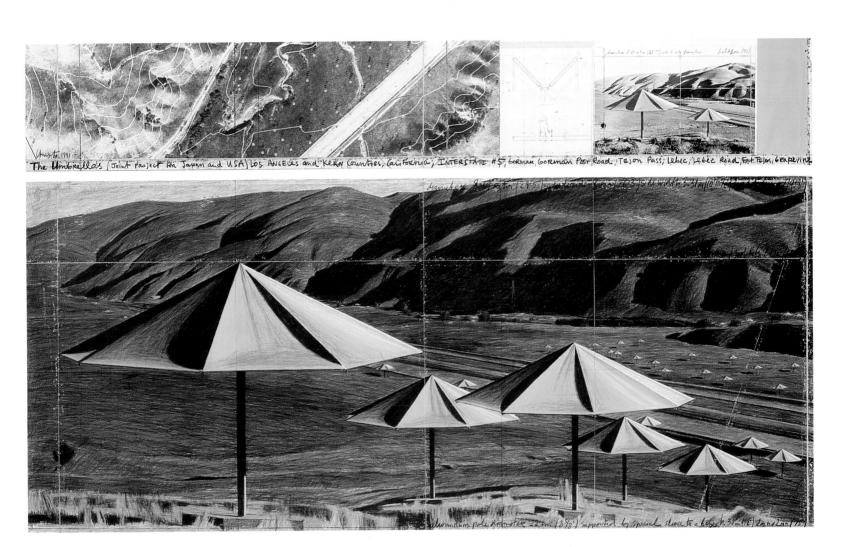

The Umbrellas, Joint Project for Japan and USA

Drawing 1991. Two parts: 38 x 244 cm (15 x 96 in) and 106.6 x 244 cm (42 x 96 in)

Pencil, charcoal, crayon, pastel, photograph, enamel paint, fabric sample,

technical data and map

Christo and Jeanne-Claude projects

Selected from the Lilja Collection

Christo and Jeanne-Claude projects

Selected from the Lilja Collection

With photographs by Wolfgang Volz

Azimuth Editions

First published in Norway 1995

This edition published in the United Kingdom by
Azimuth Editions Limited

Azimuth Editions Limited, 33 Ladbroke Grove, London W11 3AY

ISBN 1-898592-06-3

Per Hovdenakk's essay on pp.15–17 translated by Peter Shield

Editorial and typesetting: Azimuth Editions
Design: Anikst Associates
Reproduction: PJ Reproductions, London
Printed in the United Kingdom by PJ Reproductions, London

Contents

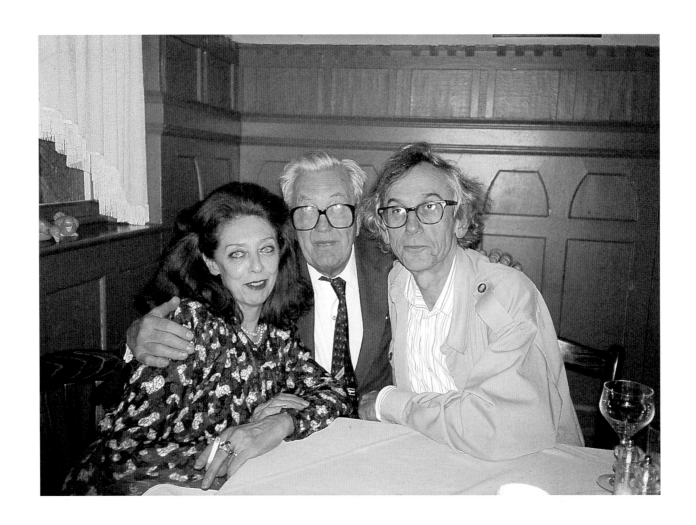

Christo and Jeanne-Claude with Torsten Lilja, February 1995.

Preface
Torsten Lilja

For me, a work of art has at least two dimensions: a *visual dimension* that gives me a thrill; something that my eyes can appreciate; something that stays in my memory as a picture, an image; a *creative dimension*, the end result of a creative process; something that stays in my memory as a thought and gives me mental stimulation.

Artists and entrepreneurs

More and more the creative dimension has come to dominate. There are several reasons for this: the three most important are these.

I come from a family of creative entrepreneurs, which would suggest that I have inherited similar characteristics. My business career in marketing has made me greatly appreciate the value of creative thinking.

Extensive travelling around the world has allowed me many opportunities to meet creative individuals from entirely different professions: artists, business people from small and large companies and with a variety of functions, scientists, inventors, authors, teachers, conductors, performance artists, chefs, chess-players and football coaches, among others. I have learned a lot from these meetings.

Over 25 years I have enjoyed a close relationship with Christo and Jeanne-Claude.

In retrospect, perhaps the most interesting conclusion to draw from my experience is that a dialogue between creative individuals from different backgrounds and with different personalities and areas of knowledge could activate human resources, with the result that 1 + 1 will amount not only to 2, but rather to 3, 4 or 5. The kind of dialogue I mean is one conducted directly between individuals, not by mass communications methods such as the Internet or data banks.

Such dialogues could take place by chance or they might be planned to happen in, for instance, a forum. The interest in and the result of such a forum would naturally be much greater if the thoughts and ideas expressed in the dialogues could be visually illustrated, not only through the usual overhead projections and diapositives, but by a major art exhibition.

The Christos at the 'Creative Crossroads'

For a long time I have hoped to arrange such a forum. This dream came true in Linköping, Sweden. In a joint effort between Linköping University and the Östergötlands Länsmuseum, a symposium – called 'Creative Crossroads' – and a large exhibition of works – 'Christo and Jeanne-Claude Projects' – were arranged to take place simultaneously in September 1995.

Furthermore, the venues for the symposium and the exhibition were across the street from each other, so that one had good opportunities to see illustrated in the exhibition what one could hear about in the symposium.

The speakers at the symposium and the workshops came from utterly different backgrounds: business people, artists, the head of the Dramatic Theatre in Stockholm, a professor in economic analysis, a professor in entrepreneurship. Unfortunately, representatives of other disciplines – architecture, interior decorating, sports and performance arts, for instance – had to be excluded so that the symposium did not become too large.

The exhibition showed only works from the Christos' projects, as distinct from Christo's earlier work. It was a major exhibition and the first of its kind in Sweden. All works were borrowed from the Lilja Art Fund Foundation.

The Christos were also present.

The Christos were the obvious choice for the exhibition. They are not only great artists but also great entrepreneurs. As a team they themselves reflect what the whole event was all about, 'Creative Crossroads'. Furthermore, 1995 saw the fulfilment of the *Wrapped Reichstag* project, bringing to completion a 24-year programme of collaboration with engineers, politicians and the people of Berlin.

This book contains pictures of all works in the exhibition. It is my hope that creative people who see the pictures and read the data can also have a silent dialogue with the Christos and be influenced by their creative entrepreneurship. After all, the Christos successfully started, operated and dissolved 15 companies in 20 years, all self-financed to the tune of $160 million (by the 1995 value of the dollar). Who else has done that?

Team Christo's Creative Process
Torsten Lilja

The background for the thoughts I express in this article is my many stimulating meetings with Christo and Jeanne-Claude during the last 20 years. They have taken place in Christo's studio in New York, and at various exhibition openings and similar events. Our most interesting and rewarding discussions have been held during the numerous long journeys – in aeroplanes, trains, cars, buses and boats – we have made together all over the world, and the late evenings spent with the Christo group in various hotel rooms in very different environments. I particularly remember my travels in Japan in 1985 with Jeanne-Claude, Christo, Josy Kraft (the Christos' curator) and two curators from the Seibu Museum in Tokyo, during two weeks spent deciding on suitable venues for various museum exhibitions. Through lively discussion – which can sometimes be very loud – you get to know sides of a person other than those you would see at a dinner table or at a party.

As further background to the opinions I express below, I should like to mention my experience of the Christos' reliability and directness.

In November 1986, while we were in Berlin, I made a bet with Christo that the market price for his collages, in particular *Surrounded Islands* and *The Pont Neuf, Wrapped*, would increase to $50,000 before the end of 1987. At that time the price was $15,000. The bet involved two collages. Christo lost and the Lilja Collection got its two collages.

One Sunday at the beginning of 1988, Christo, Jeanne-Claude, Josy Kraft, Henry Scott-Stokes, director of the Japanese section of *The Umbrellas* project, my wife and I met with a large management team from Nippon Steel, one of Japan's most important companies, at their main office in Tokyo. At the time the possibility of appointing Nippon Steel as the main contractor for *The Umbrellas* project in Japan was being evaluated. The company had prepared the meeting in detail, but they had also completely misunderstood the whole idea. Christo became irritated and told the managers rather bluntly that what they had done was of no interest. In Japan you do not behave like that if you want to continue a relationship. However, Christo's openness, his courage in saying what he meant, and his charm had a positive effect, and later the company was appointed the project's engineering contractor.

For obvious reasons I am often involved in discussions about the Christos. The following are the questions that most frequently arise.

A Christo and Jeanne-Claude project – is it really art?

What is a Christo and Jeanne-Claude project?

What does a Christo and Jeanne-Claude project mean ?

What do Christo and Jeanne-Claude want to accomplish? What is the result of a project?

A Christo and Jeanne-Claude project – is it really art?

Let me first make two general statements.

The meaning of the word 'art' has always been debated, and depends entirely upon whom you talk to. Traditionally, and in most people's minds, 'art' means painting, drawing, graphics and sculpture. But today, the definition of art can mean much more, covering, among other things, architecture, performance art, industrial design, interior decoration and fashion.

Good art of all kinds is never static. It is the result of a creative process that reflects new and dynamic developments in, for instance, techniques or social attitudes – changes in moral values and behaviour.

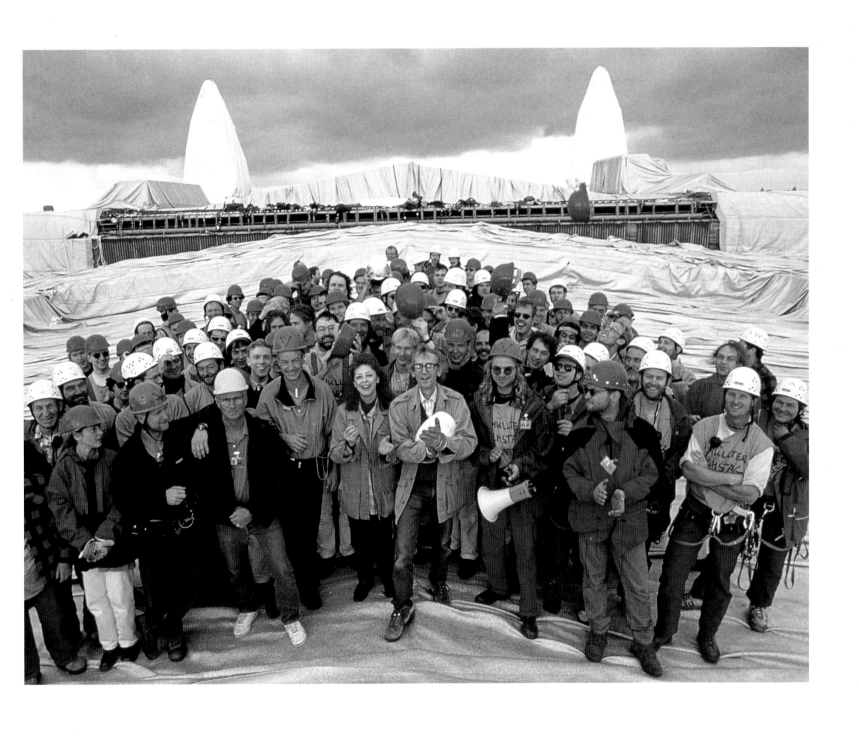

above Christo and Jeanne-Claude on the roof of the Reichstag surrounded by the team of
professional climbers, who completed the work of art in seven days.

following Wrapped Reichstag, Berlin, 1971–95

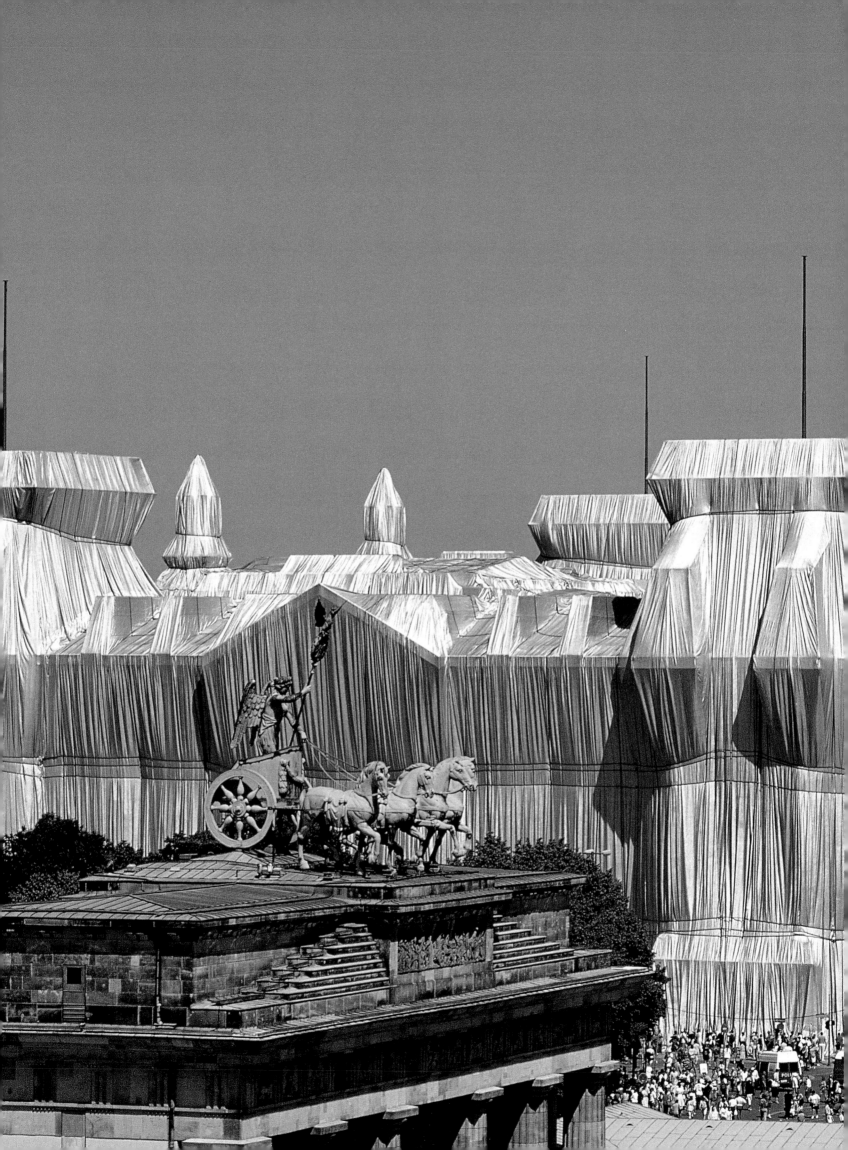

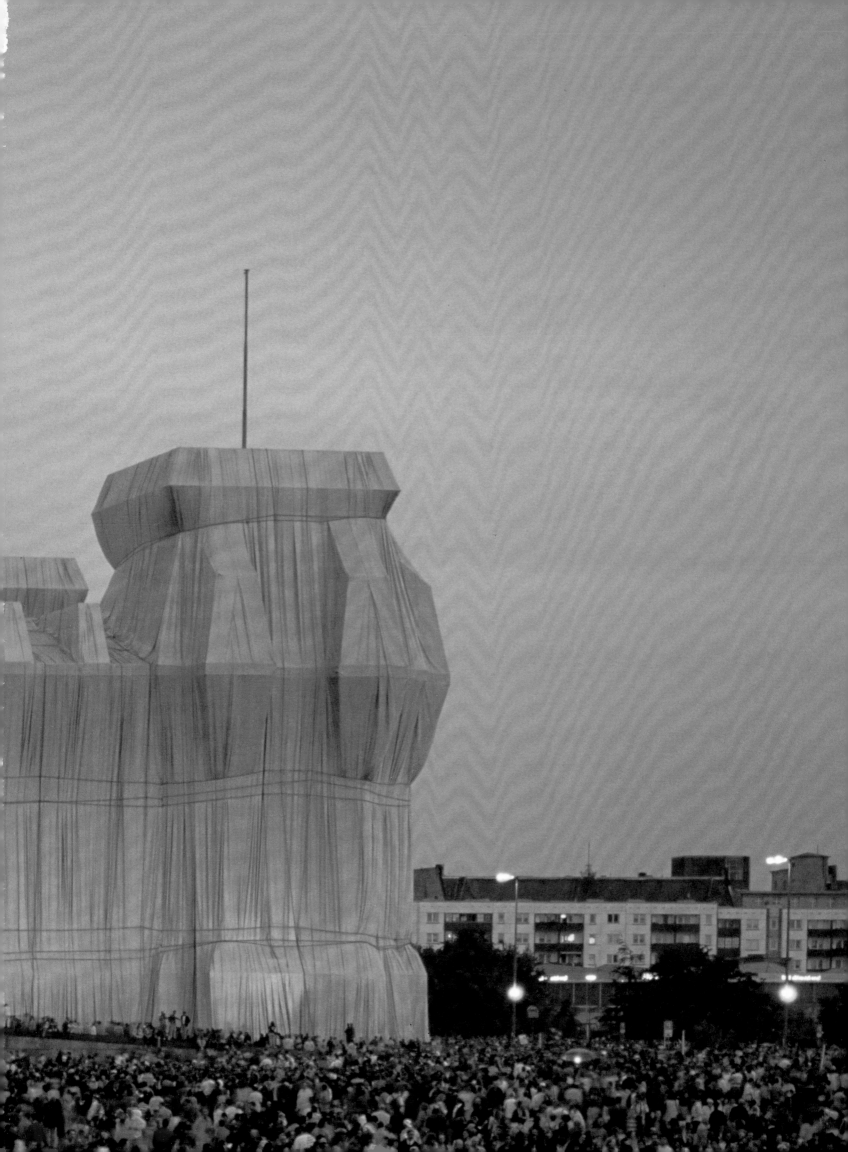

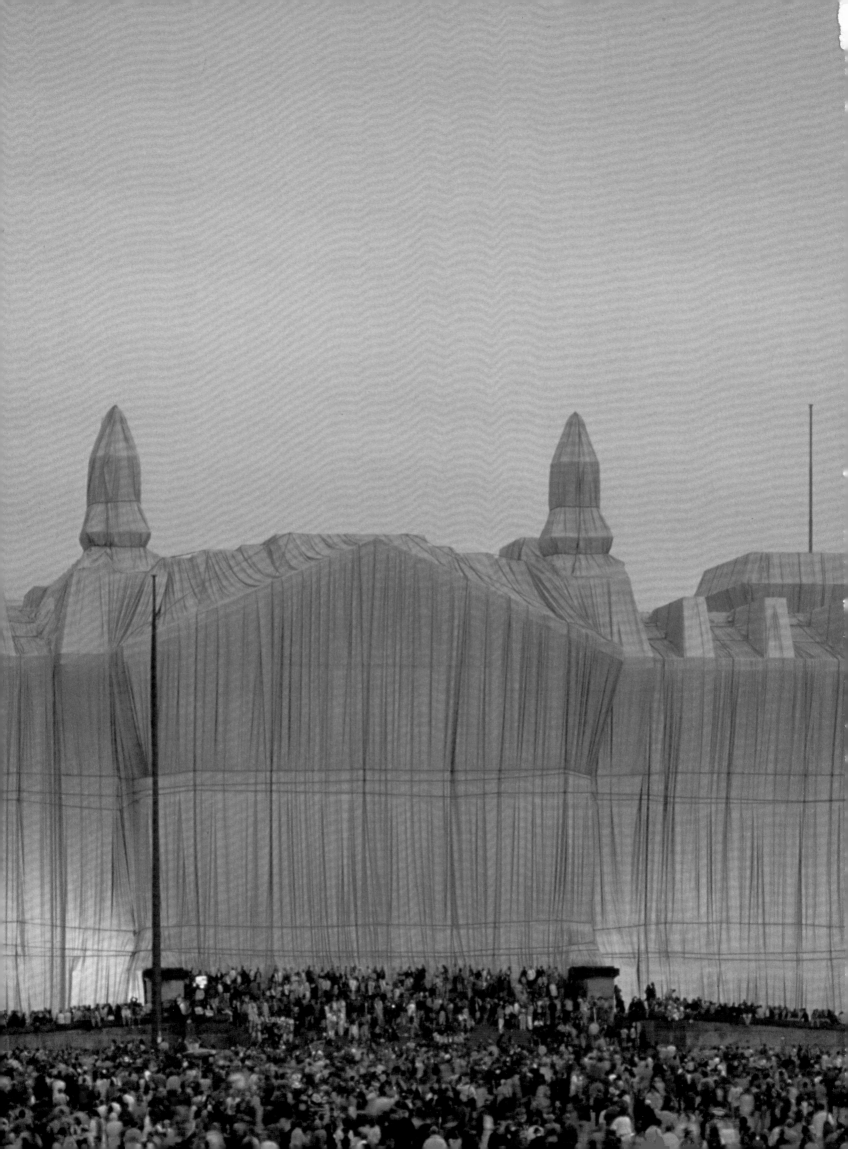

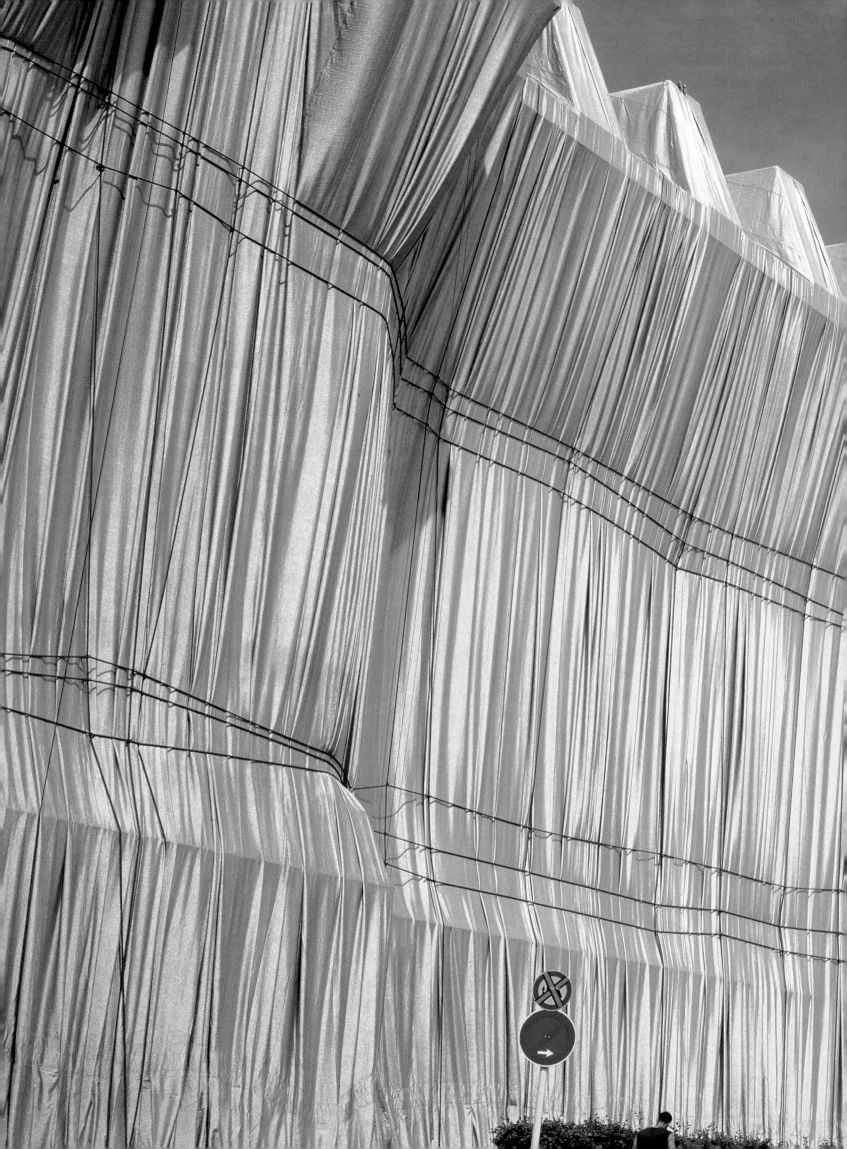

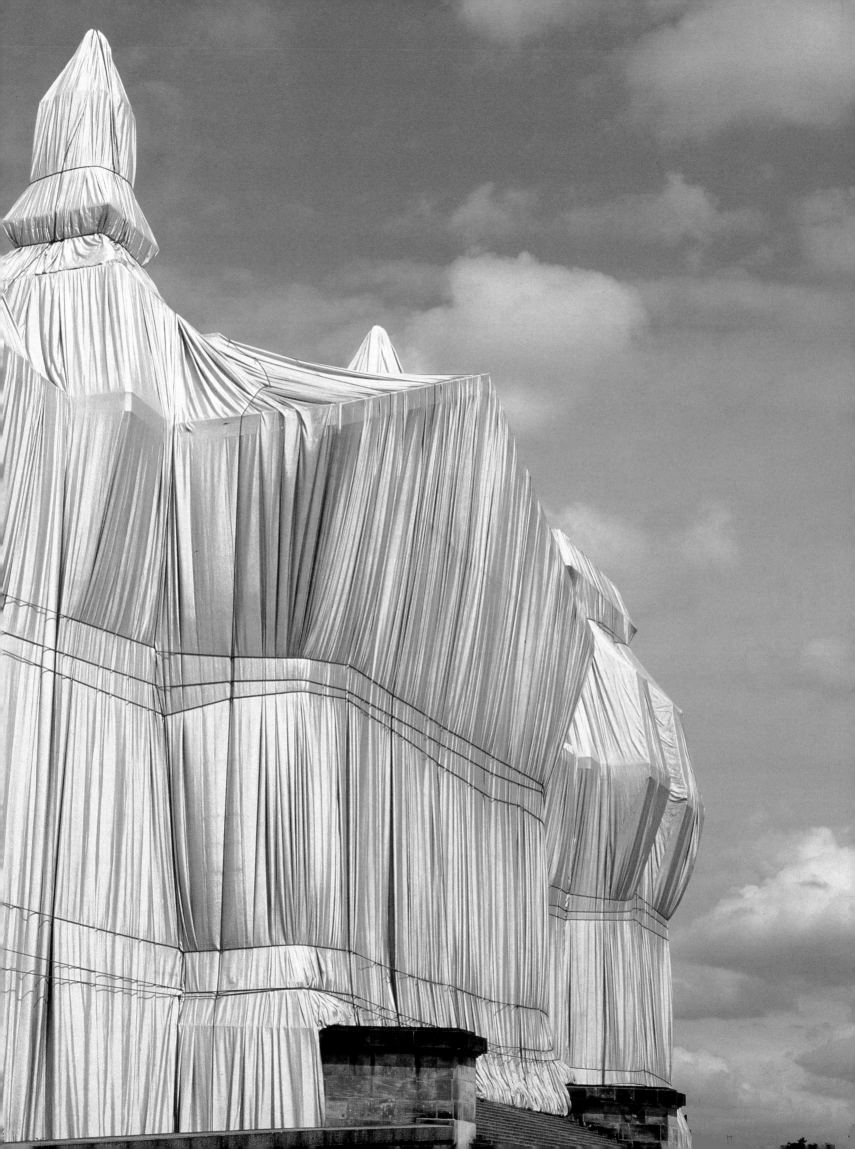

Consider the far-reaching changes in the art world that followed the introduction of photography; the changes in imagery and technique that developed from the possibility of painting in the open air and not only in the studio; and lately, the revolution in the art world connected to the introduction of electronics, computers and new communication techniques.

Now to the Christos.

Christo and Jeanne-Claude's projects are certainly new and dynamic, the result of a long creative process, and they are very different from art considered only from a traditional point of view. The two most intriguing differences are the temporary nature of each project and the way it is financed. These questions are both explored below. However, the realization can be looked upon as a vernissage. If we consider Christo and Jeanne-Claude's art in this way it remains different, but still reflects many aspects of traditional art.

Another extremely important feature is that nobody owns a Christo and Jeanne-Claude project. The Christos pay for it themselves and can therefore do whatever they want with it, within the legal limits allowed them.

The fact that the Christos' projects are seen by many people on television, and by a remarkably large number in real life, does not automatically make them great art. However, it seems that the Christos have initiated a whole new development in the art world. It remains to be seen whether it will become a milestone in art history, but the indications, and my certain belief, are that it will.

What is a Christo and Jeanne-Claude project?

As I see it, the corner-stones of a project by the Christos are as follows.

Idea

Only Christo and Jeanne-Claude themselves know how they select their ideas. These rarely originate from somebody else: although the Christos receive a large number of propositions, these practically always involve using their name for commercial purposes and therefore the answer is always 'No'. The Christos often receive extremely attractive suggestions to wrap a newly opened hotel or some other institutional building in connection with a celebration. Whatever the money involved, such proposals are not acceptable.

The realization of a project, its goal – is the final work of art. Everything else is subordinated to this sacred goal. No financial, legal, technical or other obstacle can stand in the way.

Time

Each project involves a long period of planning and preparation. Some – for example, the Reichstag project – take more than 20 years. The project's visual realization is very temporary, lasting only two or three weeks. It is almost unbelievable that somebody can devote so much energy and money, over such a long period, to a goal of such short duration.

There are several explanations.

Firstly, the realization of a project is the ultimate step, but only one step, in the Christos' long creative process. They want that step to be temporary.

Secondly, the Christos use land and buildings which belong to others; they are permitted to use the borrowed land and buildings for only a short time.

Thirdly, the material with which they work is usually fabric, whose attractiveness, freshness and colour can be greatly altered by weathering.

Preparatory studies

All the works of art that are created in Christo's atelier should be looked upon as preparatory studies, primarily serving two purposes.

In the first place, they are, next to the final realization, the most important step in the creative process.

It is through these preparatory studies that the project develops, and they make it possible for Christo himself to visualize how the final step will actually look.

In the second place, they are sold, and are the only source of income for 'Team Christo'.

Legal procedures

Christo and Jeanne-Claude's projects are socially, politically and environmentally highly controversial. In order to realize them, the Christos need the permission of a large number of state, regional, city and local governments as well as the owners of the land and buildings they use. Obtaining this permission is often a long, costly and complicated process, involving lawyers and other experts of various types. The success of the legal procedures also depends very much upon Team Christo's unique lobbying tactics. For instance:

Team Christo spent 180 days in Bonn, Germany, explaining the ideas behind the wrapping of the Reichstag to a large number of members of parliament, either individually or in small groups of three to five. This was organized by Wolfgang and Sylvie Volz, directors of the Reichstag project.

Team Christo explained *The Pont Neuf, Wrapped* to shopowners and their personnel on both banks of the Seine river, so they in turn could explain the project to the shops' customers. Shopowners were also asked to write to M. Chirac, then Mayor of Paris, requesting him to give Christo permission to wrap the bridge. This was organized by Johannes Schaub, director of the Pont Neuf project.

Team Christo also visited 459 farmers in Japan, one at a time, and explained through interpreters the ideas behind *The Umbrellas* project, in order to get written permission from each of them to use their land. They were also requested to contact their local governor and ask him to give his permission for the project. This process was organized by Henry Scott-Stokes, director of the Japanese section of the project.

Finance

The Christos' sole and only source of income is from sales of their preparatory studies – collages, drawings and original lithographs. Any form of sponsorship intended to exploit the public relations value of the Christo name is unacceptable. On several occasions I have seen offers from very well-known concerns, in both the West and East, willing to pay large sums of money if the Christos would allow their name to be associated with them, even if in a conservative manner. The answer is always 'No'. The Christos' name is not for sale at any price.

The major portion of the costs of a project arise during the period three to six months preceding its realization. This creates sometimes considerable difficulties with cashflow, and means that occasionally it is necessary to take out short-term loans for sizeable amounts. It is interesting to note that there exist banks willing to grant loans on normal terms secured mainly by the artist's own original works.

This problem of illiquidity, but quite good solidity, is one that Team Christo will have to live with. The Christos are too interested in beginning new projects to allow their liquidity to build up to an acceptable level after earlier projects.

Documentation

This is an important part of each project. Besides the original preparatory studies, it consists of a comprehensive range of books, videos, films, photographs, exhibitions, catalogues, interviews – on television, in newspapers and magazines – and protocols from meetings with, for instance, important politicians.

Marketing

There are four corner-stones in the Christos' marketing strategy.

(i) Team Christo sell the artworks themselves, and have no exclusive commitment to any gallery. Their many visits from collectors, museum directors and curators, art dealers and gallery representatives are to mutual advantage: Christo and Jeanne-Claude receive information and news directly from the market, and the market has access to the artists themselves.

(ii) The Christos promote an active exhibition and lecture programme all over the world. Their lectures take place at museums, universities, symposia of various types and business meetings, and are always very well attended.

(iii) Once a project has been realized, no further studies are made. In the context of the creative development of the project they are obviously no longer required, but it is also important for buyers of the studies to know that they do not run the risk of a new supply of works lowering the studies' value at the time when the price should, under normal circumstances, increase.

(iv) In their attitude to publicity, the Christos are unique. Although the success of their creative processes very much depends on how they are treated by the publicity machine, they themselves do not seek contact. Their activities are considered news, which means that journalists actively seek contact with them. This favourable position, however, will only last as long as the Christos are seen to be different, which in turn will last only as long as they do not let their name be used for commercial purposes by sponsors, or by any other means.

Summary

The points I have outlined above describe the cornerstones of a project by Christo and Jeanne-Claude. Evidently, the demands on human, financial, legal and technical resources are very large. It is also quite clear that the Christos make their contribution to the art world in a very different way than most other creative artists, and have therefore often been misunderstood. It has been said, for instance, that *The Pont Neuf, Wrapped* and *The Umbrellas* projects were merely big publicity stunts designed to make money for Team Christo.

However, if one looks at the realization of a project as the final work of art – the final goal – and the preparatory studies as means to reach this goal, everything becomes much easier to understand.

Furthermore, I think the fact that during the last 20 years Team Christo has paid not less than $60 million out of their own pocket for planned and completed projects, and that no sponsor's money is ever accepted, is proof enough that the Christos' projects are not money-making schemes. Offers from sponsors are never accepted because they would compromise the freedom of the artists.

What does a Christo and Jeanne-Claude project mean?

The Christos create a whole new type of art – art that is different from anything that has previously been made. Their works are temporary and pass into history only through preparatory studies, official documentation, and in the minds of people who have seen them in real life, on television, in newspapers, magazines, books, films or via some other public medium.

Christo and Jeanne-Claude wish to enable a large number of people to enjoy an art event that they will never forget.

Team Christo want to make the public conscious of something it sees daily, but no longer really sees: a bridge (*The Pont Neuf, Wrapped*, Paris); a landscape (*Valley Curtain*, Colorado); a river (*Over the River* – yet to be realized); a building (*Wrapped Reichstag*, Berlin); or a coastline (*Wrapped Coast*, Australia). There are many people who now cross the Pont Neuf in Paris who will remember it from the time it was wrapped in 1985.

What is the result of a Christo and Jeanne-Claude project?

The end results of the Christos' projects can take many forms. They produce a fantastic art happening in the middle of a city or a landscape – an event that is so different and exciting that it will be remembered for a long time.

In the process, a large number of collages, drawings and original lithographs are created that can be seen all over the world in museums, exhibitions, institutions and homes, giving many viewers aesthetic pleasure and encouraging an understanding of what creative artists can achieve.

Many collectors of Christo works are themselves entrepreneurs – architects, lawyers, fashion designers, industrialists and consultants operating their own companies. They seem to recognize their own activities in the Christos' creative process.

The Christos' projects are superb examples of entrepreneurship in a classical sense. They could almost be taken as textbook examples. Famous, charismatic artists can sometimes provide very helpful examples of entrepreneurship.

Many members of the art establishment have not accepted Christo and Jeanne-Claude's projects as art, causing much controversy and discussion that is in itself good for the art world.

Team Christo have created such a name for themselves, without the help of public relations consultants, that the Christos' exhibitions and projects are treated as news items on television, in newspapers and magazines. For example, the television programme *Good Morning America* extensively covered the *Surrounded*

Islands, *The Pont Neuf, Wrapped*, and *The Umbrellas* projects; and several German television channels broadcast the long voting procedure in the German Bundestag that gave Christo permission to wrap the Reichstag, with the result that the news was known throughout the world within minutes of voting finishing, on 25 February 1994.

It should mean a great deal to the art world, and to the popularity of visual art, that a project such as *The Pont Neuf, Wrapped* was seen on television all over the world by an estimated 200–300 million people, and by three million people in Paris during the 14 days of its installation. Compare that with an estimated 1.5 million visitors annually to the Museum of Modern Art in New York. Very few museums in the world attract an annual number of visitors that exceeds five million.

The Christos' exhibitions are very well-attended, and I have yet to see a Christo lecture in a museum, university or other institution that is not overcrowded.

Owners of artworks by Christo have done quite well financially over a longer period.

Team Christo's financial situation, in particular their liquidity, has not improved over the last 30 years. This is, however, a result of too much money going out rather than too little coming in. Christo and Jeanne-Claude's tremendous energy and willingness to start new projects produce fantastic artistic results, but also create major financial problems.

Team Christo – a unique partnership

What characteristics, what human qualities, do you need to accomplish what Team Christo have done? What makes Christo and Jeanne-Claude so different from other artists?

There have been and still are artists who are as skilful and creative as Christo, but few, if any, who master the whole creative process from idea to realization and documentation in the same way.

There are not many businessmen or entrepreneurs in the world who have, over a 20-year period, started seven important and a number of smaller companies, all involving considerable amounts of money, and have operated and terminated them skilfully with no financial loss to anyone. The contrary is more usually the case.

I believe that the explanation of the Christos' success is to be found primarily in the following points:

(i) Christo is extremely skilled in his profession. There are few artists who can match his standard of draughtsmanship.

(ii) Christo and Jeanne-Claude keep an unusually open mind to new technical solutions and ideas. Perhaps Christo's original education and earlier experience in Bulgaria has had some influence over this.

(iii) The Christos' aims are quite clear and well-defined. They are persistent, they never give up, and they are willing to take large risks, financial and social, in order to achieve their goal.

(iv) Unusually, their intuition most often leads them in the right direction.

(v) The Christos have most of the classical characteristics of successful entrepreneurs.

(vi) They are good at selecting people to work with them and they are extremely loyal to and honest with them. The Christo group is in essence the same now as it was 24 years ago.

Comparison

Let me compare a Christo and Jeanne-Claude project with another part of today's expanded art world, *haute couture*. The goal of famous fashion shows was originally to sell the designers' clothes, fabrics and so on. Now there are too few people, probably not more than 1000 in the world who can afford to buy unique *haute-couture* models, and, as a consequence, designers have started to exploit their names through *prêt à porter* lines, perfumes and the endorsement of a wide variety of products. The fashion shows are, however, becoming more and more spectacular and losing more and more money, but they are vital in generating the publicity the designers need to maintain the value of their names. The shows are no longer the goal, but rather the means to achieve the goal elsewhere. Designers' names are commercially and aggressively exploited more or less like a brandname.

The realization of a goal is now and always will be the Christos' final aim. The drawings and collages are means to reach this goal. Although the fashion show and the realization of a project both mean a great deal of publicity, they serve two quite different purposes.

Fashion shows are the means to reach a goal. The realization of a Christo and Jeanne-Claude project is the final goal.

Conclusion

The Christos are artists by profession. They are also artists with very clearly defined goals. In order to attain these goals they have developed a new and unique creative process. In this money-oriented world, such processes are normally designed to produce monetary wealth. Not so with the Christos. Their purpose is to achieve an artistic goal, and to preserve their artistic integrity.

The Christos' base their creative work not on theoretical knowledge or study but on common sense and necessity. It is fantastic that in a society that places so much value on an MBA degree, artists can develop a successful method of operation that features many elements of which business people would be proud.

I believe it possible that artists and business people of all kinds – chief executives, managers of marketing, finance, and lobbying departments – and those in other field such as science, technology, culture, sport and so on, could learn a great deal from each other.

The key to understanding Christo and Jeanne-Claude's art is to look upon the realization of their projects, such as *Wrapped Reichstag, The Pont Neuf, Wrapped*, and *The Umbrellas*, as their ultimate goal. Every other aspect of their activities is only the means to realize that goal.

Roots
Per Hovdenakk

'A square of canvas is a feeble and irrelevant means of
communication, when the streets are yours to paint,
the squares and bridges the obvious arena of activity.
'We do not need a dead mausoleum of art, where dead
works are worshipped, but a living factory of the human
spirit – in the streets, in the tramways, in the factories,
workshops and workers' homes.' *Vladimir Mayakovsky*

Christo Javacheff was born on 13 June 1935. His father
had considerable interests in the chemical industry,
and his grandfather was an archaeologist. His mother's
family came from Macedonia and had its roots in
Mediterranean culture. She herself worked for a time
as general secretary for the Art Academy in Sofia. Both
parents were interested in new ideas in art and culture,
and were also well-informed about international
affairs. Jeanne-Claude de Guillebon was born on 13
June 1935, in Casablanca, of a French military family.
Christo's mother owned a significant collection of Soviet
books of avant-garde poetry and literature, which
her son studied, and which were later burnt by the
Javacheffs so that German soldiers would not find
them during the Second World War. The period of the
war was chaotic. The schools were shut in 1943, the
Soviet Army marched into Bulgaria in 1944, and the
father's chemical factory was nationalized in 1947.
Shortly after Christo arrived in Prague in 1956 the uprising
in Hungary occurred, and political restrictions were
expected to affect the whole of Eastern Europe.
Christo decided to flee to the West, and travelled to
Vienna as a stowaway on a train. After six months as
a student at the art academy in Vienna, he moved to
Geneva in 1957 and then, in March 1958, to Paris.
In Paris Christo came into contact with the European avant-
garde in the form of *Nouveau Réalisme*, which could
be characterized as a French parallel to American and
English Pop Art. In the course of a few months he had
made his first packages and wrapped objects and laid
the course for his later work. He wrapped objects in
a range of sizes – bottles, chairs, tables, motorcycles,
a car. A temporary installation in the Rue Visconti,
which he blocked with empty oil-barrels, indicated
that artistic activity was on the way out of the studio
and emerging into a wider space.
In 1964 the Christos moved to New York, which has since
been the point of departure for projects which have
spanned almost the whole world. It was here that
the Christos' work took on its true dimensions.

No contemporary artists communicate with a wider public
than Christo and Jeanne-Claude. Of course, this is con-
nected with the format of their projects, which attract
the attention of the media, but also with the structure
of the work generally, and the degree of clarity and
originality it attempts.
The Christos' production is comprehensive in terms
of both size and media. The large urban and land-
scape projects function as the framing superstruc-
ture of their output. Before the projects are realized,
the artistic idea is worked out in drawings, collages
and models. Each one of these works has an auto-
nomous value, and is at the same time part of a co-
ordinated strategy.
While Christo continues to work on the preparatory draw-
ings for a project, he and Jeanne-Claude collect tech-
nical data, test practical solutions, choose a location
where the project can be sited most effectively, and
present the idea to the public bodies and private con-
cerns whose permission is necessary for the realization
of the project. Three separate but parallel processes –
preparatory work in the studio, analysis of technical
limitations and possibilities and the study of the pro-
ject's interreaction with its intended environment –
act upon each other, and are equally valid elements of
each project. The drawings, collages and scale models
which are created in Christo's studio both document
the various stages of development, from the first idea
to the finished project, and simultaneously become
elements in that process. They are the Christos'
method of gathering together and working up their
experiences, of channelling their ideas into the project
as it gradually takes on its own independent existence
within the framework of technical, practical and politi-
cal circumstances. Each project therefore consists not
just of the final result, but of a whole process.
In most cases, this process takes place over a long period –
the *Wrapped Reichstag* project was initiated 24 years
ago – and some projects are never completed, either
because the Christos lost interest, or because they
failed to get the necessary permission.
The dialectic clarity of the projects and the complex rela-
tionship between process and work has led to a para-

doxical situation whereby the Christos communicate with a large public whilst many critics and art historians find it problematic to define their position within the contemporary art scene.

Many of these have attempted to explain the Christos' works in the light of changing currents in Western European and American contemporary art, in Dada, Surrealism, Pop Art, *Nouveau Réalisme* and Conceptual Art. Of course, Christo and Jeanne-Claude have adopted ideas and experiences from all these movements, but the fundamental elements can be traced back to Christo's experiences in Sofia in the 1950s.

Christo was a student at the Art Academy in Sofia from 1953 to 1956. He studied painting, sculpture, architecture and design. The academy's teaching was based upon the traditions of Socialist Realism: students were indoctrinated to make heroic representations of workers and peasants, and emphasis was given to a thorough schooling in classical techniques. As an element of his art historical studies, Christo also learnt about utopian architectural projects.

Other experiences were equally important. Even before his time at the academy, Christo had become acquainted with the big street parades and decoration of official buildings which celebrated the anniversary of the October Revolution in Moscow.

Christo also met the Russian film-maker Sergei Vassiliev, who was visiting Sofia for a time. Vassiliev brought with him experiences of Russian film-making of the 1920s, in which mass-appearances were an important element in the efforts to communicate a distinctly revolutionary message.

The filmic environment as a whole was important to Christo and to other young artists in Sofia in the 1950s. It attracted people from many different countries and encouraged the involvement of pictorial artists, for example, in the choice and arrangement of locations and in set design.

Russian art of the 1920s was associated with the work of Agitprop, in which avant-garde artists had been engaged. Agitprop was built upon a fundamental optimism and belief in the future promised by the October Revolution. A new society was to be built which would be better for all. Artistic activity – as a means of spreading the message, of influencing attitudes and of engendering optimism – was included in the work towards this new society. This was particularly relevant to the situation in the Soviet Union, where a great part of the population was illiterate. Thus it was not enough to print books and newspapers: more

visual methods, which could project the message to many with great clarity and swiftness, had to be used. The developing media of that time, in particular films and architecture, became important.

Bulgarian intellectuals like Christo's parents engaged in and were well informed about the great changes in Russian art which had been consequences of the 1917 revolution. The work of avant-garde artists Vladimir Tatlin and El Lissitzky, theatre director Vsevelod Meyerhold and the Futurist writer Vladimir Mayakovsky were well known, and Bulgarian artists and intellectuals shared their enthusiasm for ideas of the artist as a worker for the revolution and a better society for all. Tatlin's architectural monuments and Mayakovsky's theatre productions were perhaps the most influential.

Agitprop had the further consequence that large groups of the population were confronted with art and the working methods of artists for the first time. Artistic work had to be explained and defended not just in the light of an ideological superstructure, but as an autonomous development. Agitprop, therefore, can be seen more as an advance for art than for Marxist philosophy.

However, the intrinsic independence of art represented a danger to the Soviet system and, as early as 1921, Josef Stalin prohibited the inclusion of avant-garde art in the work of Agitprop.

When Stalin died in 1953, artists were once again allowed to participate in such work. Agitprop was given a high priority in Bulgaria in the 'fifties, and Christo actively participated in it: this experience was to be of key importance to Christo and Jeanne-Claude's later art. It explains their striving for clarity and distinctiveness, and their capacity to see the work of art as an integrated process, in dialogue with social forces other than those which have traditionally intersected with artistic concerns.

Christo and other art students helped to make posters, and to transfer quotations from Lenin and Stalin onto walls and billboards in Sofia and other parts of Bulgaria. A stranger task was the 'stage managing' of the regions through which the Orient Express train passed, with a view to presenting its passengers with the best possible impression of socialist Bulgaria. Christo and his student comrades visited agricultural collectives and factories to instruct them how best to 'exhibit' their tractors and other equipment, how to stack the hay in attractive formations, and to keep rubbish out of sight of the train.

In 1956 Christo went to Prague to visit some of his relatives. In Prague, he also had an opportunity to visit the base-

ment of the National Gallery, which contained works by Picasso, Wassily Kandinsky, Joan Miró, Henri Matisse and others.

Christo has often indicated the importance of these early experiences when giving 'explanations' of his artistic activity. The Christos wish their projects to appear as concrete and direct as possible, without great theoretical superstructures. Because of the Christos' explanations, through hundreds of lectures all over the world, it is possible to define some obvious preconditions for the distinctive quality of their work, and chief among these is their cultural upbringing.

Modern Bulgaria occupies the land that was once Thrace, the northernmost part of ancient Greece and the homeland of Orpheus in Greek mythology. It is neighbour to Macedonia, and Christo grew up in Plovdiv, ancient Philippopolis, built by Philip of Macedon, the father of Alexander the Great. The coastal areas were important for Greek trade and were integrated into the international culture of the time, that of Greece. The area's proximity to Byzantium, which became the capital of Christendom in 330 AD, was also of great significance: Thrace/Bulgaria became an intermediary for Christianity in countries further to the west and north.

The Bulgars first came from the east around 600 AD and conquered the Slav population of the country, which had come from the Ukraine to Thrace a century before. Bulgaria later fell under the rule of the Ottoman Turks, and in the 19th century under German influence, as an element in the efforts to build an axis from Berlin to Baghdad.

However, the country's connection with Russia was without doubt the most important. For example, the Russian or Cyrillic alphabet is built upon a variant of the Greek established in the 7th century by the Byzantine monk Cyril and his brother, Methodius, for the King of Bulgaria, Simeon. The Christos' son is named Cyril. This close contact endured for many hundreds of years, up to the subordination of Eastern Europe by the Soviet Union.

Bulgaria occupied a more problematic position than most other countries in Communist Eastern Europe. Its association with Russia was compromised by the Soviet hegemony. Important aspects of Bulgarian culture were weakened, and Bulgaria became one of the lands from which least was heard in the period when the Soviet Union was in control. Bulgaria's history and especially its manifold and exciting culture were also, therefore, almost invisible to those in Western Europe. For this reason, it has been difficult for most critics to define the central preconditions for Christo and Jeanne-Claude's work.

Christo and Jeanne-Claude
Biography

1935 Christo: born Christo Javacheff, 13 June, Gabrovo, of a Bulgarian industrialist family.

Jeanne-Claude: born Jeanne-Claude de Guillebon, 13 June, Casablanca, of a French military family.

1952 Jeanne-Claude: Baccalaureat in Latin and Philosophy, University of Tunis.

1953–56 Christo: studies at Fine Arts Academy, Sofia. 1956: arrival in Prague.

1957 One semester's study at the Fine Arts Academy, Vienna.

1958 Christo: arrival in Paris. Packages and *Wrapped Objects*.

1960 Birth of their son, Cyril, 11 May.

1961 Project for the *Wrapping of a Public Building*.

Stacked Oil Barrels and *Dockside Packages* in Cologne Harbour.

1962 *Iron Curtain-Wall of Oil Barrels* blocking the Rue Visconti, Paris.

Stacked Oil Barrels in Gentilly, near Paris.

Wrapping a Girl, London.

1963 *Showcases*.

1964 Establishment of permanent residence in New York City. *Store Fronts*.

1966 *Air Package* and *Wrapped Tree*, Stedelijk van Abbemuseum, Eindhoven.

42,390 cubic feet Package, Walker Art Center, Minneapolis School of Art.

1968 *Wrapped Fountain* and *Wrapped Medieval Tower*, Spoleto.

Wrapping of a public building *Kunsthalle, Berne*.

5,600 cubic meter Package, Documenta 4, Kassel. Air package 280 feet high, foundations arranged in a 900 feet diameter circle.

Corridor Store Front. Total area: 1,500 square feet.

1,240 Oil Barrels Mastaba and *Two Tons of Stacked Hay*, Institute of Contemporary Art, Philadelphia.

1969 *Wrapped Museum of Contemporary Art*, Chicago.

Wrapped Floor and Stairway. 2,800 square feet drop cloths, Museum of Contemporary Art, Chicago.

Wrapped Coast, Little Bay, One Million Square Feet, Sydney, Australia. Erosion Control fabric and 36 miles of ropes.

Project for stacked Oil Barrels, *Houston Mastaba, Texas*: 1,249,000 barrels.

Project for *Closed Highway*.

1970 *Wrapped Monuments*, Milano: Monument to Vittorio Emanuele, Piazza Duomo;

Monument to Leonardo da Vinci, Piazza Scala.

1971 *Wrapped Floors, Covered Windows and Wrapped Walk Ways*, Haus Lange, Krefeld, Germany.

1972 *Valley Curtain, Grand Hogback, Rifle, Colorado, 1970–72*. Width: 1,250–1,368 feet. Height: 185–365 feet; 200,000 square feet of nylon polyamide; 110,000 lbs of steel cables; 800 tons of concrete.

1974 *The Wall, Wrapped Roman Wall, Via V. Veneto and Villa Borghese, Rome*.

Ocean Front, Newport, Rhode Island. 150,000 square feet of floating polypropylene fabric over the ocean.

1976 *Running Fence, Sonoma and Marin Counties, California, 1972–76*. 18 feet high, 24 $1/2$ miles long. Two million square feet of woven nylon fabric. 90 miles of steel cables. 2,050 steel poles (each: 3 $1/2$ inch diameter, 21 feet long).

1978 *Wrapped Walk Ways, Jacob Loose Park, Kansas City, Missouri, 1977–78*.

15,000 square yards of woven nylon fabric, over 2.8 miles of walk ways.

1979 *The Mastaba of Abu Dhabi, Project for United Arab Emirates*, in progress.

1980 *The Gates, Project for Central Park, New York City*, in progress.

1983 *Surrounded Islands, Biscayne Bay, Greater Miami, Florida, 1980–83*.

6 $1/2$ million sq. ft. pink woven polypropylene fabric.

1984 *Wrapped Floors and Stairways* of Architecture Museum, Basel, Switzerland.

1985 *The Pont Neuf, Wrapped, Paris, 1975–85*. 440,000 sq. ft. woven polyamide fabric. 42,900 ft. of rope.

1991 *The Umbrellas, Japan–USA, 1984–91*. 1340 blue umbrellas in Ibaraki, Japan; 1760 yellow umbrellas in California, USA. Height: 19 ft 8 in. Diameter: 28 ft 6 in.

1992 *Over the River, Project for Western USA*, in progress.

1995 *Wrapped Floors and Stairways, and Covered Windows*, Museum Würth, Kunzelsau.

Wrapped Reichstag, Berlin, 1971–95.

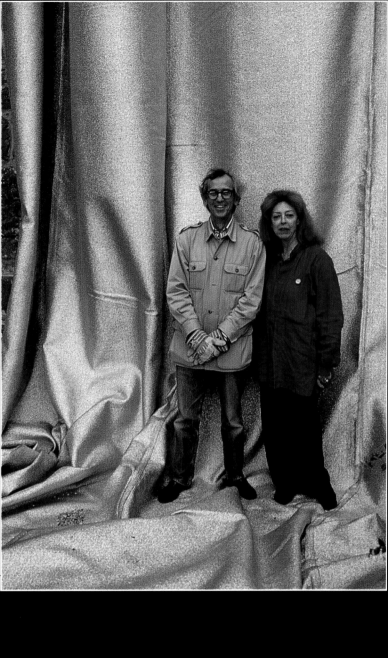

On 25 June 1993, on the outside wall of the castle of Graf and Gräfin Peter Metternich, in Adelebsen, Germany, Christo and Jeanne-Claude chose the colour and texture of the fabric for the 'Wrapped Reichstag, Project for Berlin', after Wolfgang and Sylvia Volz had organized the various possible samples.

Wrapped Reichstag, Berlin, 1971–95

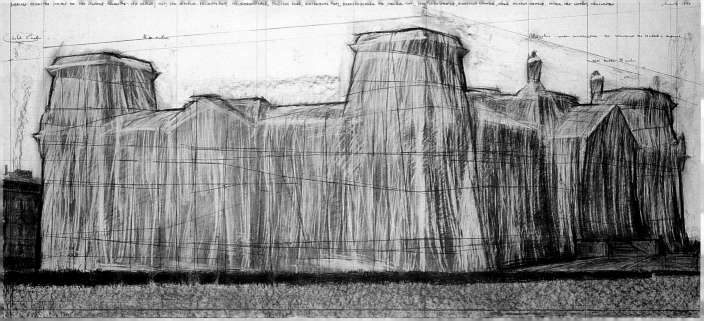

Christo and Jeanne-Claude:
Wrapped Reichstag, Berlin, 1971–95

Press Release

After a struggle spanning through the Seventies, Eighties and Nineties, the wrapping of the Reichstag is to be completed on June 23rd 1995, weather permitting, by a workforce of 90 professional climbers and 120 installation workers. The Reichstag remains wrapped for 14 days, the removal starts on July 7 and all materials are to be recycled.

Ten companies in Germany, started in September 1994 to manufacture all the various materials according to the specifications of the engineers. During the months of April, May and June 1995, iron workers installed the steel structures on the towers, the roof, the statues and the stone vases to allow the folds of fabric to cascade down from the roof to the ground.

100,000 square meters (1,076,000 square feet) of thick woven polypropylene fabric with an aluminum surface, and 15,600 meters (51,181 feet) of blue polypropylene rope, diameter 3.2 cm (1 1/4" inches), were used for the wrapping of the Reichstag. The facades, the towers and the roof were covered by 70 tailor-made fabric panels, twice as much fabric as the surface of the building.

The work of art is entirely financed by the artists, as they have done for all their projects, through the sale of preparatory studies, drawings, collages, scale models as well as early works and original lithographs. The artists do not accept sponsorship of any kind.

The Wrapped Reichstag represents not only 24 years of efforts in the lives of the artists, but also years of team work by its leading members Michael S. Cullen, Wolfgang and Sylvia Volz and Roland Specker.

In Bonn, on February 25th 1994, at a plenary session, presided over by Prof. Dr Rita Süssmuth, the German Bundestag (parliament) debated for 70 minutes and voted on the work of art. The result of the roll call vote was: 292 in favor, 223 against and 9 abstentions.

The Reichstag stands up in an open, strangely metaphysical area. The building has experienced its own continuous changes and perturbations: built in 1894, burnt in 1933, almost destroyed in 1945 it was restored in the sixties, but the Reichstag always remained the symbol of Democracy.

Throughout the history of art, the use of fabric has been a fascination for artists. From the most ancient times to the present, fabric, forming folds, pleats and draperies, is a significant part of paintings, frescoes, reliefs and sculptures made of wood, stone and bronze. The use of fabric for the Wrapped Reichstag follows this classical tradition. Fabric, like clothing or skin, is fragile, it translates the unique quality of impermanence. For a period of two weeks, the richness of the silvery fabric, shaped by the blue ropes, creates a sumptuous flow of vertical folds highlighting the features and proportions of the imposing structure, revealing the essence of the Reichstag.

Dr Willy Brandt, Jeanne-Claude and Christo, in Christo's New York studio, 20 May 1984

Deutscher Bundestag

Stenographischer Bericht

211. Sitzung

Bonn, Freitag, den 25. Februar 1994

I n h a l t :

Transcript of the debate and vote in session number 211 of the German parliament, the Deutsche Bundestag (opposite), in Bonn, on 25 February 1994, concerning the temporary work of art 'Wrapped Reichstag, Project for Berlin'.
The vote was 292 in favour, 223 against, with 9 abstentions.

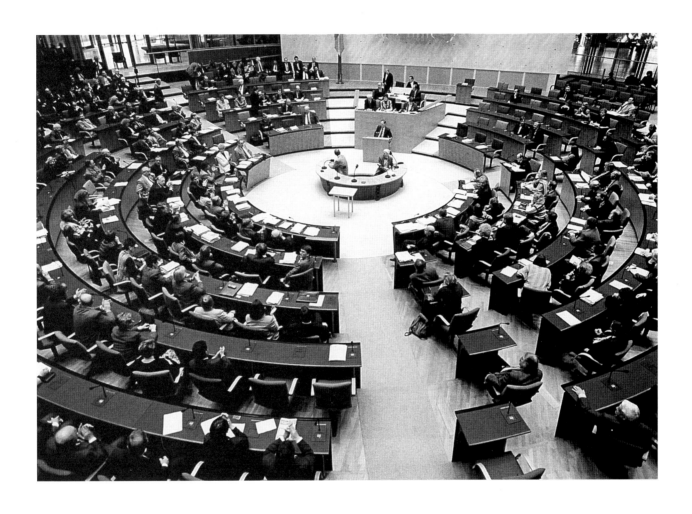

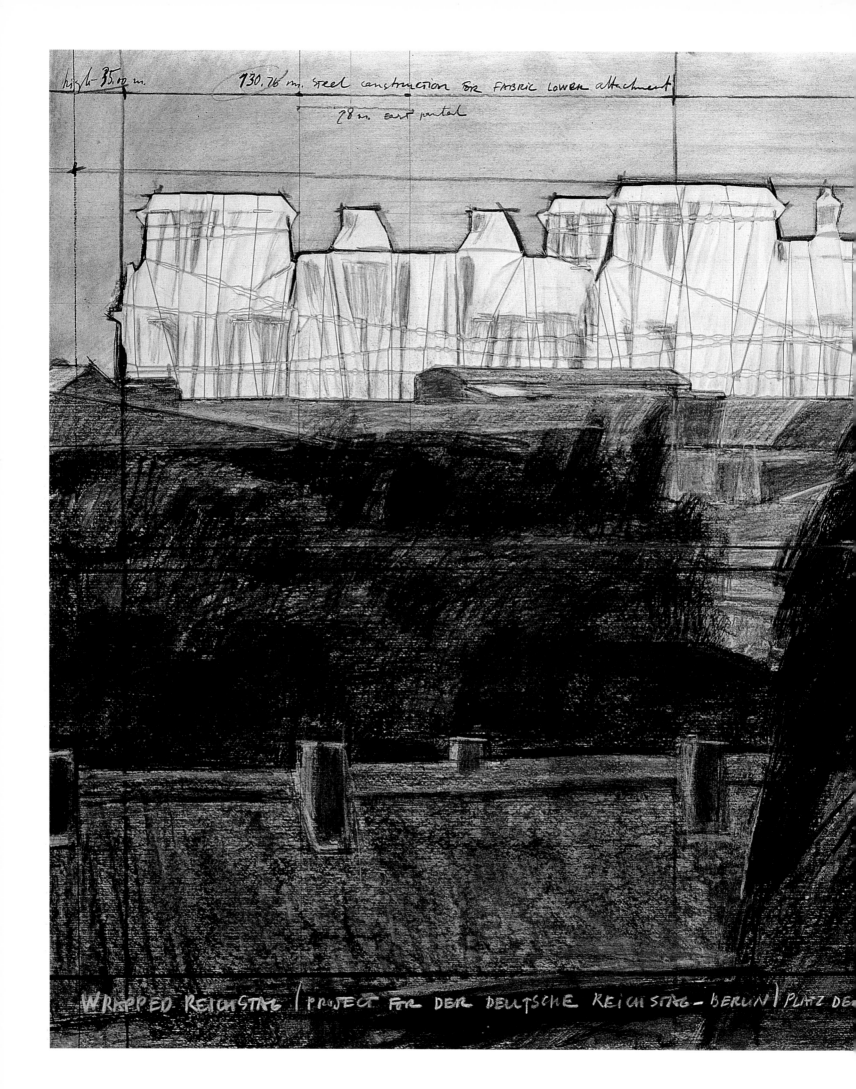

high 35.10 m. 130.76 m. steel construction for FABRIC LOWER attachment

28 m. east portal

WRAPPED REICHSTAG (PROJECT FOR DER DEUTSCHE REICHSTAG - BERLIN) PLATZ DE

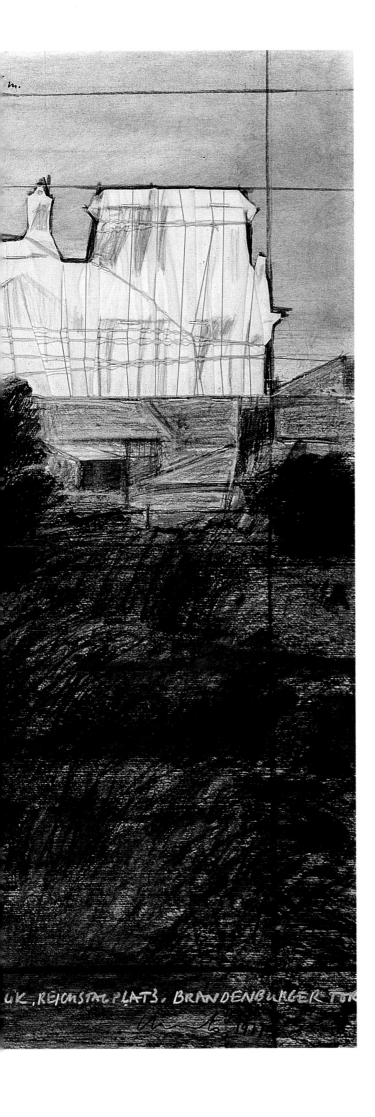

Wrapped Reichstag, Project for Berlin
Collage 1977: 56 x 71 cm (22 x 28 in)
Pencil, fabric, twine, pastel, charcoal and crayon

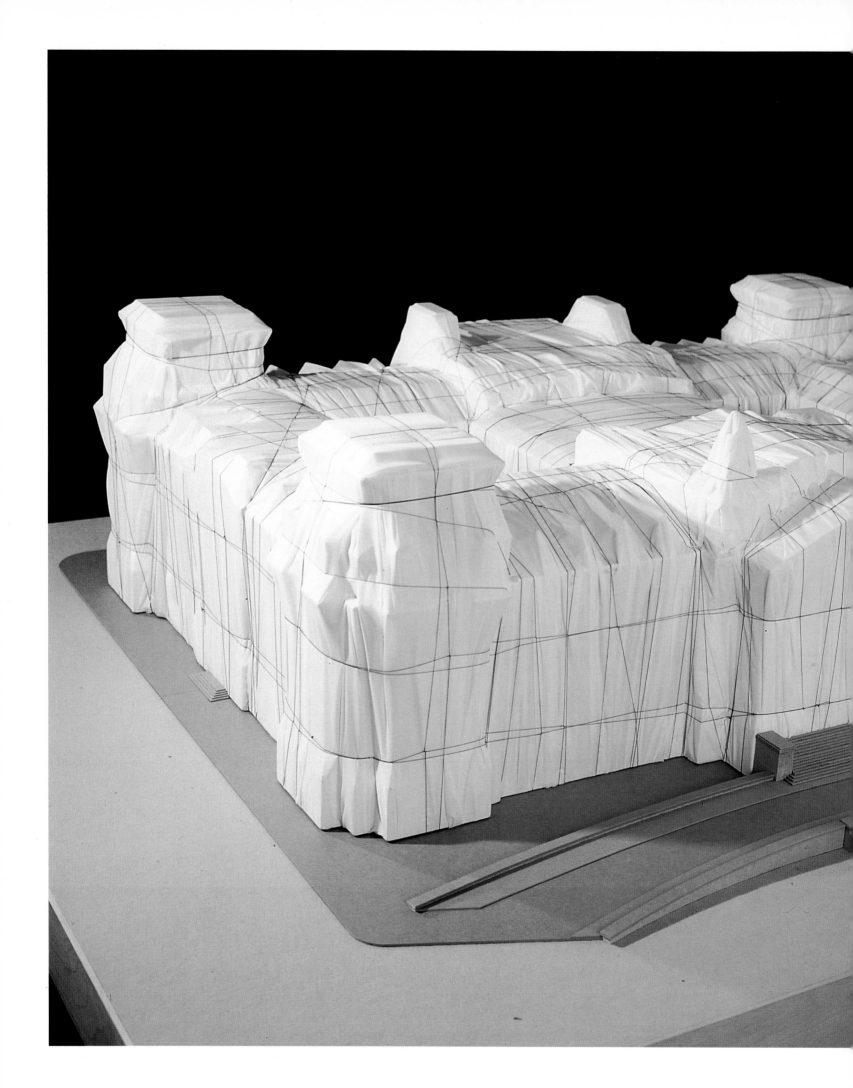

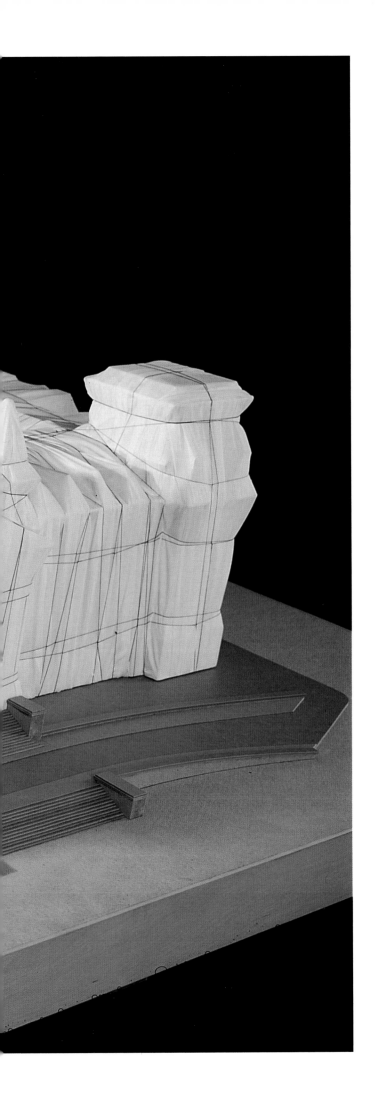

Wrapped Reichstag, Project for Berlin
Scale model 1978: 58.4 x 165.1 x 190.5 cm (23 x 65 x 75 in)
Fabric, twine, wood, cardboard and paint

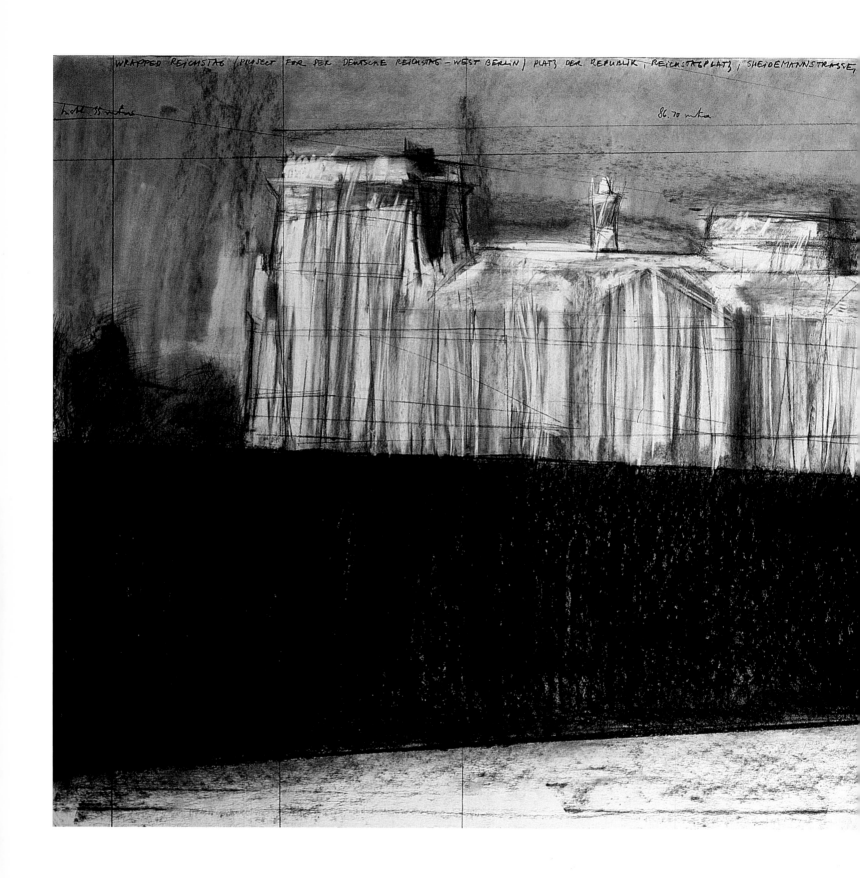

Wrapped Reichstag, Project for Berlin
Drawing 1977: 106.6 x 244 cm (42 x 96 in)
Pencil, pastel and charcoal

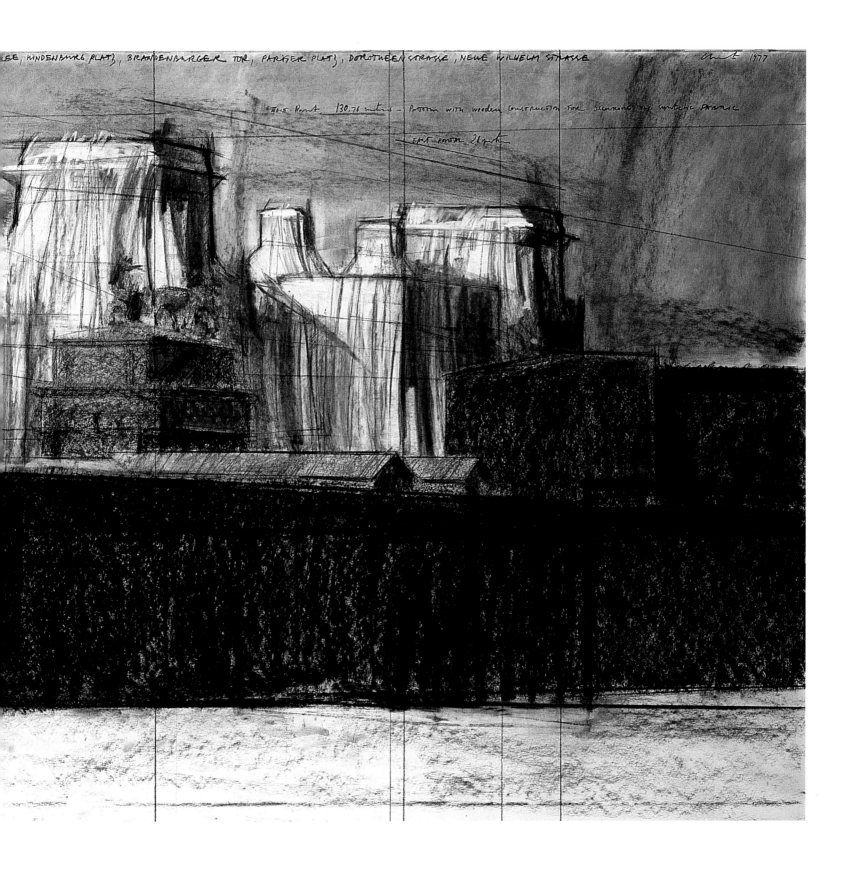

EE, HINDENBURG PLATZ, BRANDENBURGER TOR, PARISER PLATZ, DOROTHEEN STRASSE, NEUE WILHELM STRASSE Christo 1977

EAST Front 130,76 metres - Bottom with wooden construction for securing the synthetic fabric

EAST PORTAL 26 metre

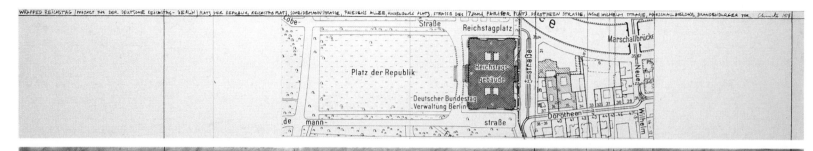

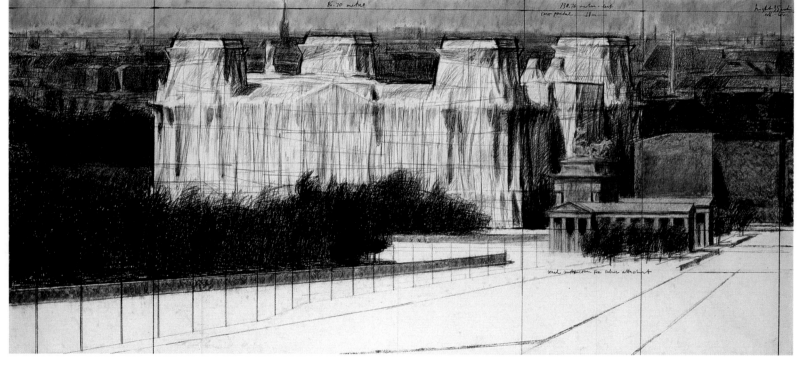

Wrapped Reichstag, Project for Berlin

Drawing 1978. Two parts: 38 x 244 cm (15 x 96 in) and 106.6 x 244 cm (42 x 96 in)

Pencil, charcoal, crayon, pastel and map

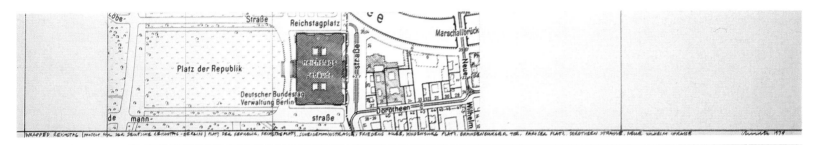

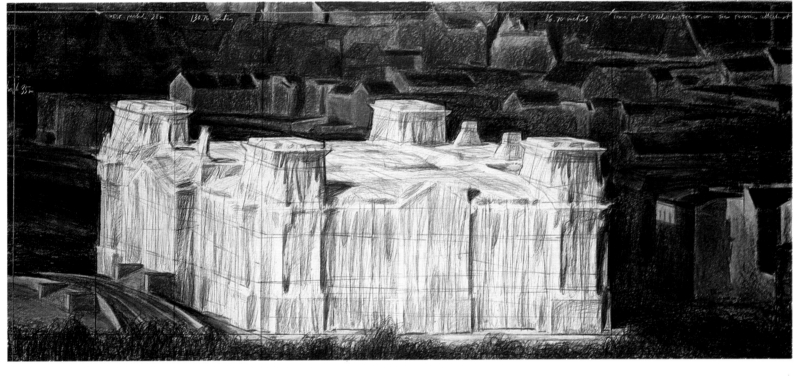

Wrapped Reichstag, Project for Berlin

Drawing 1979. Two parts: 38.1 x 243.8 cm (15 x 96 in) and 106.6 x 243.8 cm (42 x 96 in)

Pencil, pastel, charcoal, crayon and map

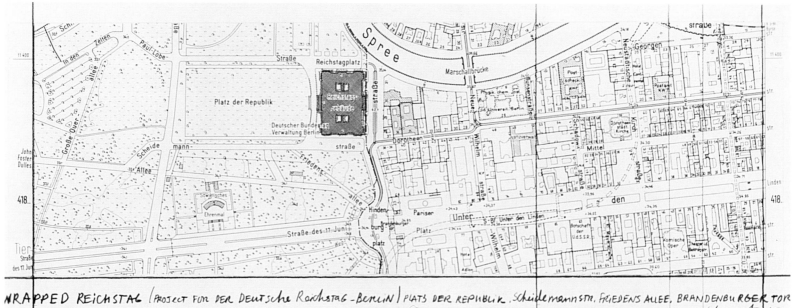

NRAPPED REICHSTAG (PROJECT FOR DER DEUTSCHE REICHSTAG - BERLIN) PLATS DER REPUBLIK, Scheidemannstr. FRIEDENS ALLEE, BRANDENBURGER TOR

Christo 1979

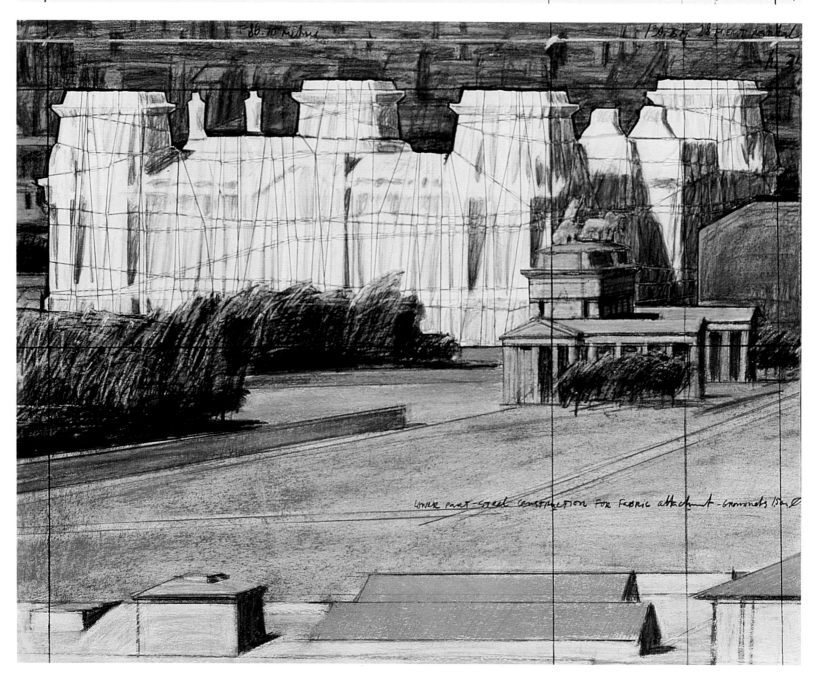

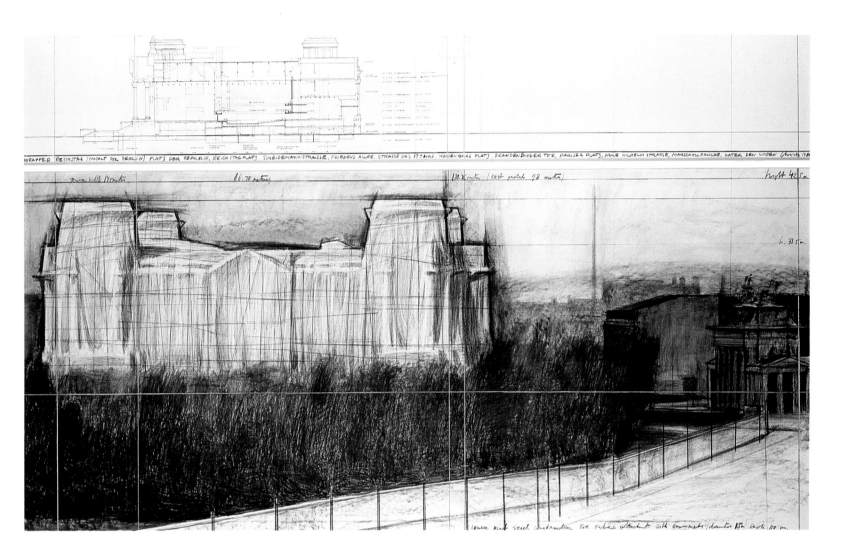

opposite Wrapped Reichstag, Project for Berlin
 Collage 1979. Two parts: 28 x 71 cm (11 x 28 in) and 56 x 71 cm (22 x 28 in)
 Pencil, fabric, twine, pastel, charcoal, crayon and map

above Wrapped Reichstag, Project for Berlin
 Drawing 1980. Two parts: 38 x 244 cm (15 x 96 in) and 106.6 x 244 cm (42 x 96 in)
 Pencil, pastel, charcoal, crayon and technical data

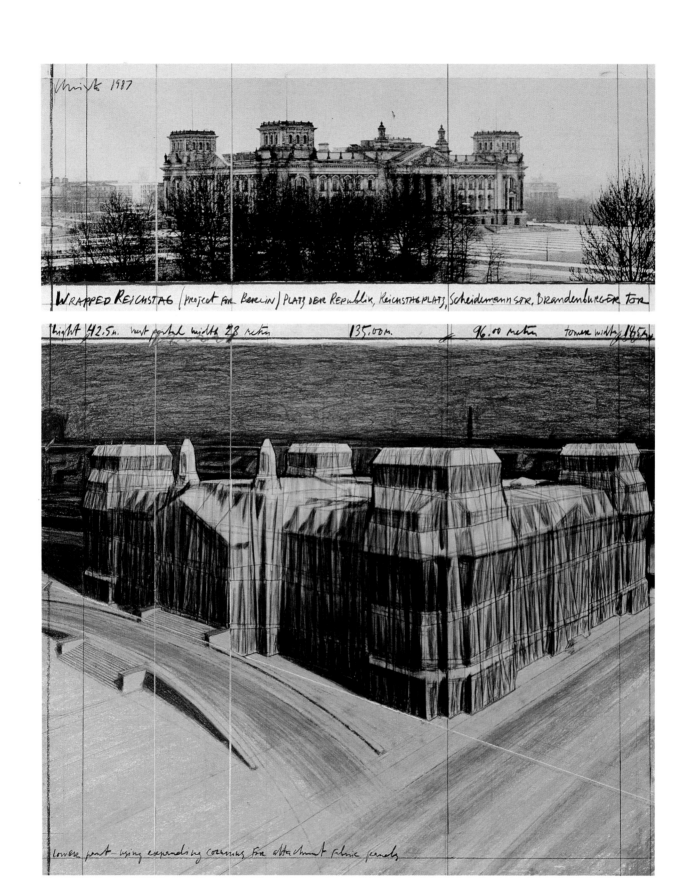

Wrapped Reichstag, Project for Berlin

Collage 1987. Two parts: 30.5 x 77.5 cm (12 x 30 1/2 in) and 66.7 x 77.5 cm (26 1/4 x 30 1/2 in)

Pencil, fabric, twine, photograph, pastel, charcoal and crayon

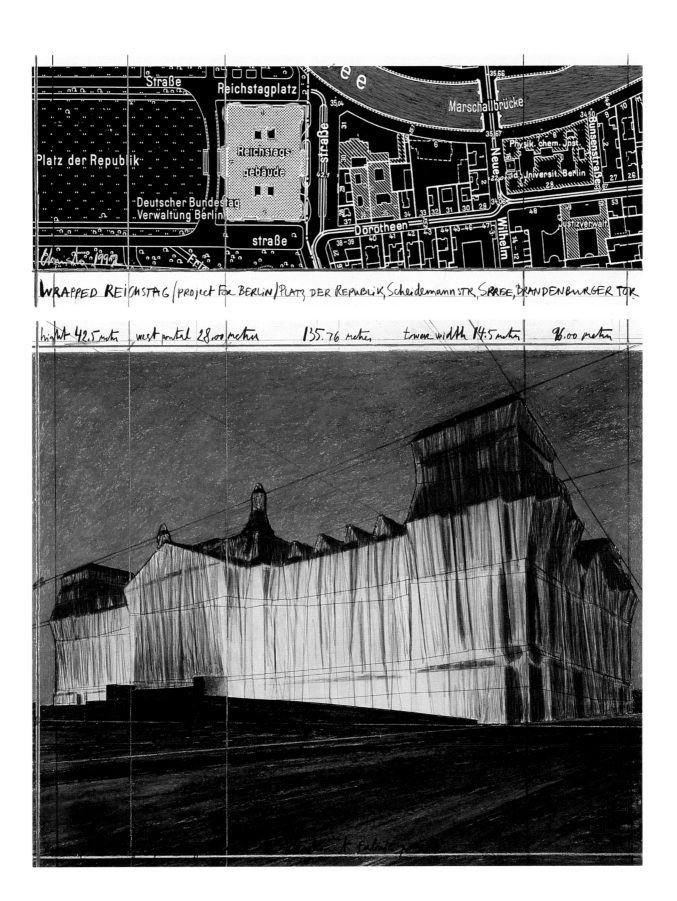

Wrapped Reichstag, Project for Berlin

Collage 1992. Two parts: 30.5 x 77.5 cm (12 x 30¹/₂ in) and 66.7 x 77.5 cm (26 ¹/₄ x 30¹/₂ in)

Pencil, fabric, twine, crayon, pastel and map

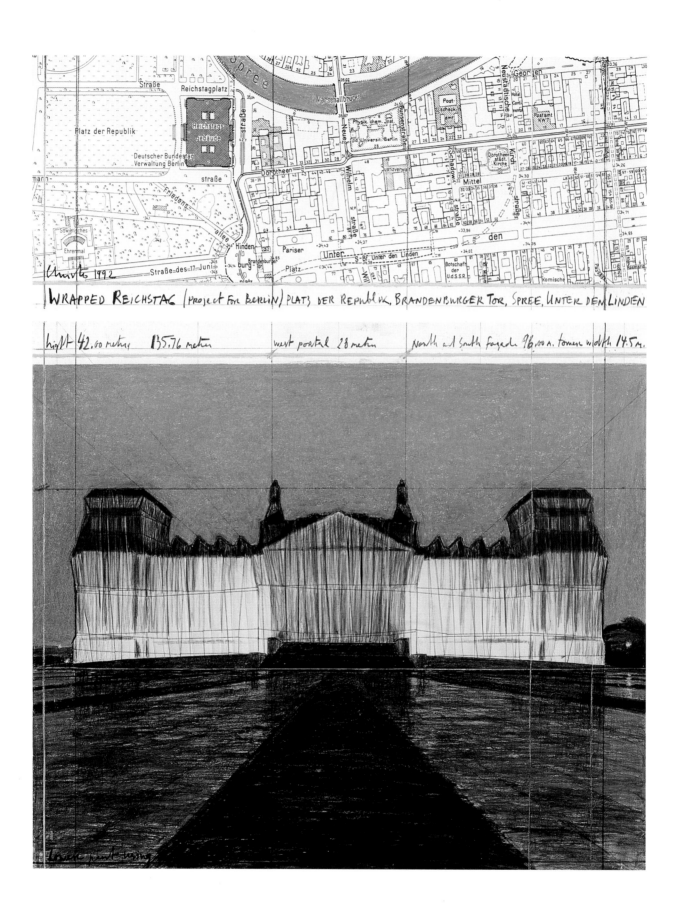

WRAPPED REICHSTAG (PROJECT FOR BERLIN) PLATZ DER REPUBLIK, BRANDENBURGER TOR, SPREE, UNTER DEM LINDEN

Wrapped Reichstag, Project for Berlin

Collage 1993. Two parts: 30.5 x 77.5 cm (12 x 30 1/2 in) and 66.7 x 77.5 cm (26 1/4 x 30 1/2 in)

Pencil, fabric, twine, pastel, charcoal and map

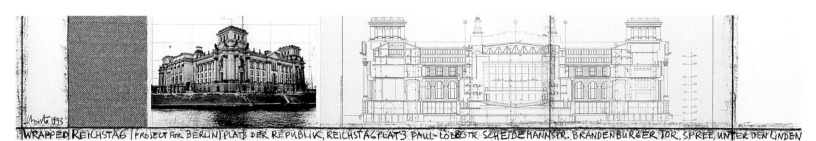

WRAPPED REICHSTAG (PROJECT FOR BERLIN) PLATZ DER REPUBLIK, REICHSTAGPLATZ PAUL-LÖBESTR. SCHEIDEMANNSTR. BRANDENBURGER TOR, SPREE, UNTER DEN LINDEN

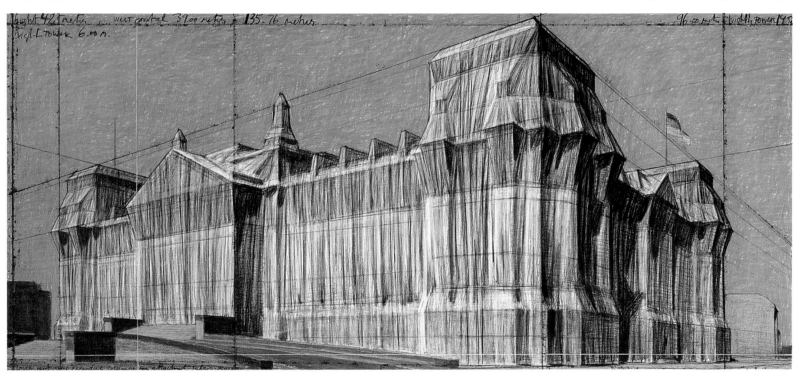

Wrapped Reichstag, Project for Berlin
Drawing 1993. Two parts: 38 x 244 cm (15 x 96 in) and 106.6 x 244 cm (42 x 96 in)
Pencil, charcoal, pastel, crayon, photograph, technical data and fabric sample

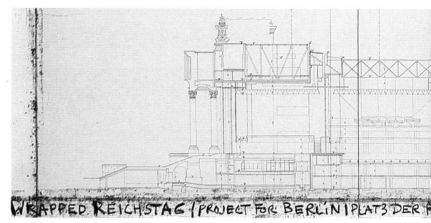

WRAPPED REICHSTAG / PROJECT FOR BERLIN | PLAT3 DER F

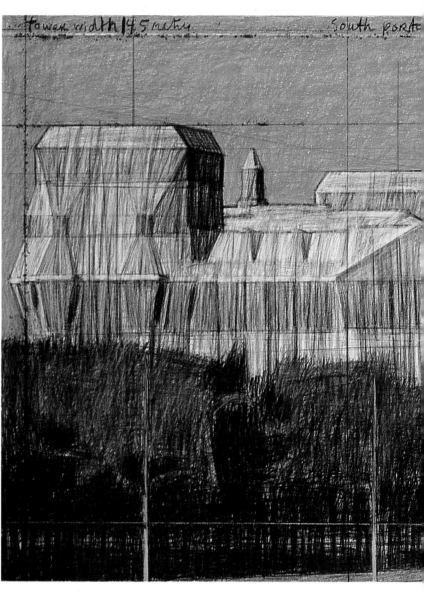

tower width 145 meter South port

Wrapped Reichstag, Project for Berlin

Drawing 1993. Two parts: 38 x 244 cm (15 x 96 in) and 106.6 x 244 cm (42 x 96 in)

Pencil, charcoal, pastel, crayon, technical data and fabric sample

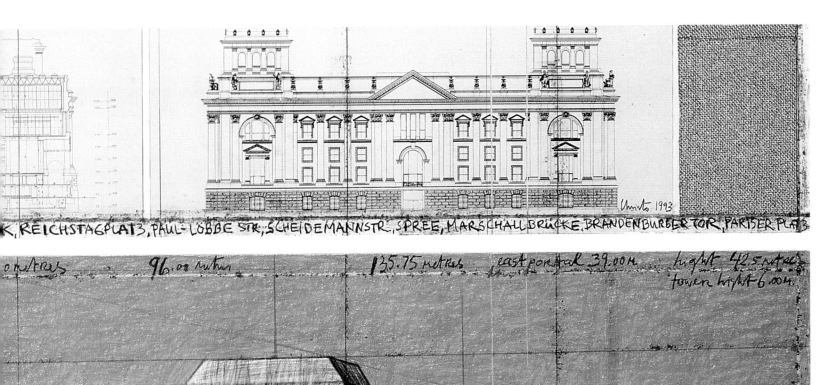

Christo 1993

K. REICHSTAGPLATЗ, PAUL-LÖBBE STR., SCHEIDEMANNSTR., SPREE, MARSCHALLBRÜCKE, BRANDENBURGER TOR, PARISER PLAZ

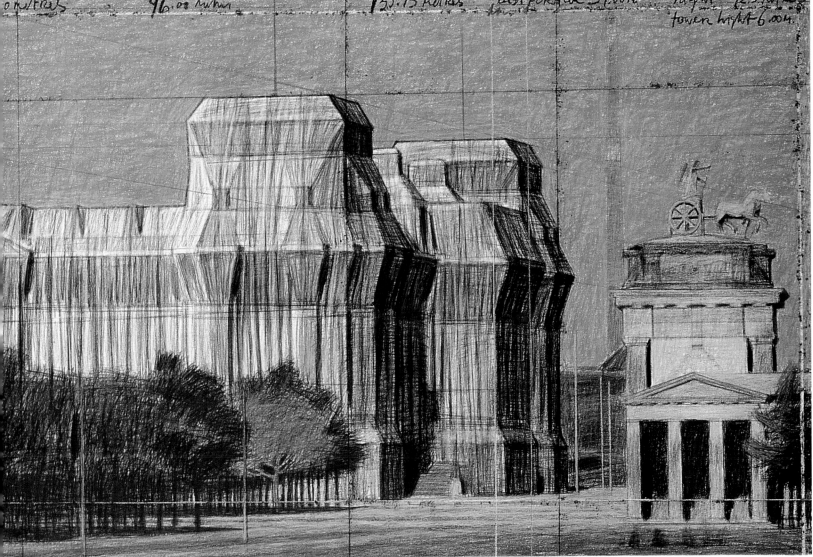

o metres 96.00 metres 135.75 metres east portal 39.00 M hight 42.5 metres
 tower hight 6.00 M

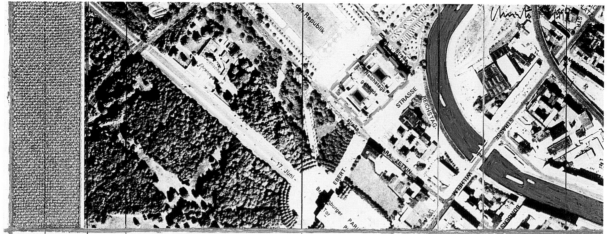

WRAPPED REICHSTAG (PROJECT FOR BERLIN) PLATZ DER REPUBLIK, PAUL-LÖBE STR. SPREE, BRANDENBURGERTOR UNTER DEN LINDEN

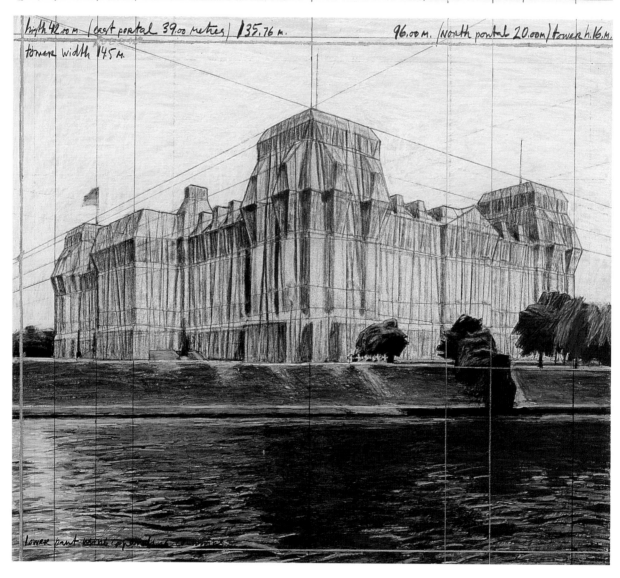

high 42.00 m (east portal 39.00 metres) 135.76 m. 96.00 M. (North portal 20.00m) tower h. 16. m.
tower width 145 m.

lower part with copper bronze aluminium

Wrapped Reichstag, Project for Berlin

Collage 1994. Two parts: 30.5 cm x 77.5 cm (12 x 30 1/2 in) and 66.7 x 77.5 cm (26 1/3 x 30 1/2 in)

Pencil, fabric, twine, pastel, charcoal, crayon, aerial map and fabric sample

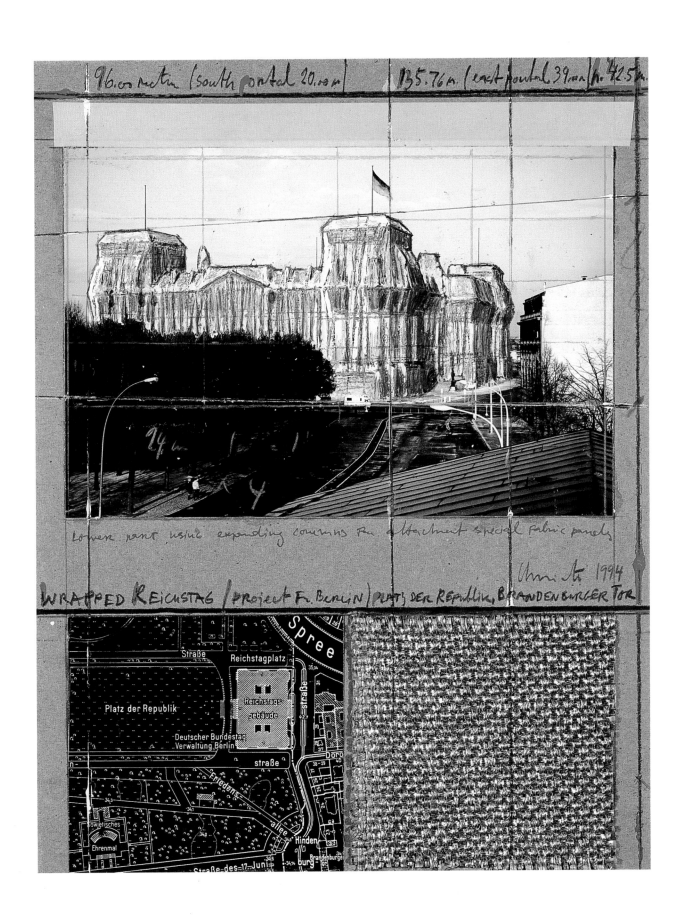

Wrapped Reichstag, Project for Berlin
Collage 1994: 35.5 x 28 cm (14 x 11 in)
Pencil, enamel paint, photograph, charcoal, crayon, map, fabric sample,
ballpoint pen and tape on brown-grey cardboard

The Gates, Project for Central Park, New York City

Fabric panel · (h. 230 meter x 2.50 – 2.50 m/ 15%) 2.50 - 3 m. 2.50 - 3 m. h. 4 m.
steel pole

h 230 m.

THE HUNDRED Gates (PROJECT FOR 750 Gates For Wenkenpark – Basel Switzerland) Christo 1979

Christo and Jeanne-Claude:
The Gates, Project for Central Park

Press Release

The Gates will be 15 feet high with a width varying from 9 to 28 feet following the edges of the walk ways, perpendicular to the selected foot paths of Central Park. Attached to the top of each steel gate, spaced at 9 feet intervals, the fabric will come down to 5 feet 6 inches from the ground, allowing the synthetic woven panels to wave horizontally towards the next gate.

The Gates are planned to remain for 14 days in the last two weeks of a month of October, after which the 27 mile long work of art shall be removed and the ground restored to its original condition.

The Gates will be entirely financed by Christo and Jeanne-Claude through the sale of studies, preparatory drawings and collages, scale models and original lithographs.

Neither the City nor the Park shall bear any of the expenses for The Gates.

A written contract shall be drafted between the Department of Parks and our organization based upon the agreements made in California with all relevant Governmental Agencies at the time of the construction of the Running Fence project, which brought complete satisfaction to the authorities and international attention to that area.

The contract shall require us to provide:
– Personal and Property Liability Insurance holding the Department of Parks harmless.
– Environmental Impact Statement would be prepared if requested by the Park.
– Removal Bond providing funds for complete restoration of the ground.
– Full co-operation with the Community Boards, the Department of Parks, the New York City Arts Commission, and the Landmarks Commission.
– Employment of local Manhattan residents.
– Clearance for the usual activities in the Park and access of Rangers, maintenance, clean-up, Police and Emergency Service vehicles.
– Direct cost of the Park's supervision shall be charged to us.
– The configuration of the path of The Gates shall be selected together with the Department of Parks.
– No vegetation nor rock formations shall be disturbed.
– Only vehicles of small size will be used and will be confined to the perimeter of existing walk ways during installation and removal.
– Great precaution will be taken in the scheduling of The Gates so as not to interfere with any of the wildlife patterns.
– All holes shall be professionally backfilled with natural material, leaving the ground in good condition and it shall be inspected by the Department of Parks who will be holding the Bond until full satisfaction.
– Financial help shall be given by us to the Department of Parks in order to cover any possible additional clean-up task, secretarial work, or any expenses that might occur in direct relation to The Gates.

Full size prototype tests have been conducted by our Engineers, on the steel frames, their bottom supports and the fabric panel connections.

By up-lifting and framing the space above the walk ways, the luminous fabric of The Gates will underline the organic design in contrast to the geometric grid pattern of Manhattan and will harmonize with the beauty of Central Park.

New York City, 1980.

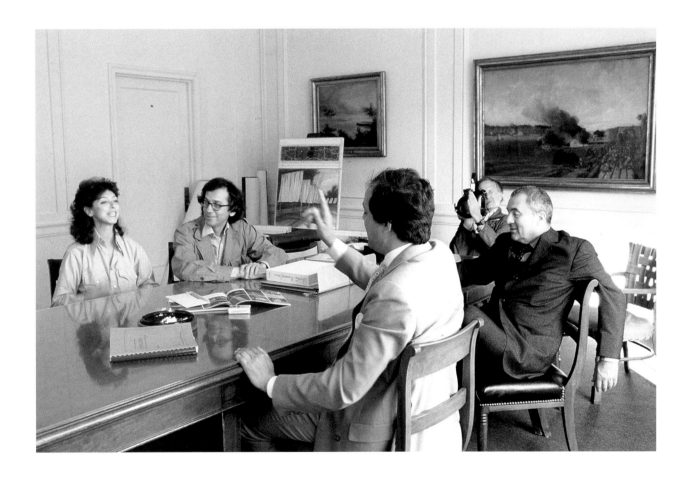

During negotiations for 'The Gates, Project for Central Park, New York City',
Jeanne-Claude, Christo and attorney Theodore Kheel explain the temporary
work of art to Parks Commissioner Gordon Davies (centre) while film-maker
Albert Maysles records the meeting, 22 April 1980.

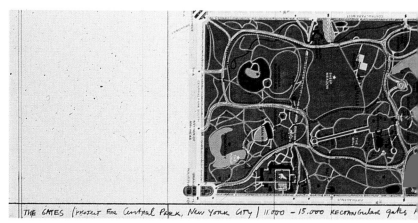

THE GATES (PROJECT FOR Central Park, New York City) 11.000 - 15.000 RECTANGULAR gates

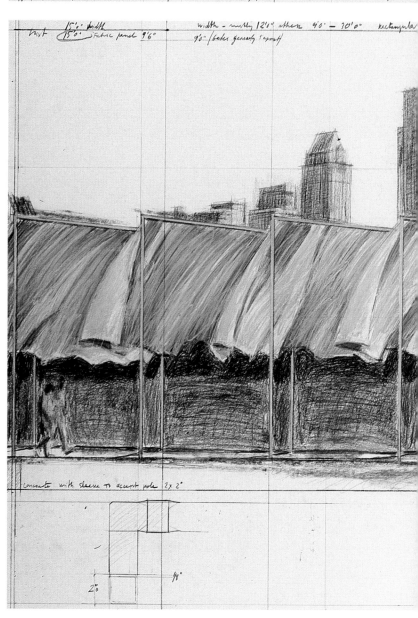

The Gates, Project for Central Park, New York City
Drawing 1980. Two parts: 38 x 244 cm (15 x 96 in) and 106.6 x 244 cm (42 x 96 in)
Pencil, pastel, charcoal and map

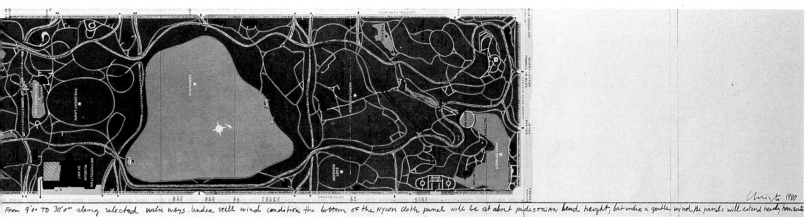

From 9'0" TO 30'0" along selected walk ways. Under still wind condition the bottom of the nylon cloth panel will be at about pedestrian head height, but under a gentle wind the panels will extend nearly horizontal

Christo 1980

with Free-Flowing panel of nylon cloth suspended from the top cross-members of the frame

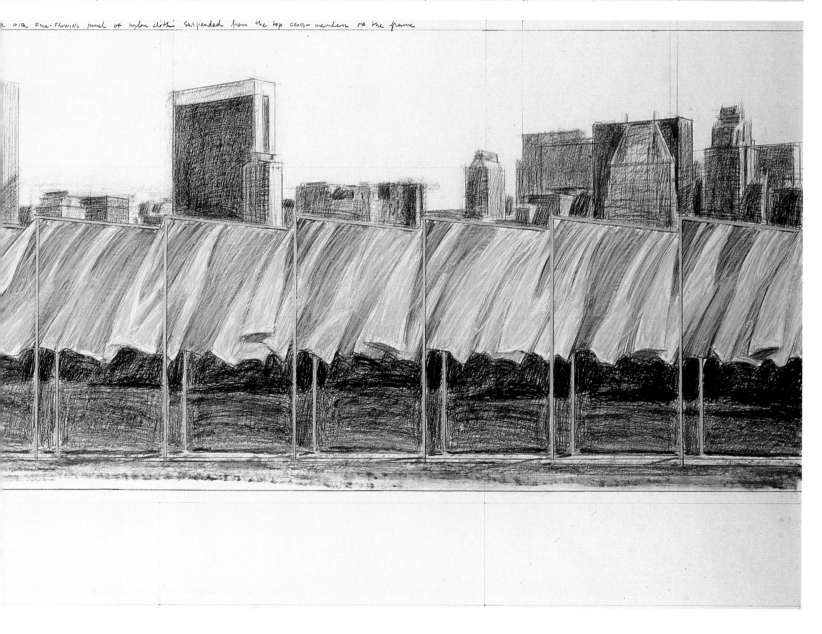

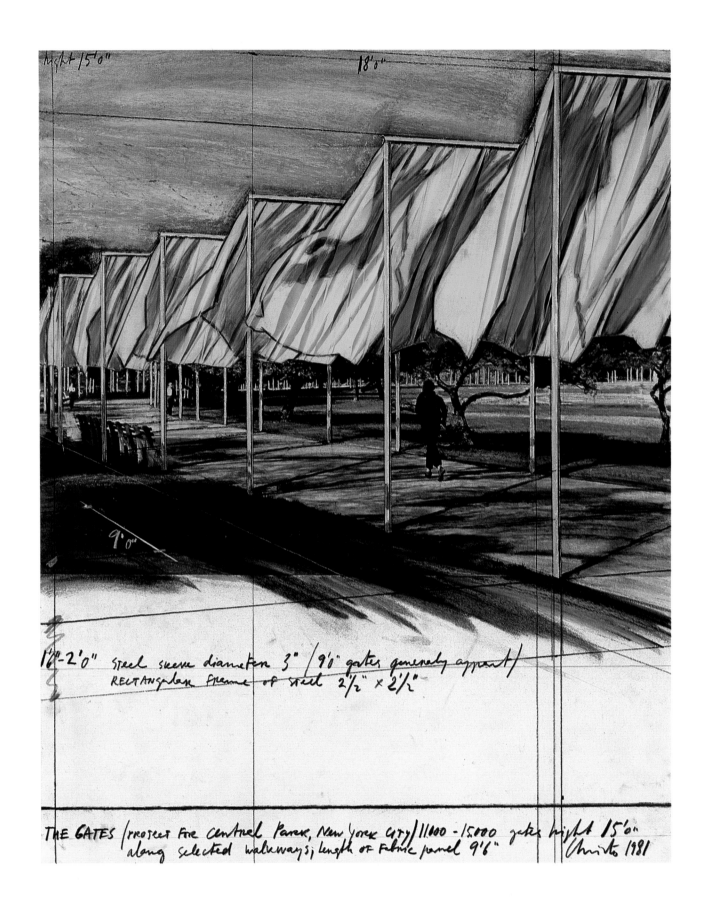

The Gates, Project for Central Park, New York City
Collage 1981: 71 x 56 cm (28 x 22 in)
Pencil, fabric, pastel, charcoal and photostat

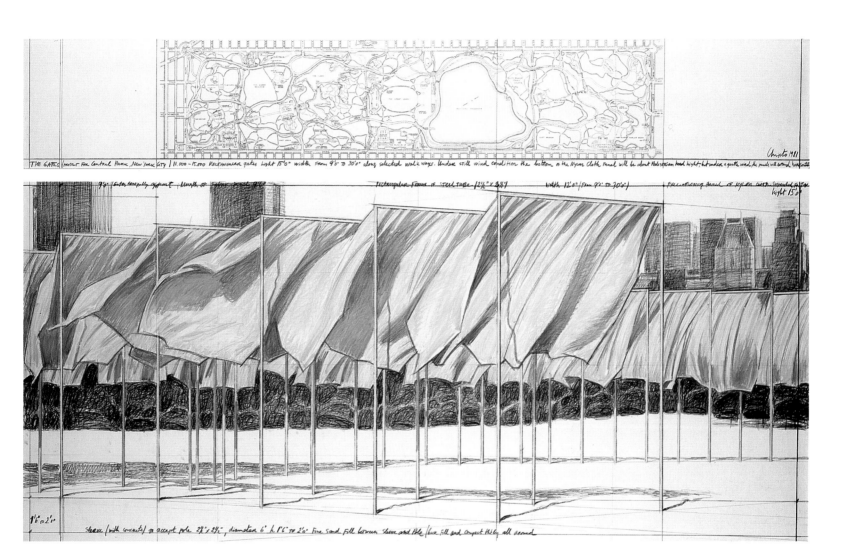

The Gates, Project for Central Park, New York City

Drawing 1981. Two parts: 38 x 244 cm (15 x 96 in) and 106.6 x 244 cm (42 x 96 in)

Pencil, pastel, charcoal and map

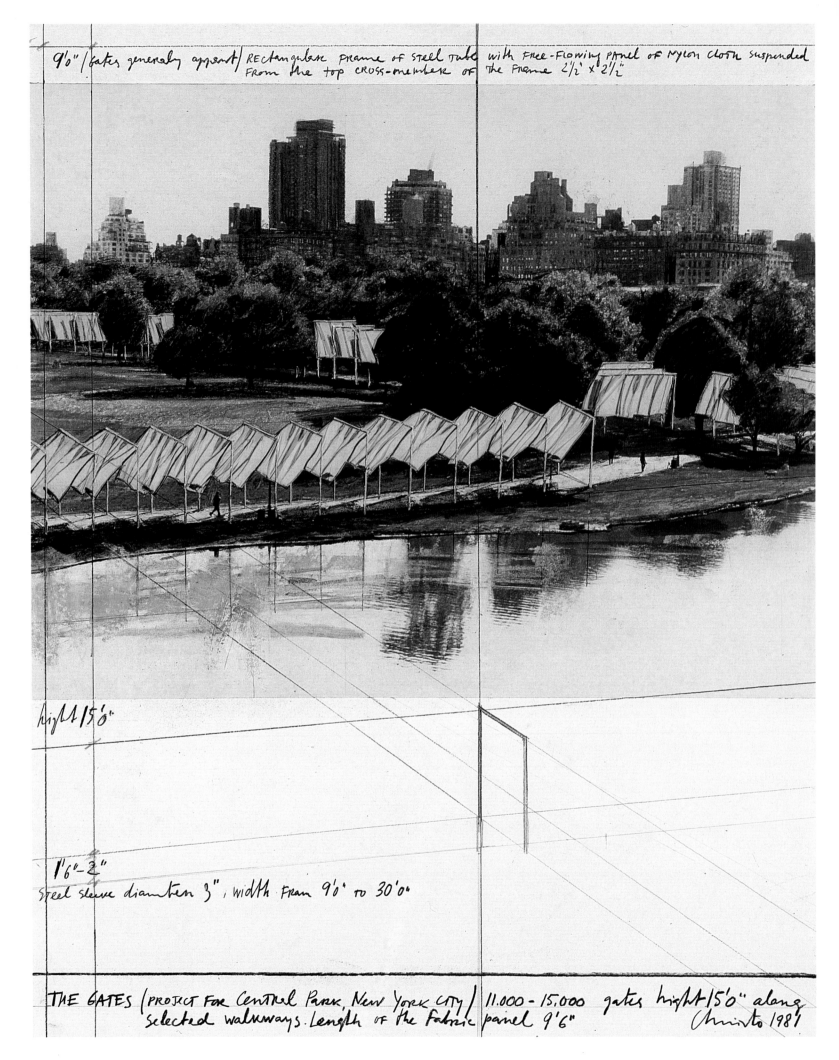

9'0" /gates generally apparent/ RECTANGULAR FRAME OF STEEL TUBE with FREE-FLOWING PANEL OF NYLON CLOTH SUSPENDED FROM THE TOP CROSS-MEMBER OF THE FRAME 2½" x 2½"

hight 15'0"

1'6"-2"
STEEL SLEEVE diameter 3", width FROM 9'0" TO 30'0"

THE GATES (PROJECT FOR CENTRAL PARK, New York CITY/ selected walkways. Length OF the Fabric panel 9'6" 11.000 - 15.000 gates hight 15'0" along

Christo 1981

52

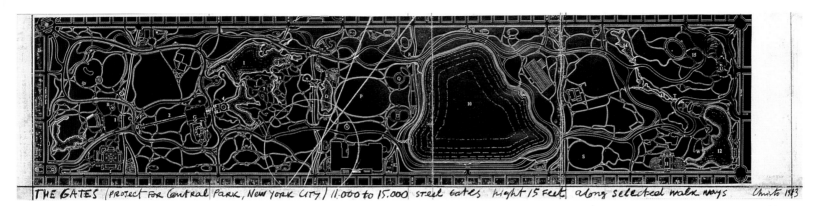

THE GATES (PROJECT FOR Central PARK, New York CITY) 11.000 to 15.000 steel gates hight 15 Feet along selected walk ways Christo 1983

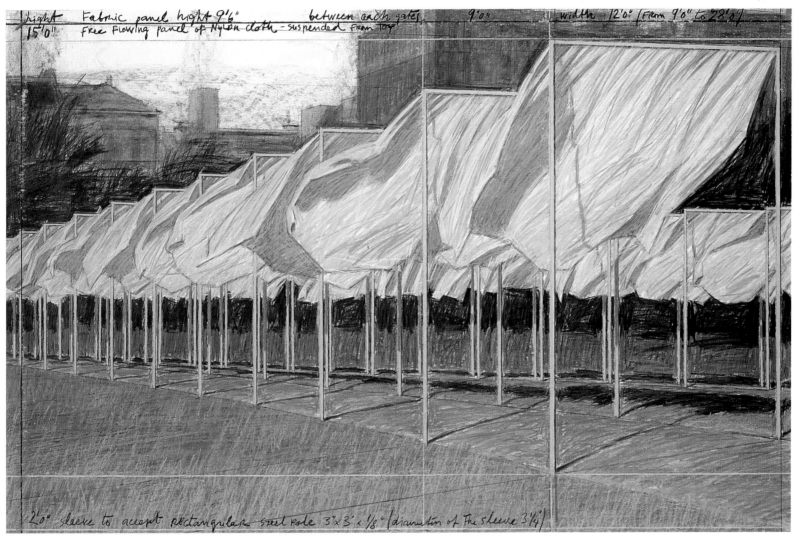

hight Fabric panel hight 9'6" between each gates 9'0" width 12'0" (From 9'0" to 28'0")
15'0" Free Flowing panel of Nylon cloth - suspended from Top

2'0" sleeve to accept rectangular steel pole 3"x 3" x 1/8" (diameter of The sleeve 3 1/4")

opposite The Gates, Project for Central Park, New York City
 Collage 1981: 71 x 56 cm (28 x 22 in)
 Pencil, fabric, pastel, charcoal and photostat

above The Gates, Project for Central Park, New York City
 Drawing 1983. Two parts: 38 x 165 cm (15 x 65 in) and 106.6 x 165 cm (42 x 65 in)
 Pencil, charcoal, pastel, crayon and map

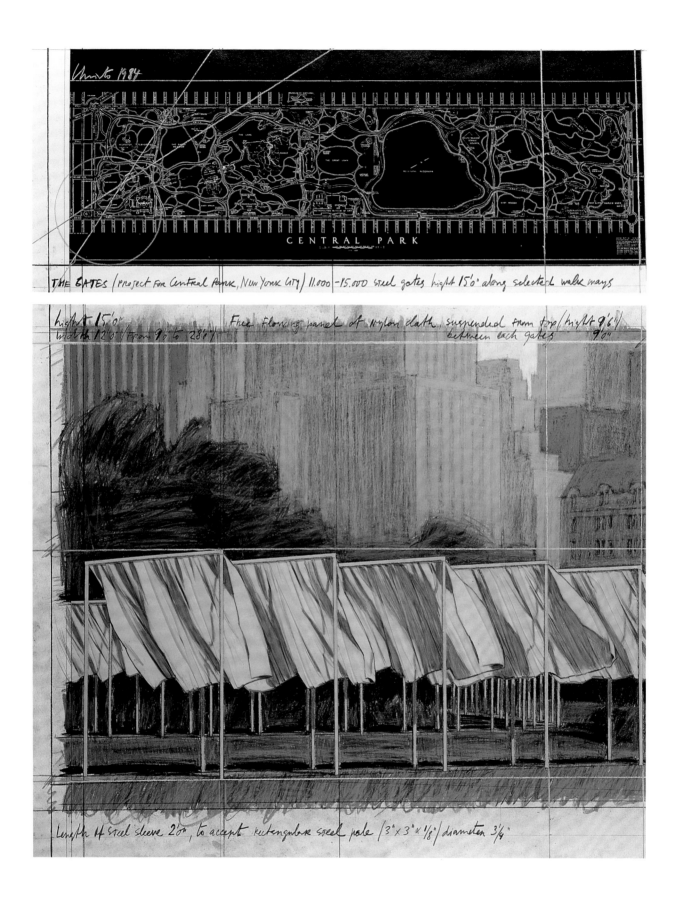

The Gates, Project for Central Park, New York City

Collage 1984. Two parts: 30.5 x 77.5 cm (12 x 30 1/2 in) and 66.7 x 77.5 cm (26 1/4 x 30 1/2 in)

Pencil, fabric, charcoal, crayon, pastel and map

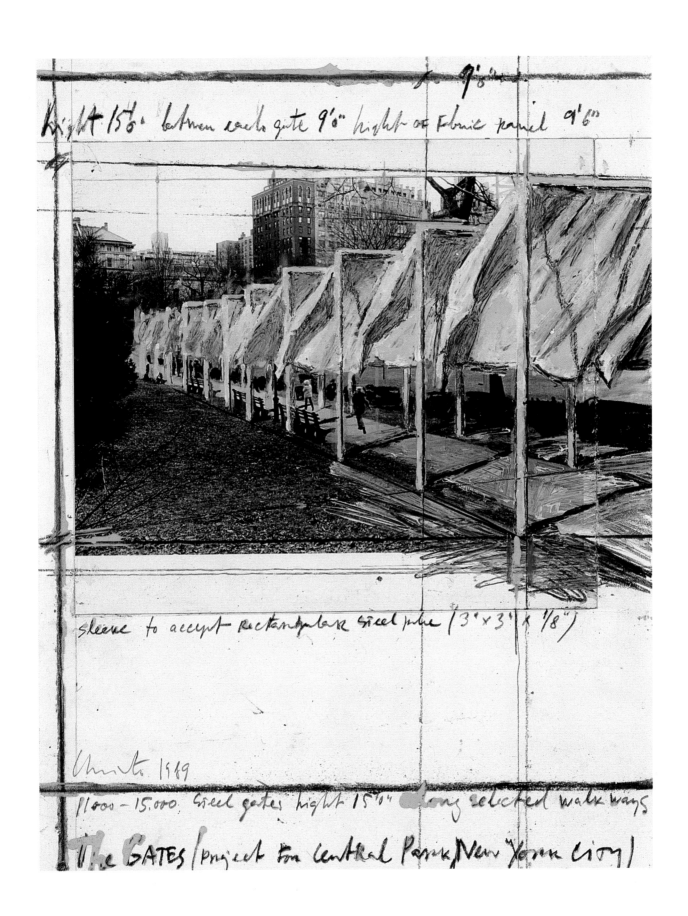

The Gates, Project for Central Park, New York City
Collage 1989: 35.5 x 28 cm (14 x 11 in)
Pencil, enamel paint, photograph, crayon and charcoal

The Mastaba of Abu Dhabi, Project for the United Arab Emirates

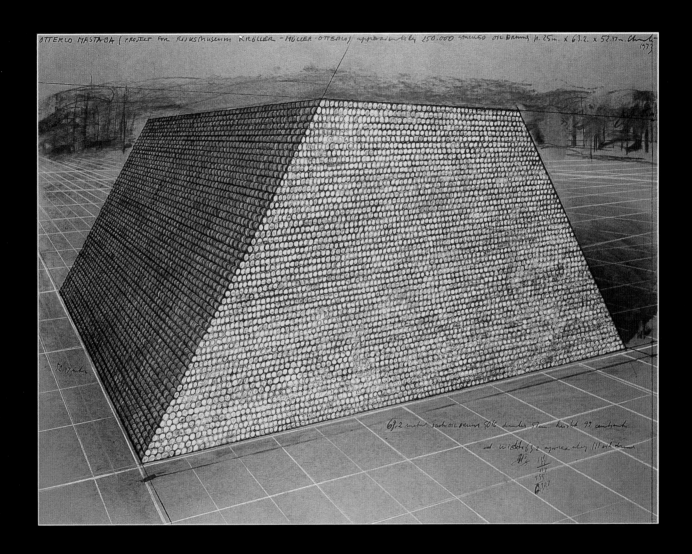

Otterlo Mastaba, Project for the Kröller-Müller Museum,
Otterlo, The Netherlands
Drawing 1973: 76 cm x 101.6 cm (30 x 40 in)
Pencil, enamel paint, charcoal and crayon

Christo and Jeanne-Claude:
The Mastaba of Abu Dhabi, Project for the United Arab Emirates

Press Release

The Mastaba of Abu Dhabi will represent:
– The symbol of the Emirate and the greatness of Sheikh Zayed, the Mastaba will be taller and more massive than the Cheops Pyramid near Cairo.
– The symbol of civilization of oil throughout the world.
– The Mastaba will be made of 390,500 oil barrels. The project has the most unique character. Nothing comparable has ever existed in any other country. Hundreds of bright colors, as enchanting as the Islamic mosaics, will give a constantly changing visual experience according to the time of the day and the quality of the light.
– The grandeur and vastness of the land will be reflected in the majesty of the Mastaba which is to be 300 meters (984 feet) wide, 225 meters (738 feet) deep and 150 meters (492 feet) high.
– The only purpose of this monument is to be itself. The Mastaba of Abu Dhabi can become the symbol of the Emirate and of the 20th Century oil civilization.

The Mastaba will be constructed of materials relative to the area: inside, natural aggregates and cement to form a concrete structure with a sand core; and outside, an overall surfacing of 55-gallon stainless steel oil barrels of various bright colors:
– All Barrels, on the 4 sides and on the top, will be installed so that they are lying horizontally on their sides.
– The two 300 meter (984 feet) wide sides will be vertical showing the circular heads of the colored barrels.
– The two 225 meter (738 feet) ends will be sloping at the 60 degree natural angle of stacked barrels showing the curved sides of the barrels.

The top of the Mastaba will be a horizontal surface 126.8 meters (416 feet) wide and 225 meters (738 feet) deep showing the rounded length of the barrels.
– The Mastaba will be of such a size that many 48 story skyscrapers could fit easily within its volume.

It is suggested that the Mastaba be situated on a slightly rising plain to allow viewers the full impact of the grandeur of the Mastaba as they approach by foot, by automobile, or by airplane. There will be no ingress except for a passageway to the elevators to take visitors to the top, 150 meters (492 feet) above the ground. From there they will enjoy superb views, being able to see approximately 50 kilometers across the countryside.

The area adjacent to the walkways approaching the Mastaba will be like an oasis to the visitor with flowers and grass. There will also be planting of palm trees, eucalyptus trees, thorn trees and other shrubbery surrounding the Mastaba at a distance to serve as a windbreak minimizing the force of the sand and windstorms.

Within this distant area there could be a complex with a worship room, parking and facilities for the visitors and lodging for the curator and guardians.

New York City, 1979

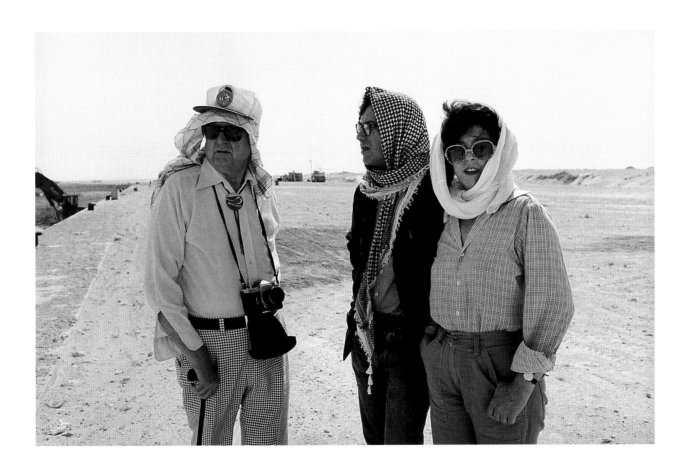

Christo, Jeanne-Claude and Wolfgang Volz made nine visits to the United Arab Emirates, of 10 to 12 days each time, during their work on the project 'The Mastaba of Abu Dhabi, Project for the United Arab Emirates' between 1978 and 1981. Here, Christo and Jeanne-Claude with Theodore Dougherty, builder-contractor from Colorado, look at a possible site for the artwork, just outside the city of Abu Dhabi. Christo and Jeanne-Claude stopped travelling to the Gulf after the start of the war between Iran and Iraq.

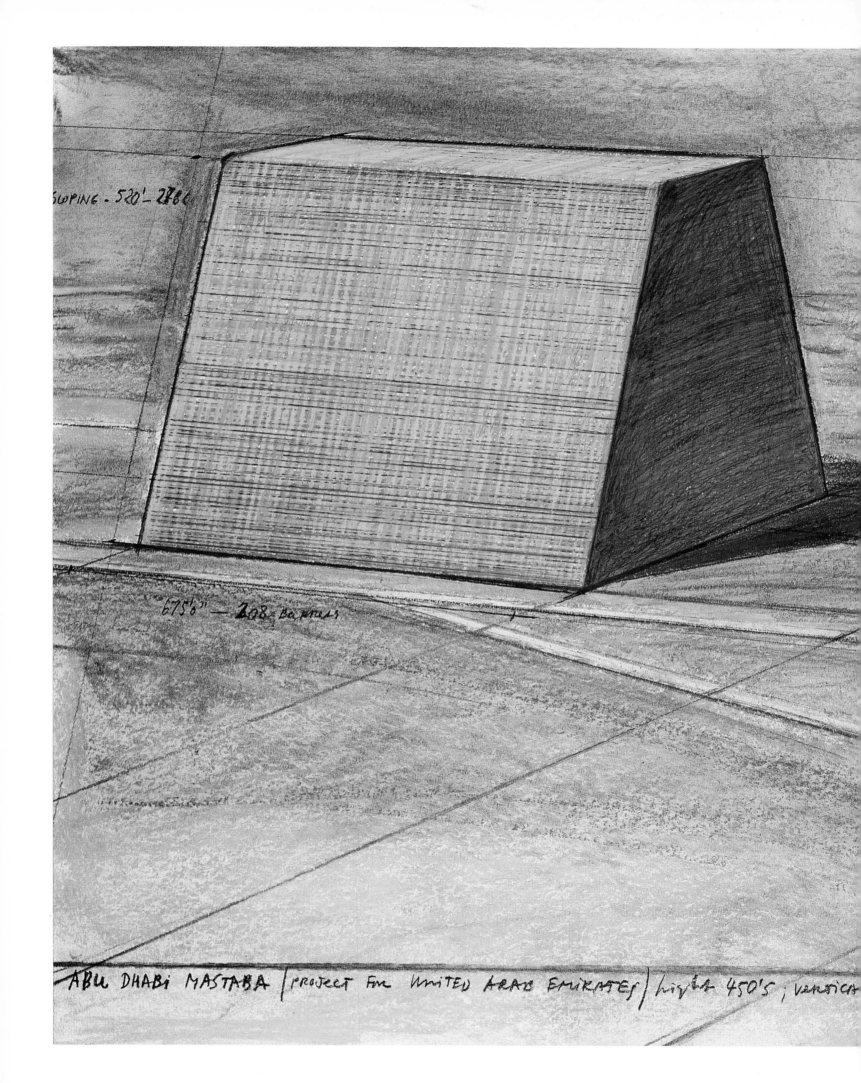

SWPING - 520' - 2786

675'6" - 208 BARRELS

ABU DHABI MASTABA (PROJECT FOR UNITED ARAB EMIRATES) height 450'S; VERTICA

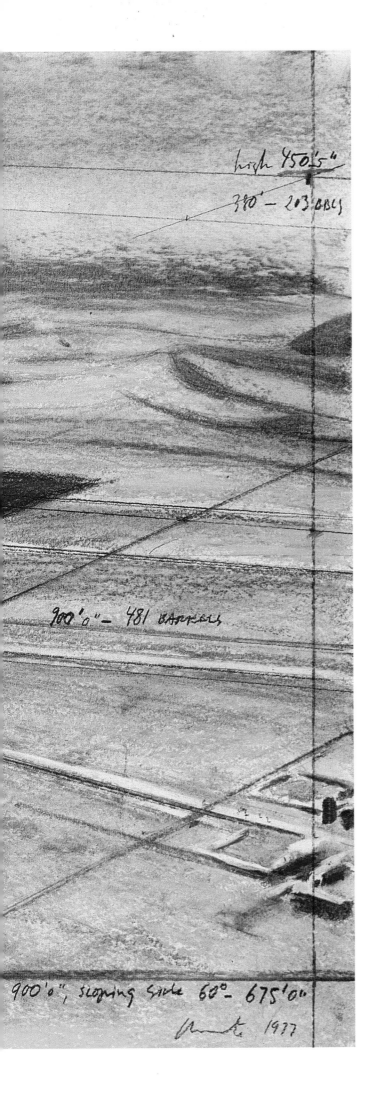

high 450'5"

380' - 203 ABU

900'0" - 481 BARRELS

900'0", sloping side 60° - 675'0"

Christo 1977

The Mastaba of Abu Dhabi, Project for the United Arab Emirates
Drawing 1977: 56 x 71 cm (22 x 28 in)
Pencil, pastel, charcoal and crayon

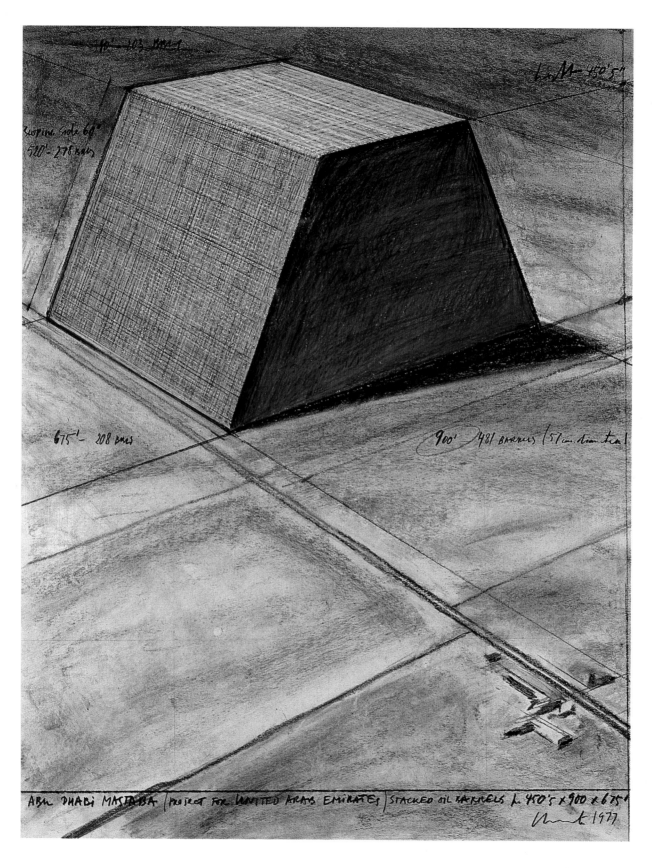

above The Mastaba of Abu Dhabi, Project for the United Arab Emirates
Drawing 1977: 71 x 56 cm (28 x 22 in)
Pencil, crayon, pastel and charcoal

opposite The Mastaba of Abu Dhabi, Project for the United Arab Emirates
Drawing 1977: 71 x 56 cm (28 x 22 in)
Pencil, pastel, charcoal, crayon, photostat and technical data

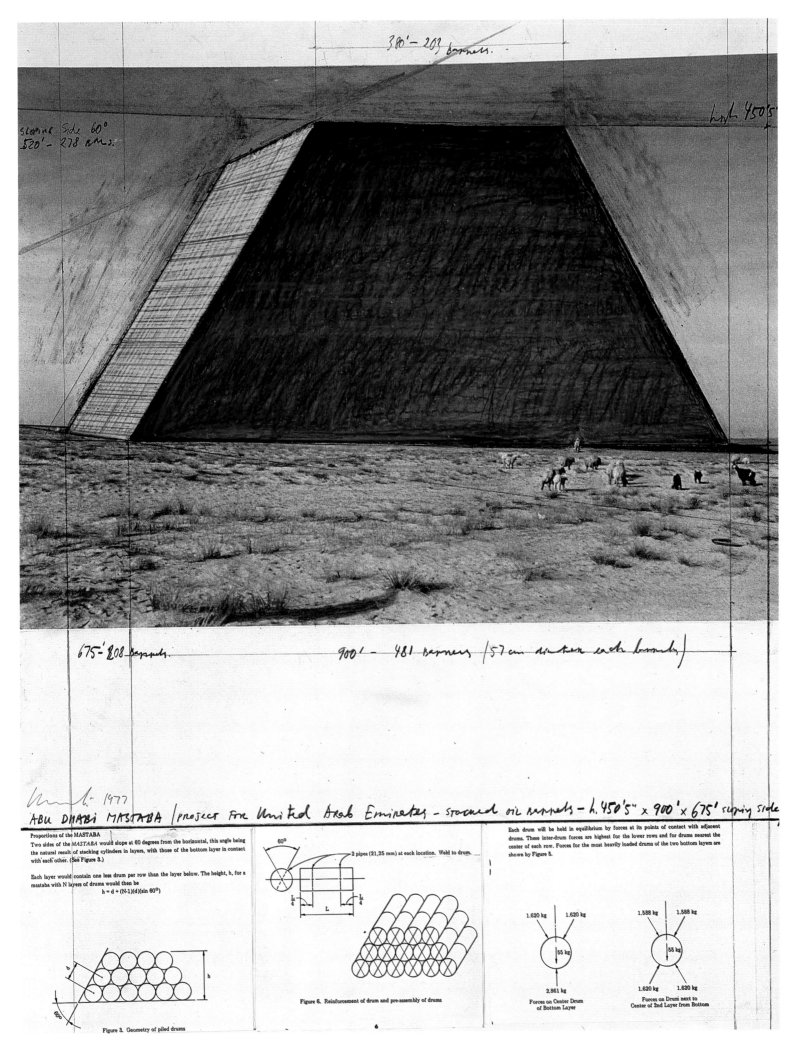

3.80' - 203 barrels.

Slopping Side 60°
520' - 278 Bbls.

lngh 450'5"

675' - 208 barrels.

900' - 481 barrels (57 cm distance each barrel)

1977

ABU DHABI MASTABA / project for United Arab Emirates - stacked oil barrels - h. 450'5" x 900' x 675' sloping side

Proportions of the MASTABA

Two sides of the *MASTABA* would slope at 60 degrees from the horizontal, this angle being the natural result of stacking cylinders in layers, with those of the bottom layer in contact with each other. (See Figure 3.)

Each layer would contain one less drum per row than the layer below. The height, h, for a mastaba with N layers of drums would then be

$$h = d + (N-1)(d)(\sin 60°)$$

Each drum will be held in equilibrium by forces at its points of contact with adjacent drums. These inter-drum forces are highest for the lower rows and for drums nearest the center of each row. Forces for the most heavily loaded drums of the two bottom layers are shown by Figure 5.

60°

2 pipes (21,25 mm) at each location. Weld to drum.

Figure 6. Reinforcement of drum and pre-assembly of drums

1.620 kg 1.620 kg

55 kg

2,861 kg

Forces on Center Drum
of Bottom Layer

1.588 kg 1.588 kg

55 kg

1.620 kg 1.620 kg

Forces on Drum next to
Center of 2nd Layer from Bottom

60°

Figure 3. Geometry of piled drums

63

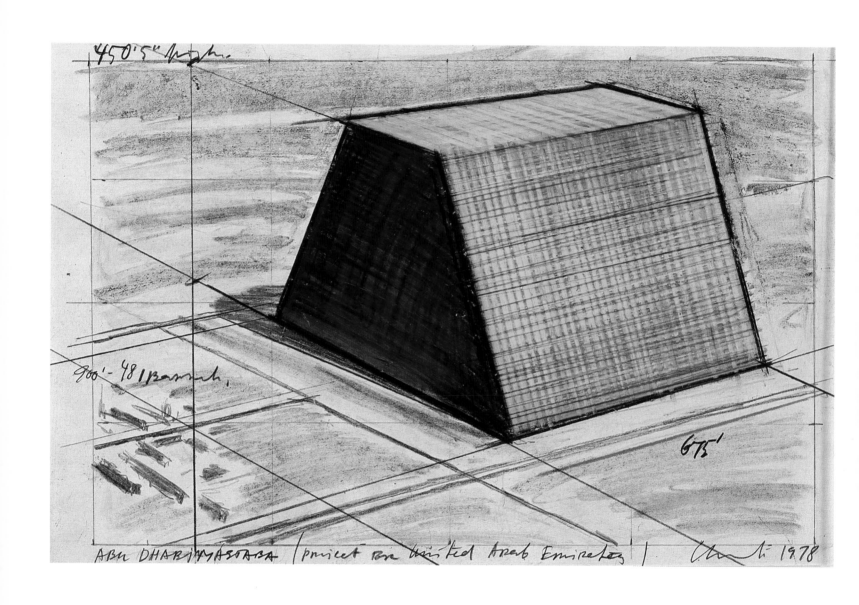

The Mastaba of Abu Dhabi, Project for the United Arab Emirates
Drawing 1978: 23 x 35.5 cm (9 x 14 in)
Pastel, charcoal and crayon

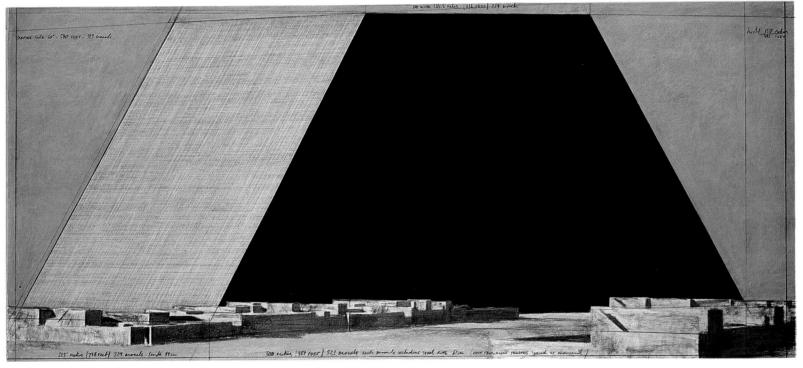

The Mastaba of Abu Dhabi, Project for the United Arab Emirates
Drawing 1979. Two parts: 38 x 244 cm (15 x 96 in) and 106.6 x 244 cm (42 x 96 in)
Pencil, pastel, charcoal, crayon, technical data and map

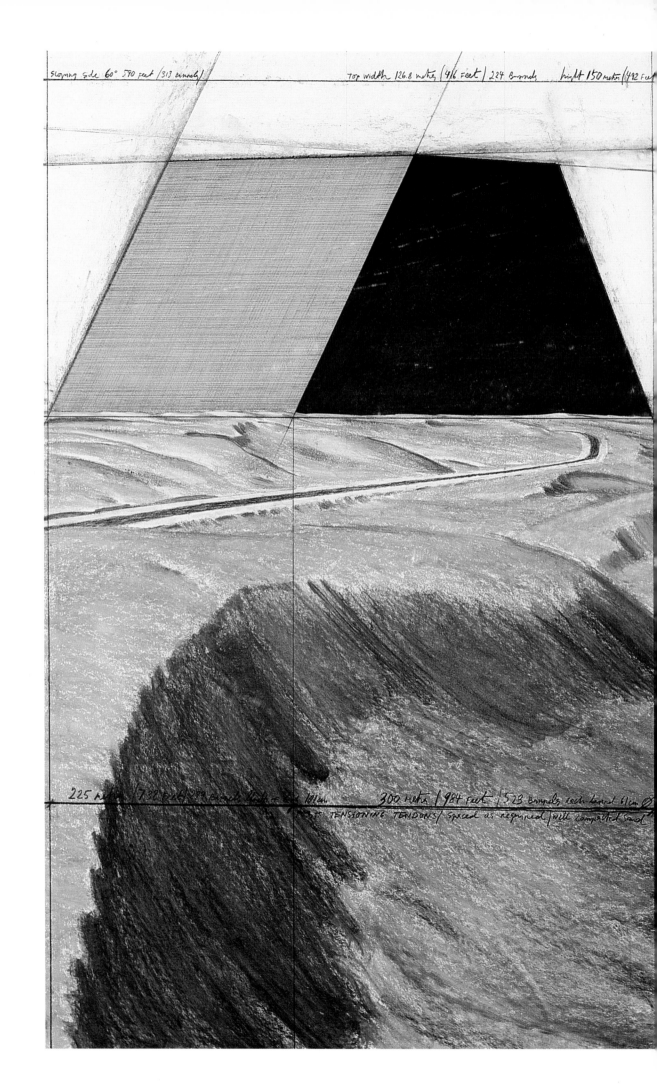

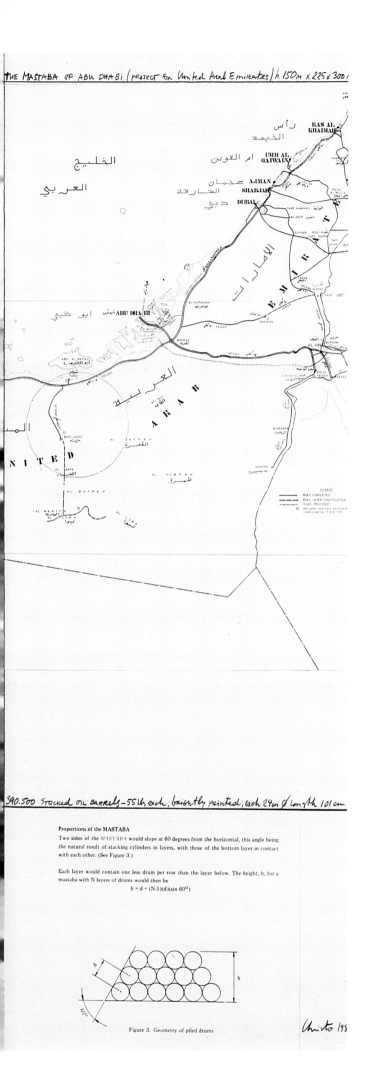

THE MASTABA OF ABU DHABI (PROJECT FOR United Arab Emirates) h. 150m x 225 x 300

390.500 Stacked oil barrels - 55 lbs each, brightly painted; each 24cm of length 101 cm

Proportions of the MASTABA

Two sides of the MASTABA would slope at 60 degrees from the horizontal, this angle being the natural result of stacking cylinders in layers, with those of the bottom layer in contact with each other. (See Figure 3.)

Each layer would contain one less drum per row than the layer below. The height, h, for a mastaba with N layers of drums would then be

$$h = d + (N-1)(d)(\sin 60^{o})$$

Figure 3. Geometry of piled drums

Christo 198

The Mastaba of Abu Dhabi, Project for the United Arab Emirates
Drawing 1980. Two parts: 165 x 106.6 cm (65 x 42 in) and 165 x 61 cm (65 x 24 in)
Pencil, pastel, charcoal, crayon, technical data and map

Over the River, Project for Western USA

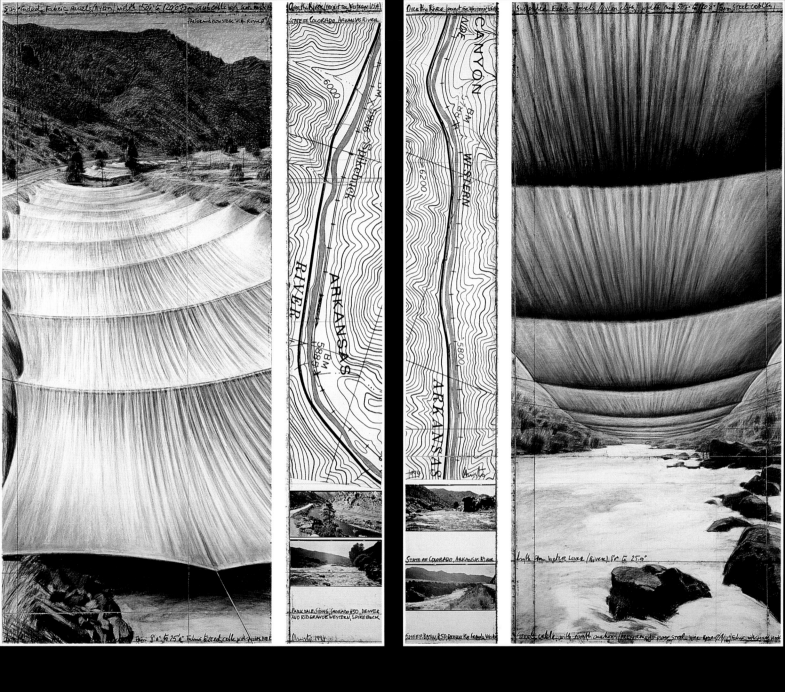

left Over the River, Project for Western USA, State of Colorado, the Arkansas River
(seen from above)
Drawing 1994. Two parts: 244 x 106.6 cm (96 x 42 in) and 244 x 38 cm (96 x 15 in)
Pencil, charcoal, pastel, photographs, crayon and map

Christo and Jeanne-Claude:
Over the River, Project for Western USA

Press Release

Fabric panels suspended horizontally above and clear of the river will follow the configuration and width of the changing course of the river's tranquil and white waters.

Steel wire cables, anchored on the upper part of the river banks, will cross the river and serve as attachment for the fabric panels.

The woven nylon panels, sewn in advance, with rows of grommets at the edges perpendicular to the river, will allow loose folds of the fabric to gather in the middle of the curving cables, 2 to 7 meters (6 to 25 feet) above the river bed. The 6.5 to 10 kilometers (4 to 6 miles) long stream of successive panels will be interrupted by bridges, rocks, trees or bushes, creating abundant flows of light.

Wide clearance between the banks and the edges of the fabric panels will create a play of contrast allowing sunlight to illuminate the river on both sides and through the luminous fabric.

As with our previous art projects, Over the River will be entirely financed by Christo and Jeanne-Claude, through the sale by C.V.J. Corporation (Jeanne-Claude Christo-Javacheff, President) of the preparatory drawings, lithographs, collages and early works.

The road running along the river, and footpaths will allow the project to be seen, approached and enjoyed from above by car and from underneath on foot. For a period of two weeks, the temporary work of art Over the River will join the recreational activities and the natural life of the river.

Christo and Jeanne-Claude, New York City, 1992.

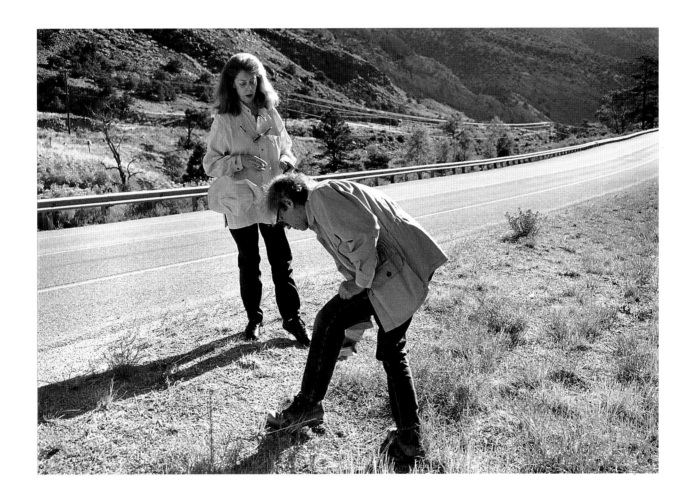

Jeanne-Claude and Christo looking at rivers in the Rocky Mountains, August 1993, for 'Over the River, Project for Western USA'. In the summers of 1992, 1993 and 1994, over 20,000 kilometres were driven in the search for sites. Six rivers have been located in four different states.

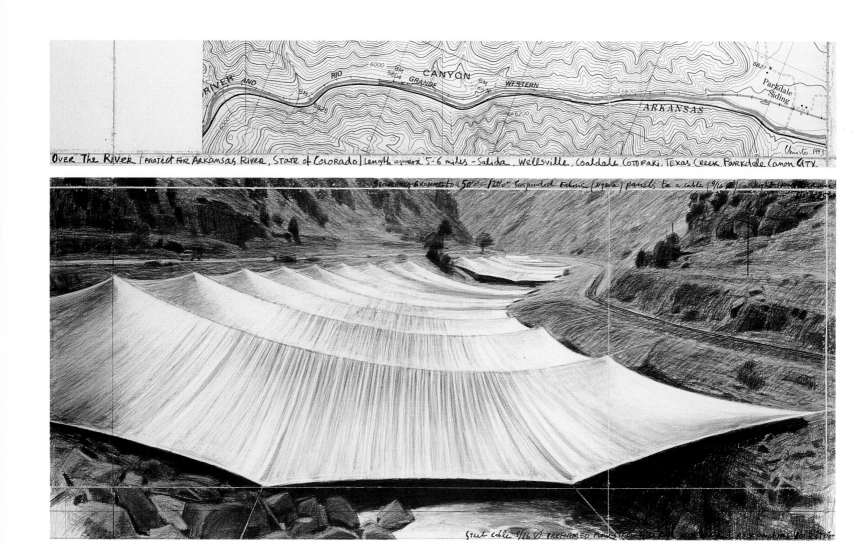

Over the River, Project for the Arkansas River, Colorado (seen from above)

Drawing 1993. Two parts: 38 x 244 cm (15 x 96 in) and 106.6 x 244 cm (42 x 96 in)

Pencil, charcoal, pastel crayon and map

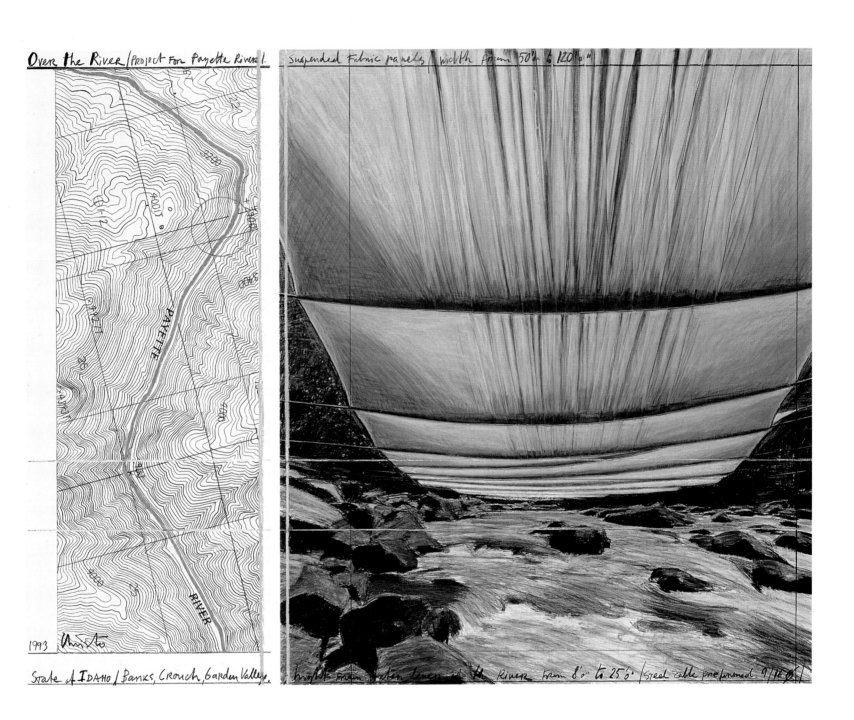

Over the River, Project for the Payette River, Idaho (seen from below)
Collage 1993. Two parts: 77.5 x 30.5 cm (30 1/2 x 12 in) and 77.5 x 66.7 cm (30 1/2 x 26 1/4 in)
Pencil, fabric, pastel, charcoal, crayon and topographic map

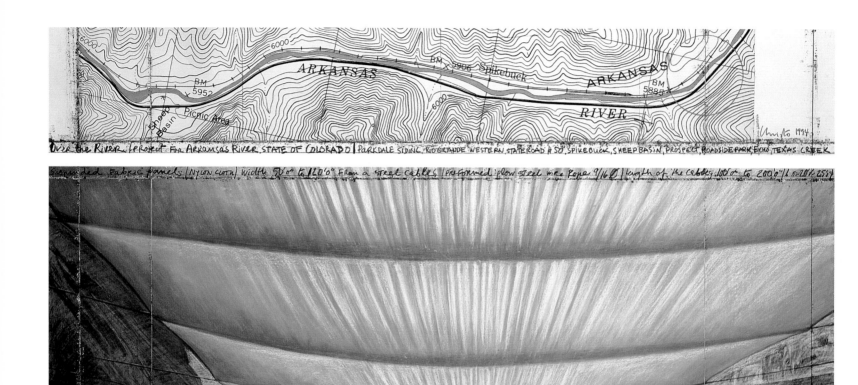

Over the River, Project for Western USA, State of Colorado, the Arkansas River (seen from below)

Drawing 1994. Two parts: 38 x 244 cm (15 x 96 in) and 106.6 x 244 cm (42 x 96 cm)

Pencil, charcoal, pastel, crayon and map

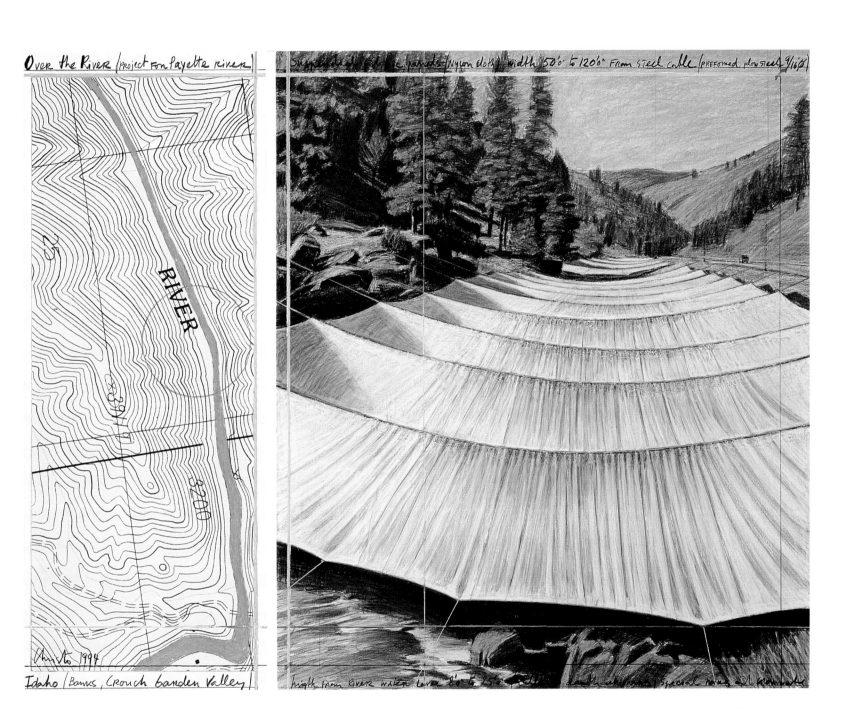

Over the River, Project for the Payette River, Idaho (seen from above)

Collage 1994. Two parts: 77.5 x 30.5 cm (30 1/2 x 12 in) and 77.5 x 66.7 cm (30 1/2 x 26 1/4 in)

Pencil, fabric, twine, pastel, charcoal, crayon and map

Valley Curtain, Rifle, Colorado, 1970–72

Height: 110 metres (365 feet), span: 394 metres (1250 feet)

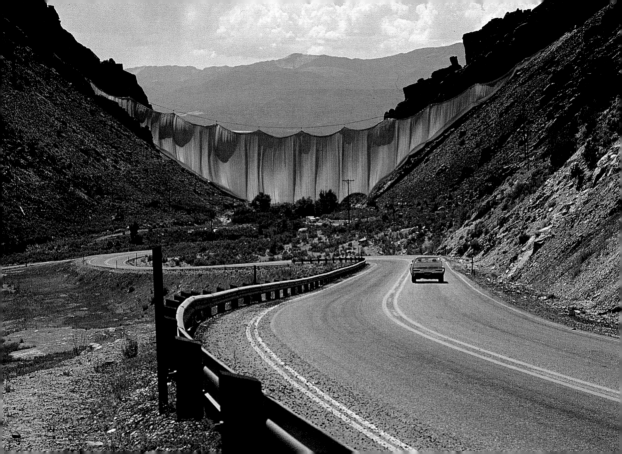

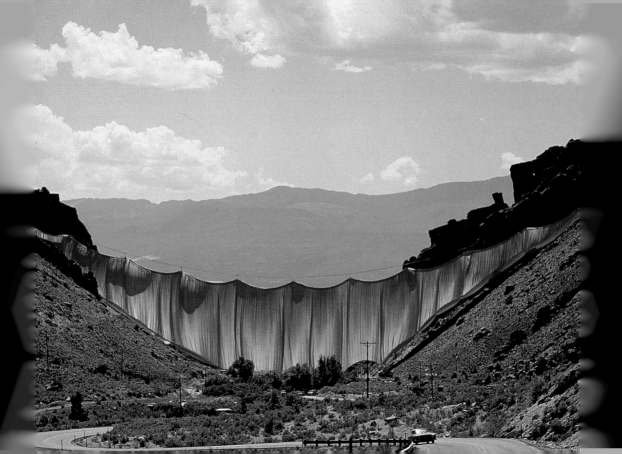

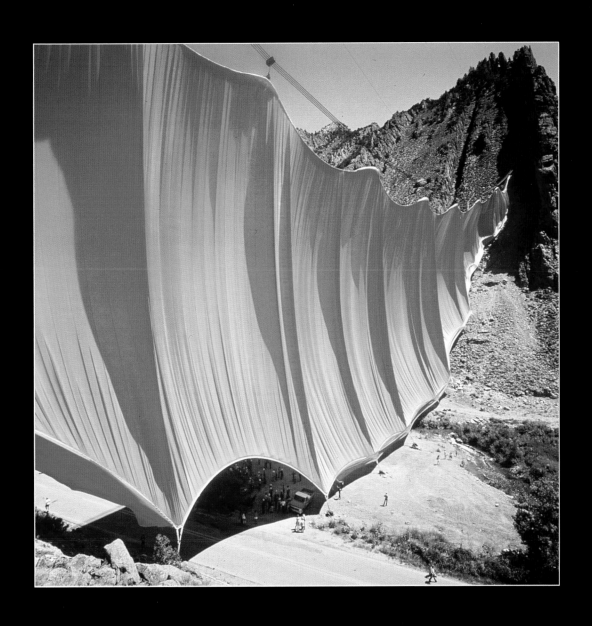

Christo and Jeanne-Claude:
Valley Curtain, Rifle, Colorado, 1970–72

Press Release

On August 10, 1972, in Rifle, Colorado, between Grand Junction and Glenwood Spring in the Grand Hogback Mountain Range, at 11am, a group of 35 construction workers and 64 temporary helpers, art schools, college students, and itinerant art workers tied down the last of 27 ropes that secured the 12,780 square meters (142,000 square feet) of woven nylon fabric orange Curtain to its moorings at Rifle Gap, 7 miles north of Rifle, on Highway 325.

Valley Curtain was designed by Dimiter Zagoroff and John Thomson of Unipolycon of Lynn, Massachusetts, and Dr. Ernest C. Harris of Ken R. White Company, Denver, Colorado. It was built by A and H Builders Inc. of Boulder, Colorado, President, Theodore Dougherty, under the site supervision of Henry B. Leininger.

By suspending the Curtain at a width of 375 meters (1250 feet) and a height curving from 111 meters (365 feet) at each end to 56 meters (182 feet) at the center, the Curtain remained clear of the slopes and the Valley bottom. A 3 meter (10 foot) skirt attached to the lower part of the Curtain visually completed the area between the thimbles and the ground.

An outer cocoon enclosed the fully fitted Curtain for protection during transit and at the time of its raising into position and securing to the 11 cable clamps connections at the 4 main upper cables. The cables spanned 417 meters (1,368 feet), weighed 49,500 kilograms (110,000 pounds), and were anchored to 720 metric tonnes (800 tons) of concrete foundations.

An inner cocoon, integral to the Curtain, provided added insurance. The bottom of the Curtain was laced to a 7.6 centimeter (3 inch) diameter dacron rope from which the control and tie-down lines ran to the 27 anchors.

The Valley Curtain Project took 28 months to complete.

Christo and Jeanne-Claude's temporary work of art was financed by the Valley Curtain Corporation (Jeanne-Claude Christo-Javacheff, President) through the sale of the studies, preparatory drawings and collages, scale models, early works, and original lithographs.

On August 11, 1972, 28 hours after completion of the Valley Curtain, a gale estimated in excess of 100 kph (60 mph) made it necessary to start the removal.

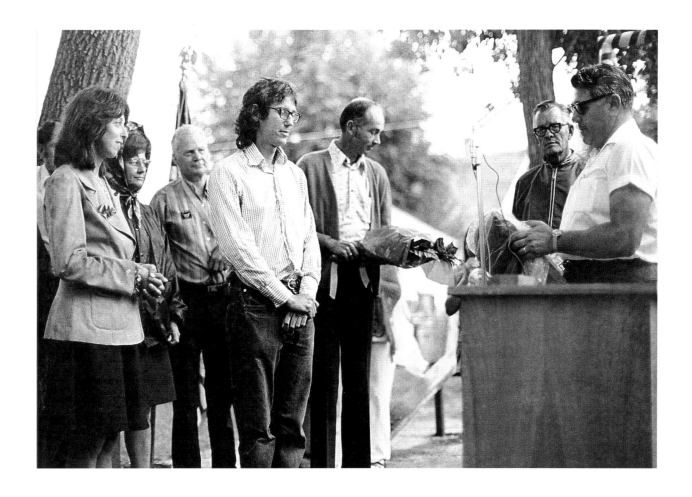

In Rifle, Colorado, on 18 August 1972, Mayor John B. Scalzo gave Jeanne-Claude and Christo
the keys to the city. The bronze plaque reads 'Presented to Christo and Jeanne-Claude, by
the citizens of Rifle, for their dedicated efforts in conceiving and achieving "The Valley Curtain",
a pure and beautiful tribute to the imagination of man.'

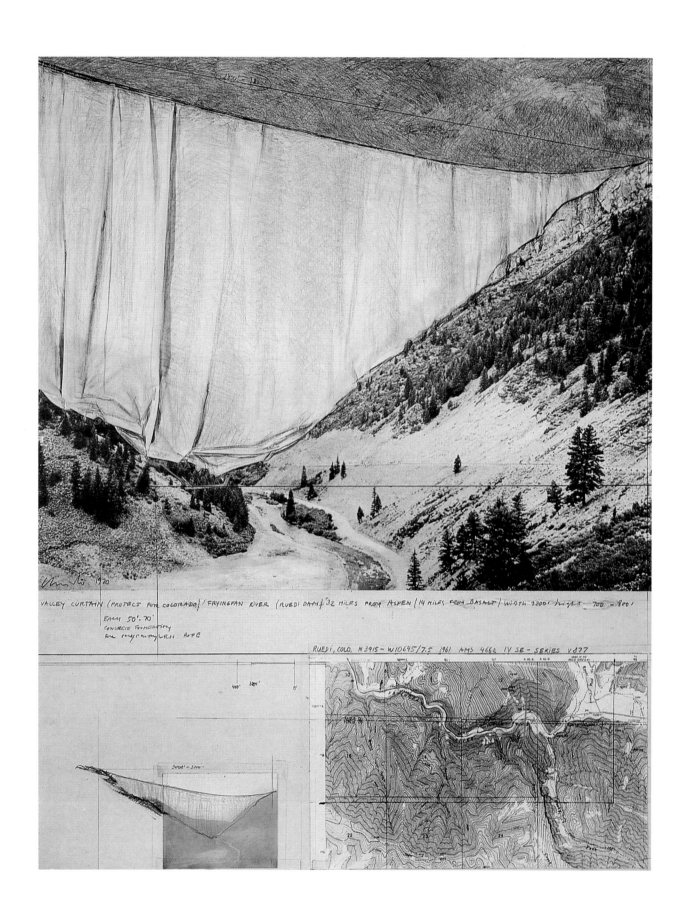

Valley Curtain, Project for Fryingpan River, Colorado

Collage 1970: 71 x 56 cm (28 x 22 in)

Pencil, fabric, photographs by Harry Shunk, crayon, charcoal, tracing paper, tape and map

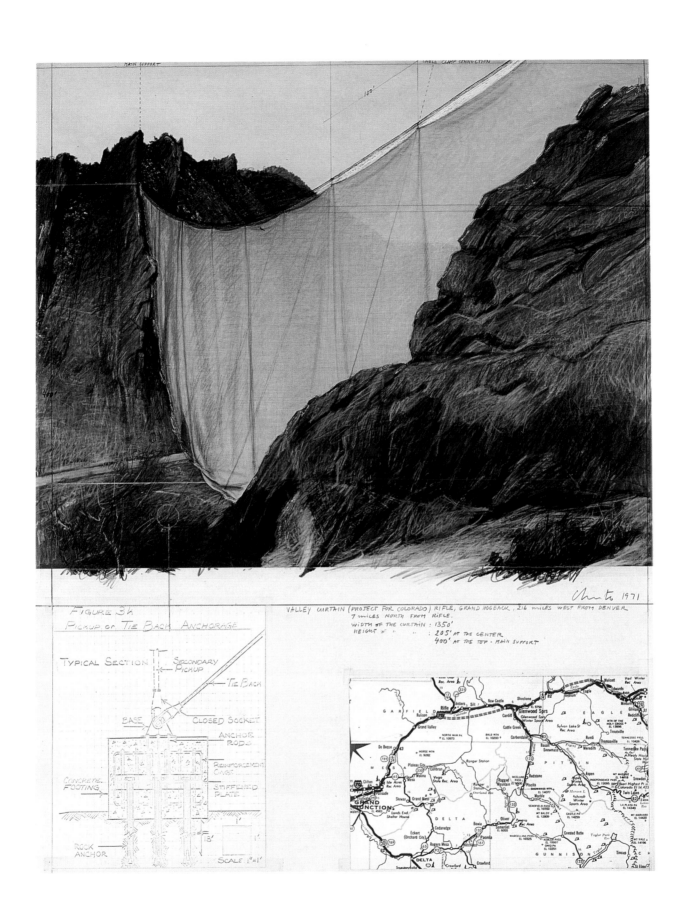

Valley Curtain, Project for Rifle, Colorado
Collage 1971: 71 x 56 cm (28 x 22 in)
Pencil, fabric, crayon, map, photostat, tape and technical data

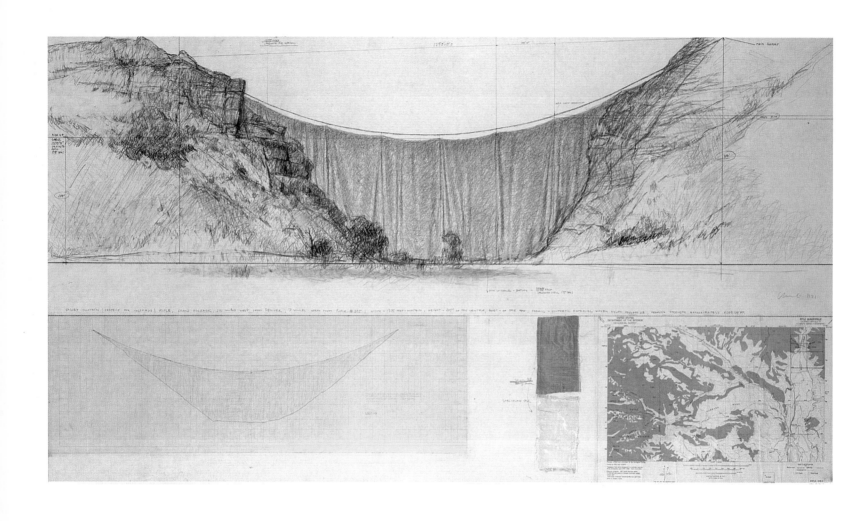

Valley Curtain, Project for Rifle, Colorado
Drawing 1971: 90.5 x 164 cm (36 x 65 in)
Pencil, charcoal, crayon, fabric samples, engineering data and map

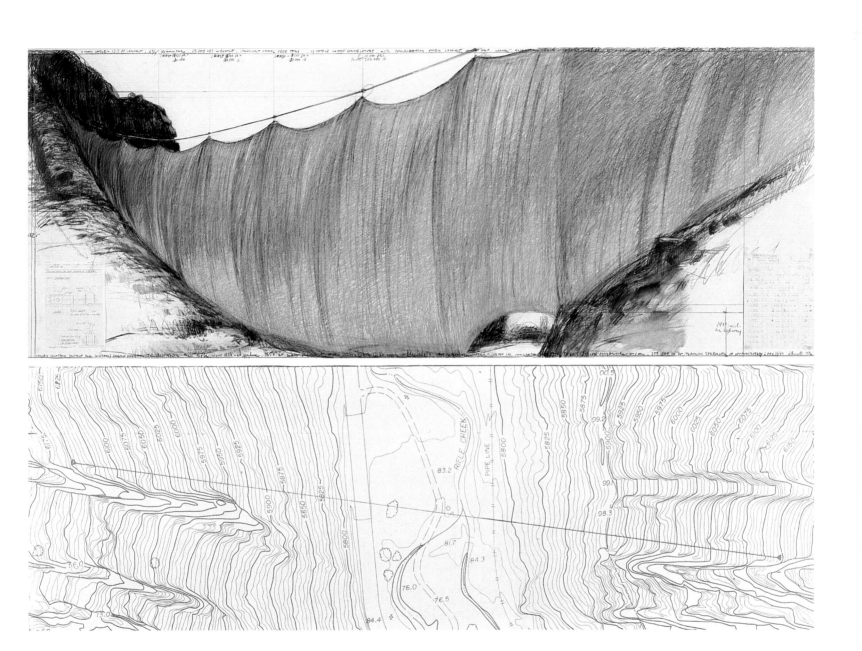

Valley Curtain, Project for Rifle, Colorado
Drawing 1972. Two parts: 81.3 x 244 cm (32 x 96 in) and 91.4 x 244 cm (36 x 96 in)
Pencil, crayon, graph paper, charcoal, map, technical data and ballpoint pen

Running Fence, Sonoma and Marin Counties, California, 1972–76

Height: 5.8 metres (18 feet), length: 40 kilometres (24 1/2 miles)

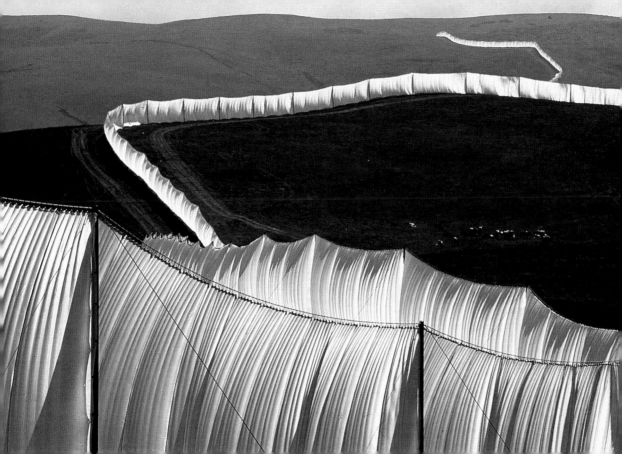

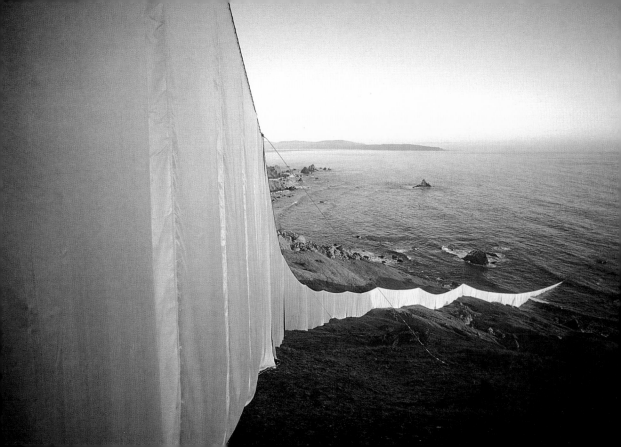

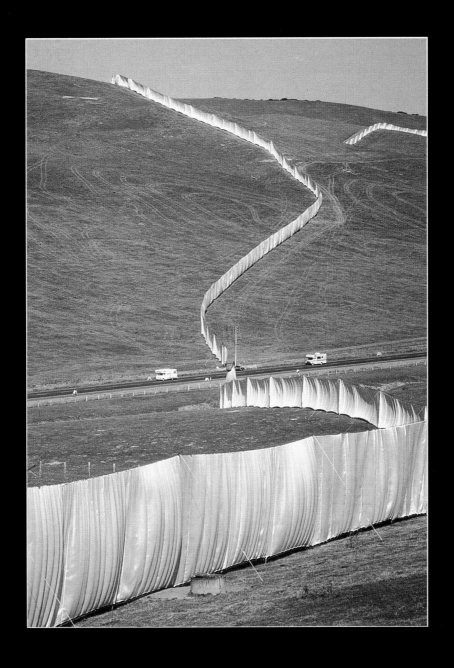

Christo and Jeanne-Claude:
Running Fence, Sonoma and Marin Counties, 1972–76

Press Release

Running Fence, 5.5 meters (eighteen feet) high, 40 kilometers (twenty-four and a half miles) long, extending East–West near Freeway 101, north of San Francisco, on the private properties of fifty-nine ranchers, following the rolling hills and dropping down to the Pacific Ocean at Bodega Bay, was completed on September 10, 1976.

The art project consisted of: forty-two months of collaborative efforts, the ranchers' participation, eighteen Public Hearings, three sessions at the Superior Courts of California, the drafting of a four-hundred and fifty page Environmental Impact Report and the temporary use of the hills, the sky and the Ocean.

All expenses for the temporary work of art were paid by Christo and Jeanne-Claude through the sale of studies, preparatory drawings and collages, scale models and original lithographs.

Running Fence was made of 200,000 square meters of heavy woven white nylon fabric, hung from a steel cable strung between 2,050 steel poles (each: 6.4 meters/21 feet long, 9 centimeters/3 $1/2$ inches in diameter) embedded 1 meter (3 feet) into the ground, using no concrete and braced laterally with guy wires (145 kilometers (90 miles) of steel cable) and 14,000 earth anchors. The top and bottom edges of the 2,050 fabric panels were secured to the upper and lower cables by 350,000 hooks. All parts of Running Fence's structure were designed for complete removal and no visible evidence of Running Fence remains on the hills of Sonoma and Marin Counties. As it had been agreed with the ranchers and with County, State and Federal Agencies, the removal of Running Fence started fourteen days after its completion and all materials were given to the ranchers. Running Fence crossed fourteen roads and the town of Valley Ford, leaving passage for cars, cattle and wildlife, and was designed to be viewed by following 65 kilometers (forty miles) of public roads, in Sonoma and Marin Counties.

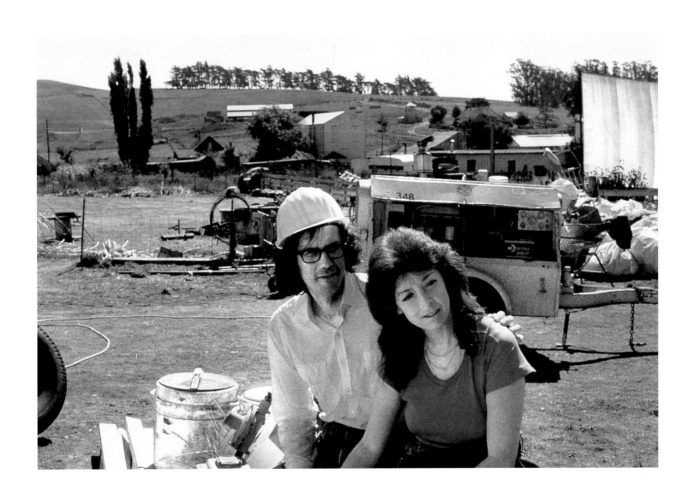

Christo and Jeanne-Claude in the construction yard during the 'Running Fence' project, September, 1976.

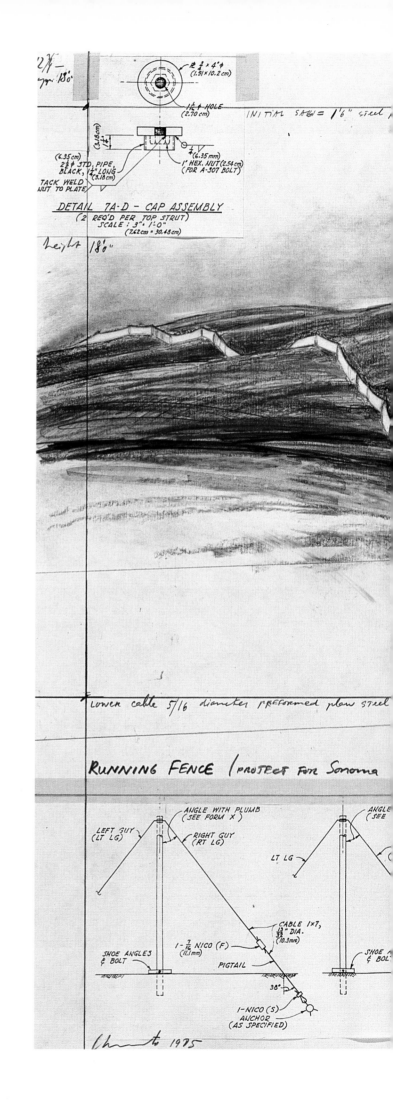

Running Fence, Sonoma and Marin Counties, California
Collage 1975: 56 x 71 cm (22 x 28 in)
Pencil, fabric, charcoal, crayon, engineering data, ballpoint pen and tape

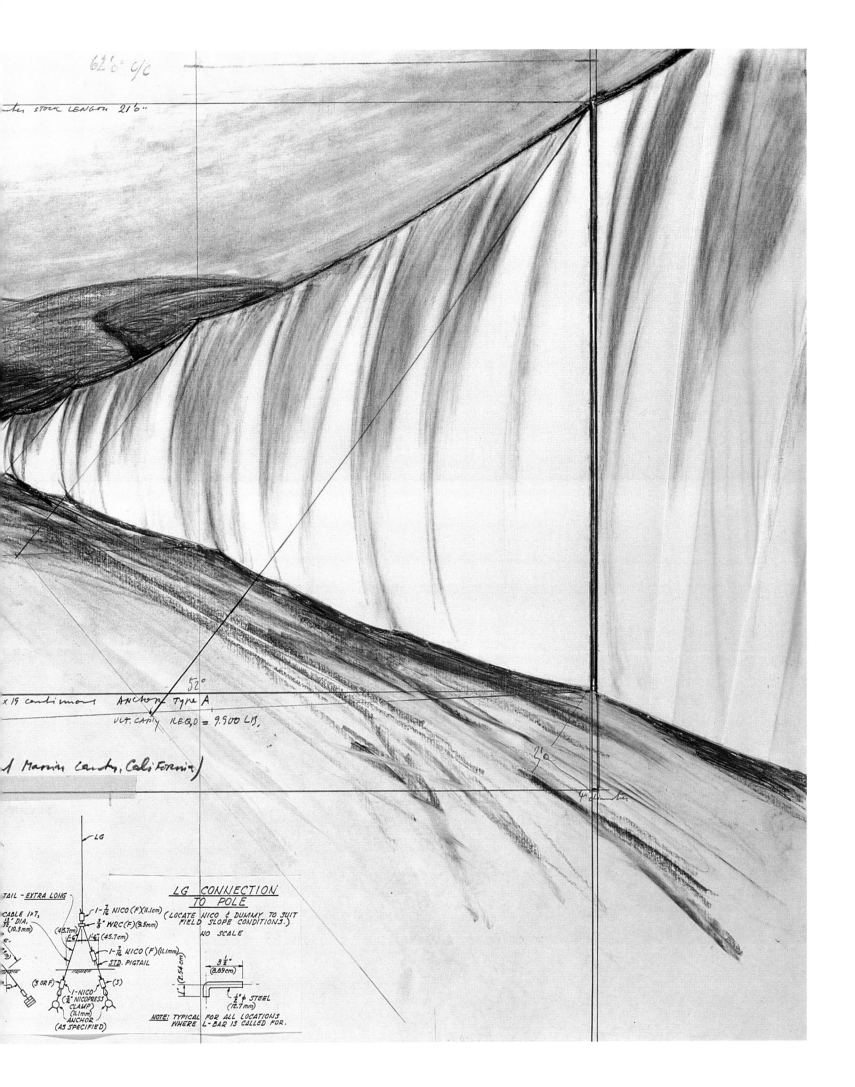

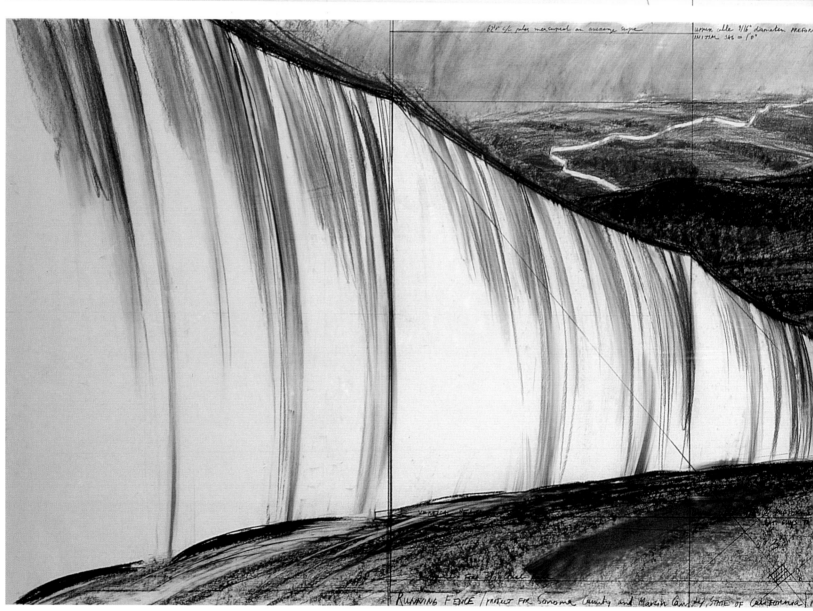

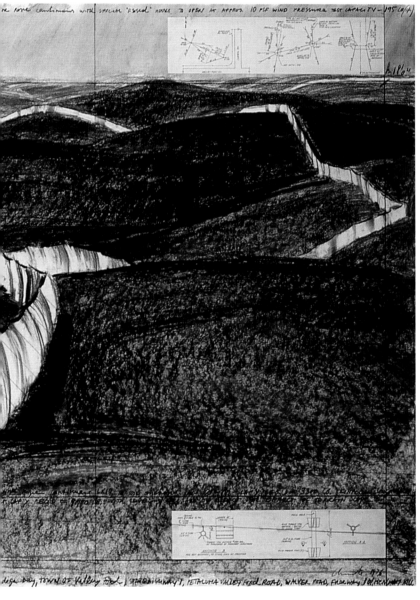

Running Fence, Sonoma and Marin Counties, California

Drawing 1976. Two parts: 38 x 244 cm (15 x 96 in) and 106.6 x 244 cm (42 x 96 in)

Pencil, pastel, charcoal, crayon, engineering data and map

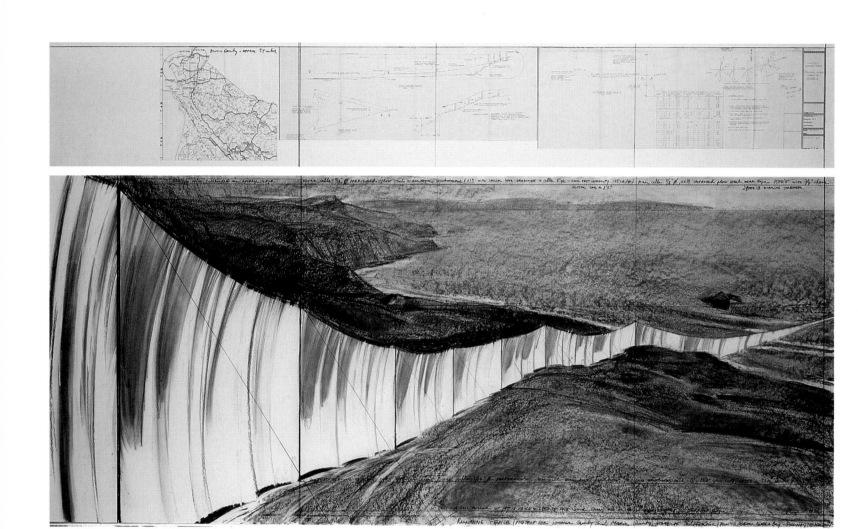

Running Fence, Sonoma and Marin Counties, California

Drawing 1976. Two parts: 38 x 244 cm (15 x 96 in) and 106.6 x 244 cm (42 x 96 in)

Pencil, pastel, charcoal, map and technical data

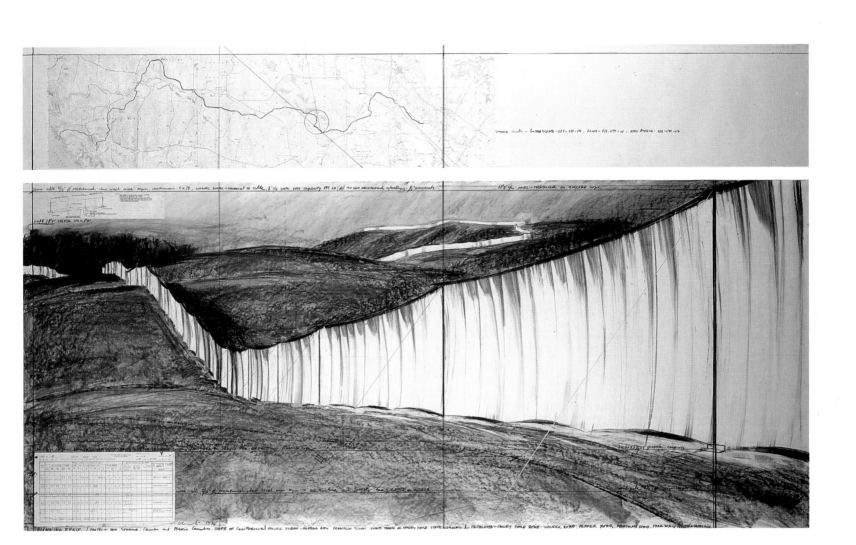

Running Fence, Sonoma and Marin Counties, California

Drawing 1976. Two parts: 38 x 244 cm (15 x 96 in) and 106.6 x 244 cm (42 x 96 in)

Pencil, charcoal, pastel, engineering data and map

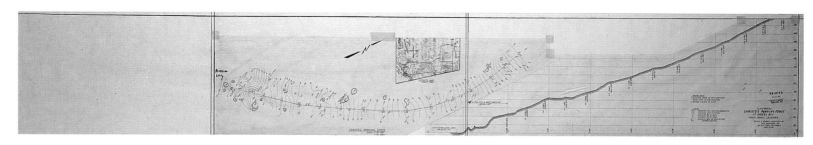

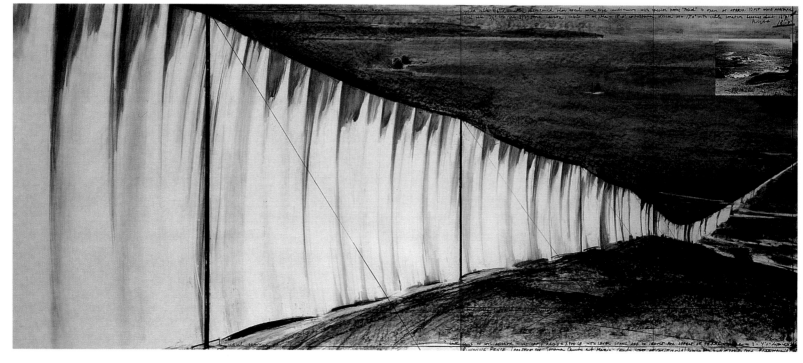

above Running Fence, Project for Sonoma and Marin Counties, California
 Drawing 1976. Two parts: 38 cm x 244 cm (15 x 96 in) and 106.6 x 244 cm (42 x 96 in)
 Pencil, pastel, charcoal, photograph by Harry Shunk, crayon, engineering data and tape

opposite Running Fence, Sonoma and Marin Counties, California
 Drawing 1976: 71 x 56 cm (28 x 22 in)
 Pencil, charcoal and pastel

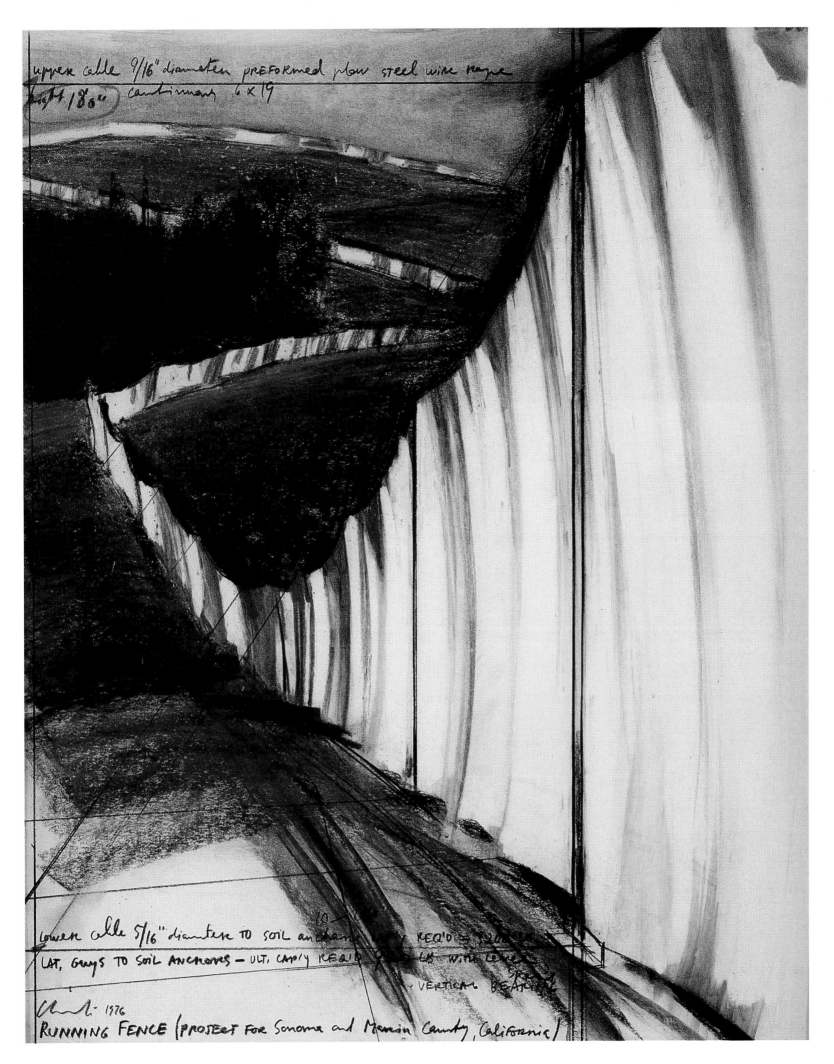

upper cable 9/16" diameter PREFORMED plow steel wire rope
height 180" continuous 6 x 19

lower cable 5/16" diameter TO SOIL ANCHORS QTY REQ'D — 120,000
LAT. GUYS TO SOIL ANCHORS — ULT. CAP'Y REQ'D LB WITH LEVER

VERTICAL BEAM

Christo 1976
RUNNING FENCE (PROJECT FOR Sonoma and Marin County, California)

Wrapped Walk Ways, Jacob Loose Park, Kansas City, Missouri, 1977–78

12,150 square metres (135,000 square feet) of fabric covering 4.5 kilometres (2.7 miles) of walk ways

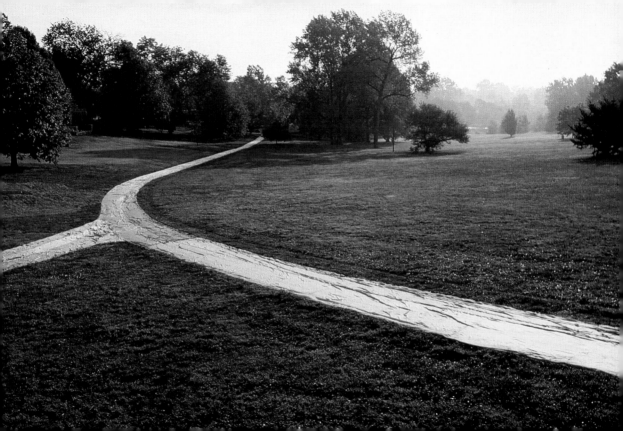

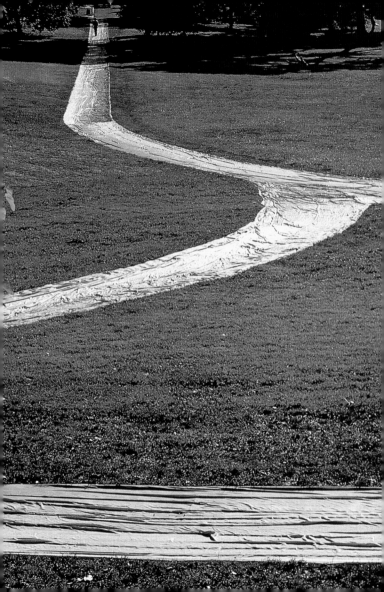

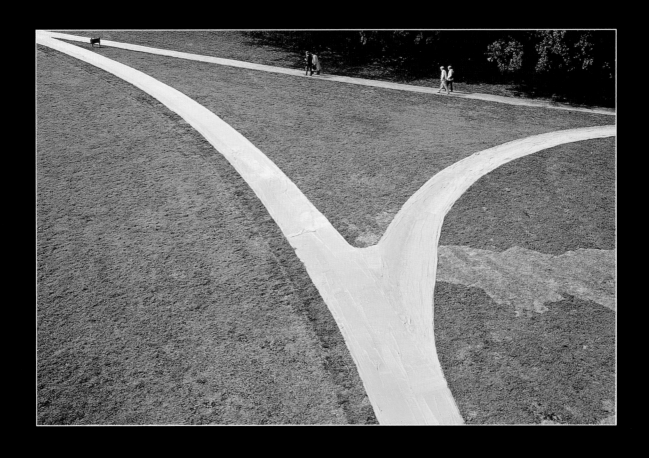

Christo and Jeanne-Claude:
Wrapped Walk Ways, Jacob Loose Park, Kansas City, Missouri, 1977–78

Press Release

Wrapped Walk Ways, in Jacob Loose Memorial Park, Kansas City, Missouri, consisted of the installation of 12,150 square meters (135,000 square feet) of saffron-colored nylon fabric covering 4.5 kilometers (2.7 miles) of formal garden walkways and jogging paths.

Installation began on Monday, October 2nd, 1978, and was completed on Wednesday, October 4th. Eighty-four people were employed by A.L. Huber and Sons, a Kansas City building contractor, to install the fabric. Among others, there were 13 construction workers and four professional seamstresses. The cloth was secured in place by 34,500 steel spikes (7" x $5/16$") driven into the soil through brass grommets along the sides of the fabric, and 40,000 staples into wooden edges on the stairways. After 52,000 feet of seams and hems had been sewn in a West Virginia factory, professional seamstresses, using portable sewing machines and aided by many assistants, completed the sewing in the park.

All expenses related to Wrapped Walk Ways were borne by Christo and Jeanne-Claude, as in all their other projects, through the sale of preparatory drawings, collages, as well as earlier works and original lithographs.

The temporary work of art remained in the park until October 16th, 1978, after which the material was removed and given to the Kansas City Parks Department for recycling, the Park was restored to its original condition.

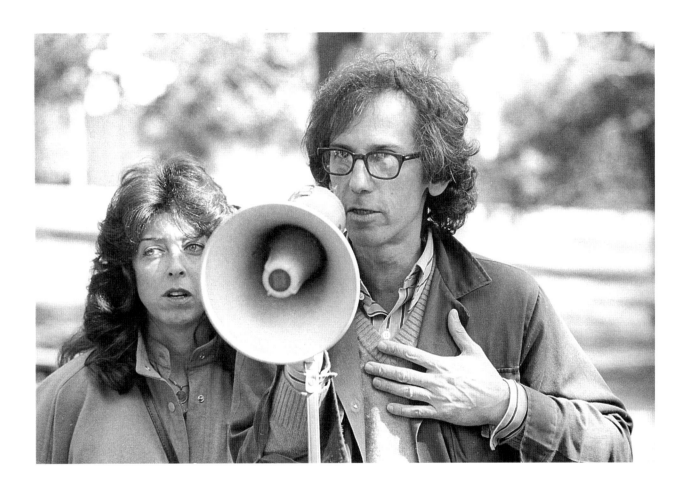

Jeanne-Claude and Christo during the installation of 'Wrapped Walk Ways' on 2 October 1978.

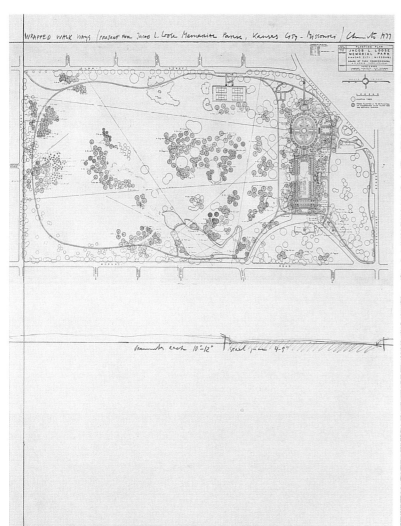

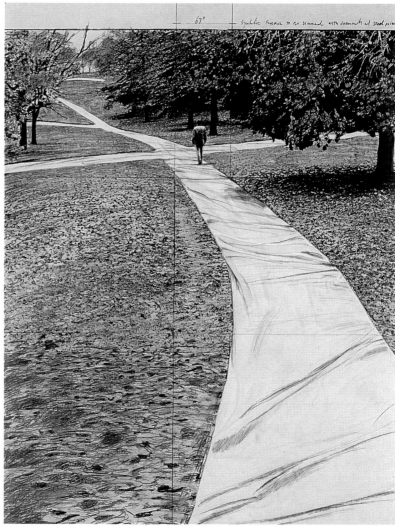

above Wrapped Walk Ways, Project for Kansas City, Missouri
Collage 1977. Two parts: each 71 x 56 cm (28 x 22 in)
Pencil, fabric, crayon, pastel, photostat, charcoal and map

opposite Wrapped Walk Ways, Project for Kansas City, Missouri
Drawing 1978. Two parts: 244 x 38 cm (96 x 15 in) and 244 x 106.6 cm (96 x 42 in)
Pencil, pastel, charcoal, crayon and map

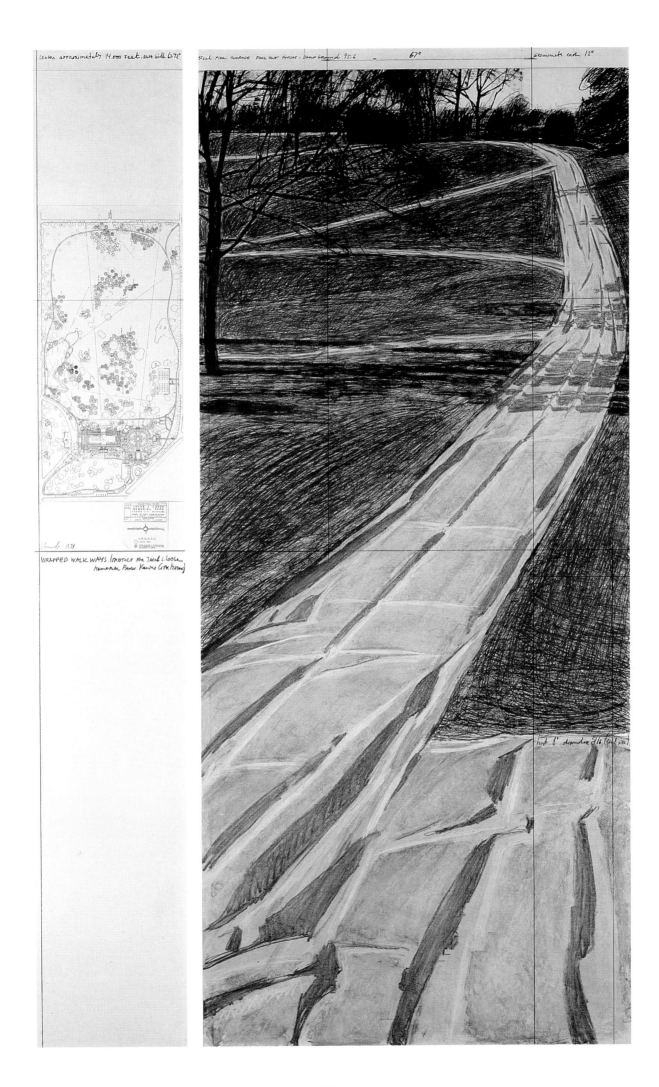

WRAPPED WALK WAYS (PROJECT FOR JACOB L. LOOSE Memorial Park Kansas City Missouri)

5/22/78
JRF

Inventory Withdrawal Tabulation

Code

A) 14877' – 10817 (SEC 2); 4060' – 291 (SEC 6); 3769' – 66 (SEC 7);
3703 – 126 (SEC 9); 3577' – 70 (SEC 10); 3507' – 56 (SEC 11);
3451' – 164' (SEC 12); 3287' – 64 (SEC 13); 3223' – 672 (SEC 14)
2551' – 760 (SEC 15); 1791 – 762 (SEC 16); 1029 – 1000 (SPARE, RESIDUE); 29'

B) 16149' – 10817 (SEC 2); 5332' – 438 (SEC 4); 4894' – 582 (SEC 6);
4312' – 66 (SEC 7); 4246' – 315 (SEC 8); 3931' – 252 (SEC 9);
3679 – 210 (SEC 10); 3469 – 272 (SEC 11); 3197 – 376 (SEC 12);
2821' – 48 (SEC 13); 2773 – 168 (SEC 14); 2605' – 380 (SEC 15);
2225' – 254 (SEC 16); 1971' – 1000 (SPARE PANEL, RESIDUE);
971'

C) 6279' – 500 (SEC 1); 5779' – 2000 (SEC 3); 3779' – 3644 (SEC 5);
135' – 135' (SEC 8); – 0 –

Synthetic woven fabric 20 x 20 min INCH. Christo 19

5/22/78
JRF

Inventory Usage, Sewing

SECTION	PATH WIDTH	MATERIAL CODE	RUNNING FEET													
1.	48"	[C]	500'													
2.	70"	[A	B]	10,817'												
3.	42'	PATTERN #1	200'													
4.	84"	[B	B]	219'												
5.	96"	[C	C] (135' SECTION- HEM + GROMMETS 1 SIDE ONLY)	1,822'												
6.	120"	[B	A	B]	291'											
7.	156"	[B	A	A	B]	33'										
8.	456"	[C	B	B	C	B	B	B	C] 7 B's 3 C's	45'						
9.	240"	[B	B	A	A	B] 2 A's 4 B's	63'									
10.	168"	[B	B	A	B]	2 x 35' LENGTHS										
11.		PATTERN #2	2 x 34' "													
12.		PATTERN #3	2 x 41' "													
13.	264"	[B	A	A	A	A	B] 4 A's 3 B's	16'								
14.	720" (FIELD CUT)	[B	B	A	A	A	A	A	A	A	A	A	A	B	B] 16 A's 4 B's	42'
15.	108"	[A	B	A]	380'											
16.	144"	[A	A	A	B]	254'										
RESIDUE	70"	[A	B]	1000'												

Wrapped Walk Ways, Project for Kansas City, Missouri
Collage 1978. Two parts: 71 x 28 cm (28 x 11 in) and 71 x 56 cm (28 x 22 in)
Pencil, enamel paint, charcoal, crayon, photostat and technical data

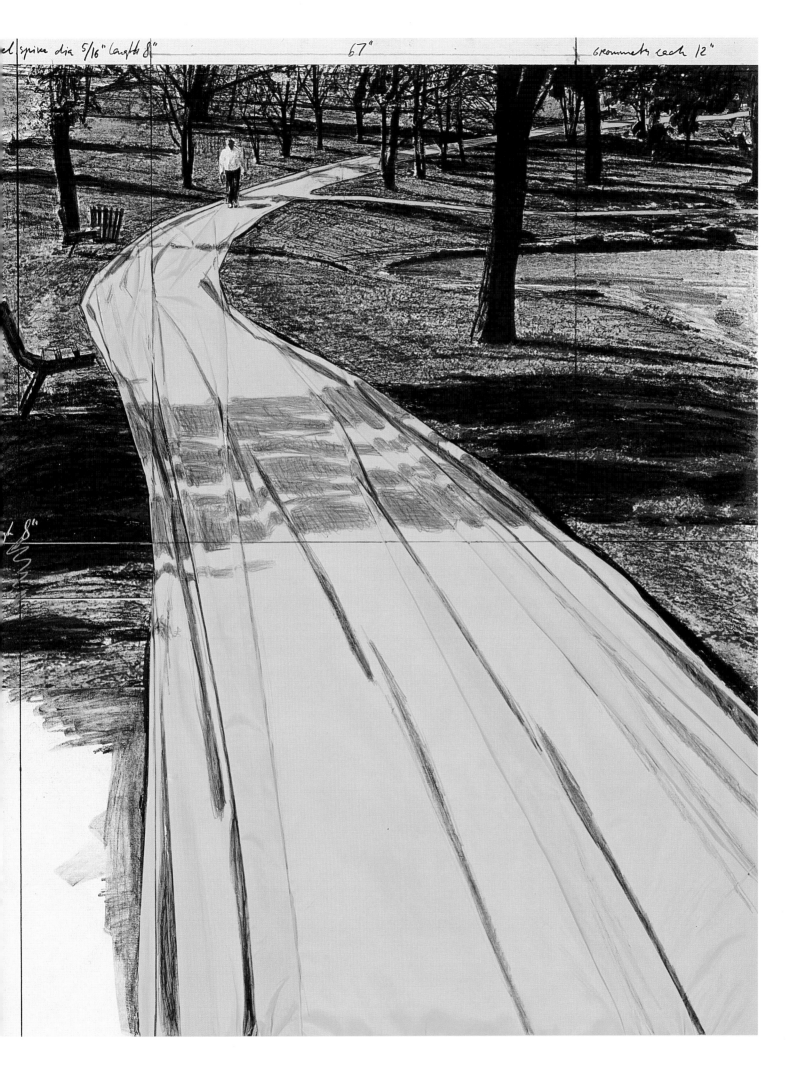

spike dia 5/16" length 8" 67" Grommets each 12"

8"

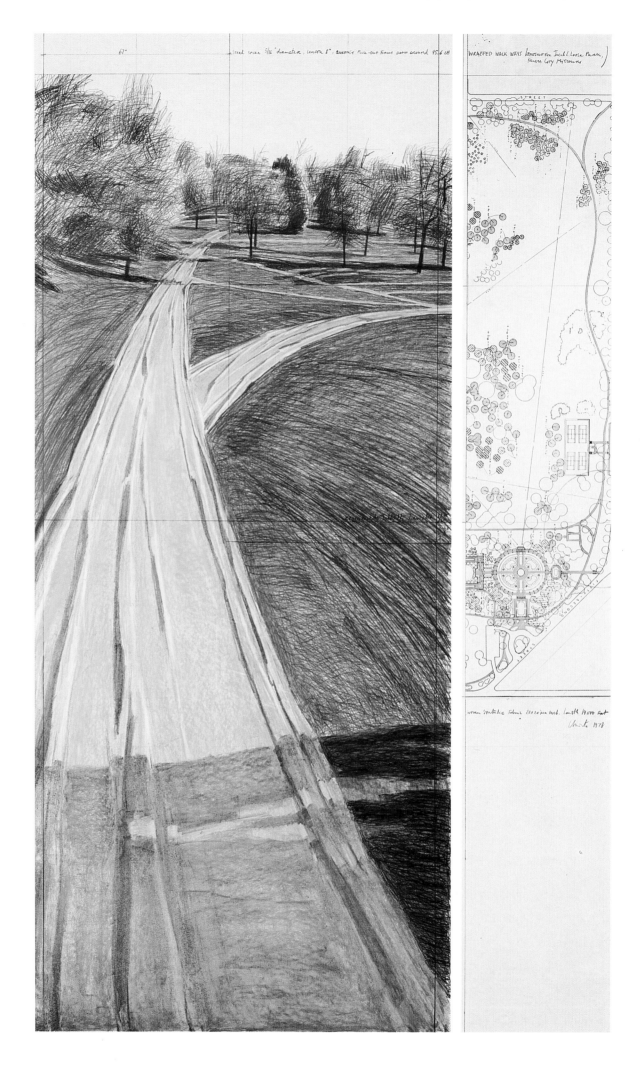

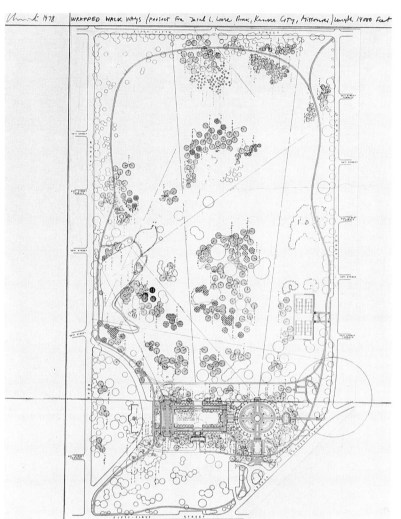
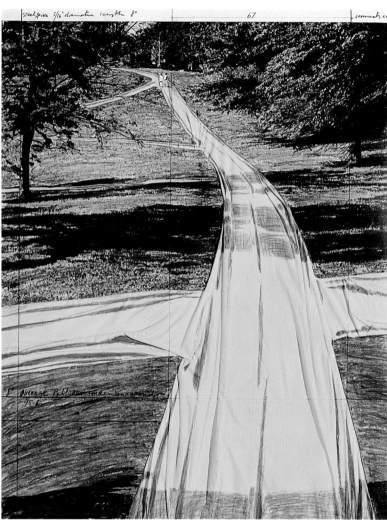

above Wrapped Walk Ways, Project for Kansas City, Missouri
Collage 1978. Two parts: 71 x 56 cm (28 x 22in) and 71 x 56 cm (28 x 22 in)
Pencil, fabric, photostat, pastel, charcoal, crayon and map

opposite Wrapped Walk Ways, Project for Kansas City, Missouri
Drawing 1978. Two parts: 244 x 38 cm (96 x 15 in) and 244 x 106.6 cm (96 x 42 in)
Pencil, pastel, crayon, charcoal and map

111

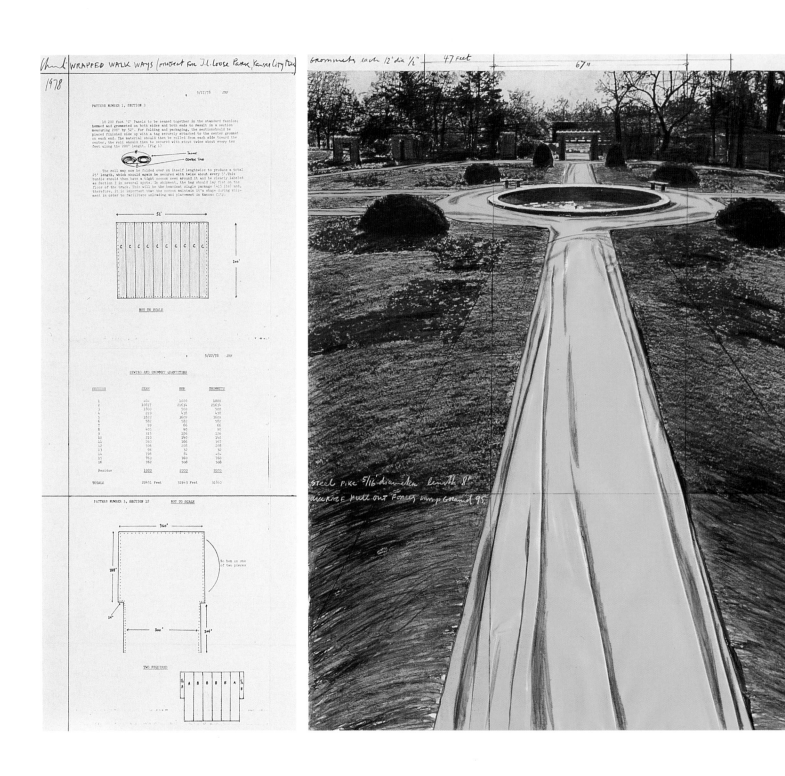

Wrapped Walk Ways, Project for Kansas City, Missouri

Collage 1978. Two parts: 71 x 28 cm (28 x 11 in) 71 x 56 cm (28 x 22 in)

Pencil, fabric, pastel, crayon, charcoal and technical data

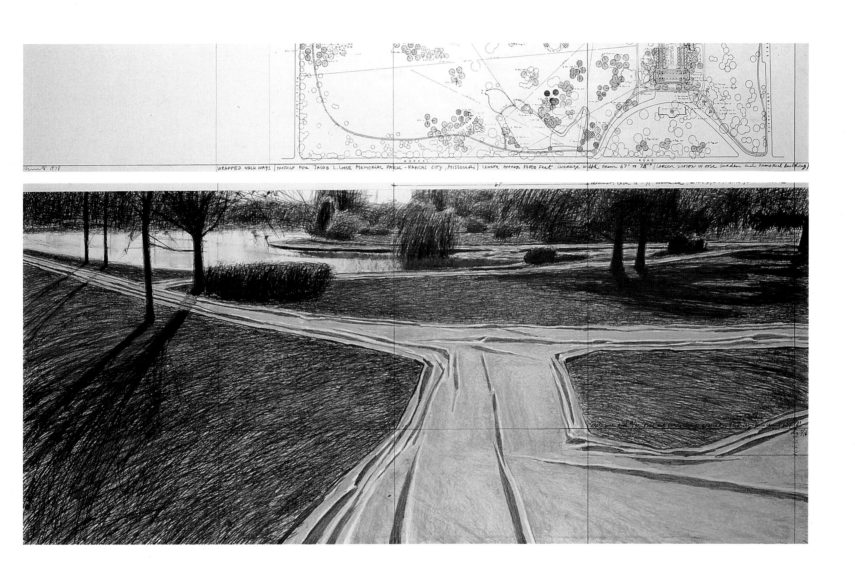

Wrapped Walk Ways, Project for Kansas City, Missouri

Drawing 1978: 38 x 244 cm (15 x 96 in) and 106.6 x 244 cm (42 x 96 in)

Pencil, pastel, charcoal, crayon and map

Surrounded Islands, Biscayne Bay, Greater Miami, Florida, 1980-83

585,000 square metres (6 1/2 million square feet) of fabric floating around 11 islands, May 1983

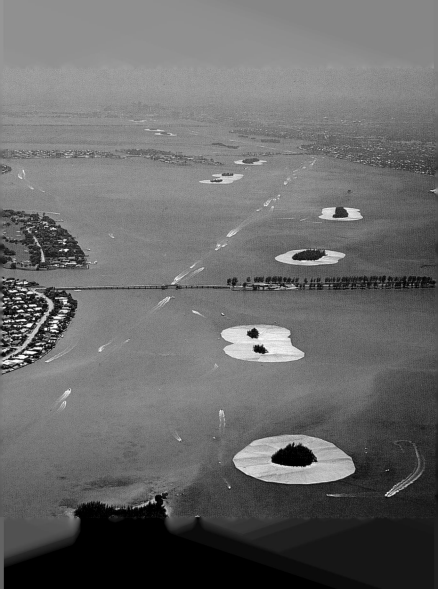

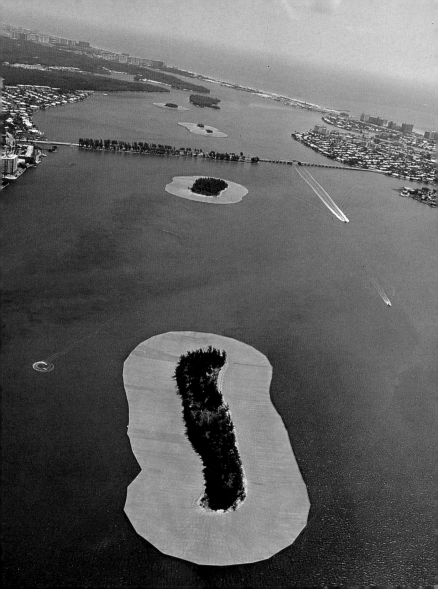

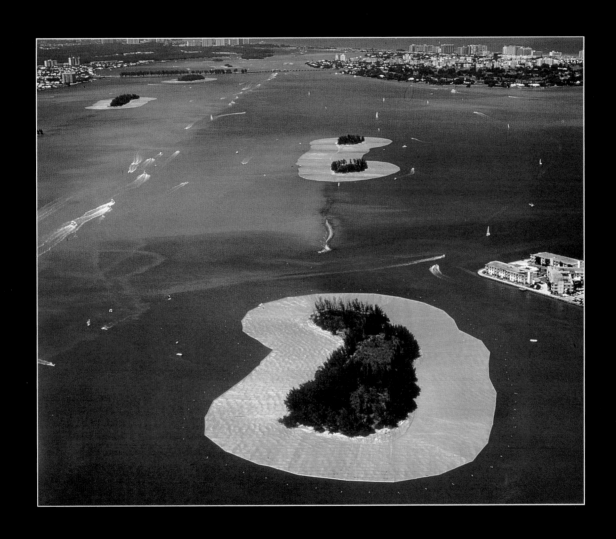

Christo and Jeanne-Claude:
Surrounded Islands, Biscayne Bay, Greater Miami, Florida, 1980–83

Press Release

On May 7, 1983 the installation of Surrounded Islands was completed. In Biscayne Bay, between the city of Miami, North Miami, the village of Miami Shores and Miami Beach, 11 of the islands situated in the area of Bakers Haulover Cut, Broad Causeway, 79th Street Causeway, Julia Tuttle Causeway, and Venetian Causeway were surrounded with 60 hectares (6.5 million square feet) of pink woven polypropylene fabric covering the surface of the water, floating and extending out 60 meters (200 feet) from each island into the Bay. The fabric was sewn into 79 patterns to follow the contours of the 11 islands.

For 2 weeks Surrounded Islands spreading over 11 kilometers (7 miles) was seen, approached and enjoyed by the public, from the causeways, the land, the water and the air. The luminous pink color of the shiny fabric was in harmony with the tropical vegetation of the uninhabited verdant island, the light of the Miami sky and the colors of the shallow waters of Biscayne Bay.

Since April 1981, attorneys Joseph Z. Fleming, Joseph W. Landers, marine biologist Dr. Anitra Thorhaug, ornithologists Dr. Oscar Owre and Meri Cummings, mammal expert Dr. Daniel Odell, marine engineer John Michel, four consulting engineers, and builder-contractor, Ted Dougherty of A & H Builders, Inc. had been working on the preparation of the Surrounded Islands. The marine and land crews picked up debris from the eleven islands, putting refuse in bags and carting it away after they had removed some forty tons of varied garbage: refrigerator doors, tires, kitchen sinks, mattresses and an abandoned boat.

Permits were obtained from the following governmental agencies: The Governor of Florida and the Cabinet; the Dade County Commission; the Department of Environmental Regulation; the City of Miami Commission; the City of North Miami; the Village of Miami Shores; the U.S. Army Corps of Engineers; the Dade County Department of Environmental Resources Management. From November 1982 until April 1983, 6,500,000 square feet of woven polypropylene fabric were sewn at the rented Hialeah factory, into 79 different patterns to follow the contours of the 11 islands. A flotation strip was sewn in each seam. At the Opa Locka Blimp Hangar, the sewn sections were accordion folded to ease the unfurling on the water.

The outer edge of the floating fabric was attached to a 30.5 centimeters (12 inch) diameter octagonal boom, in sections, of the same color as the fabric. The boom was connected to the radial anchor lines which extended from the anchors at the island to the 610 specially made anchors, spaced at 15 meter (50 feet) intervals, 76 meters (250 feet) beyond the perimeter of each island, driven into the limestone at the bottom of the Bay. Earth anchors were driven into the land, near the foot of the trees, to secure the inland edge of the fabric, covering the surface of the beach and disappearing under the vegetation.

The floating rafts of fabric and booms, varying from 3.5 m to 6 meters (12 to 22 feet) in width and from 121 to 171 meters (400 to 600 feet) in length were towed through the Bay to each island. There are 11 islands, but on two occasions, two islands were surrounded together as one configuration.

As with Christo and Jeanne-Claude's previous art projects, Surrounded Islands was entirely financed by the artists, through the sale by C.V.J. Corporation (Jeanne-Claude Christo-Javacheff, President) of the preparatory pastel and charcoal drawings, collages, lithographs and early works.

On May 4, 1983, out of a total work force of 430, the unfurling crew began to blossom the pink fabric. Surrounded Islands was tended day and night by 120 monitors in inflatable boats.

Surrounded Islands was a work of art which underlined various elements and ways in which the people of Miami live, between land and water.

In the office of the Mayor of Miami, Maurice A. Ferre, 1982. From left to right: Joseph Z. Fleming, the project's attorney, Maurice Ferre, Theodore Dougherty, the builder-contractor in charge of the 'Surrounded Islands' project, Jeanne-Claude, Christo, art professor Jonathan Fineberg and project historian and film-maker David Maysles, hear that the Mayor looks favourably upon the project.

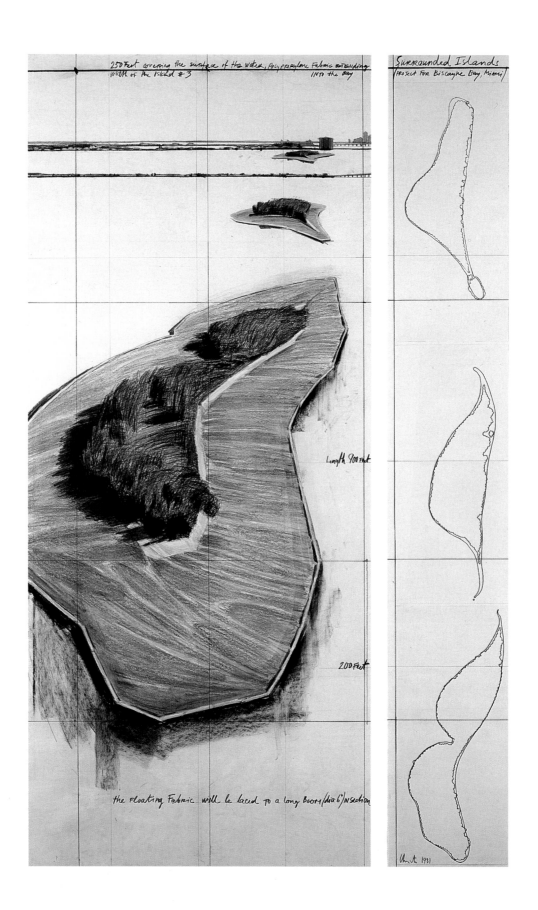

Surrounded Islands, Project for Biscayne Bay, Greater Miami, Florida
Drawing 1981. Two parts: 244 x 106.6 cm (96 x 42 in) and 244 x 38 cm (96 x 15 in)
Pencil, pastel, charcoal, crayon and engineering drawing

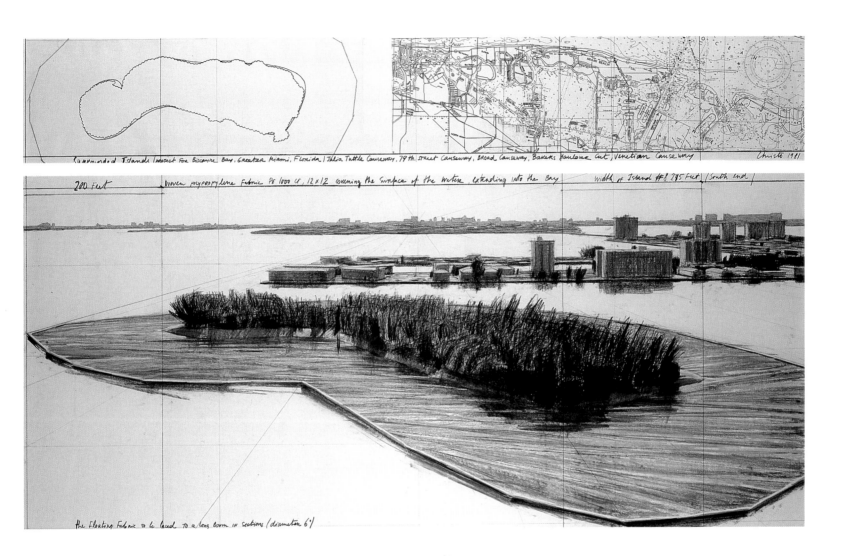

Surrounded Islands, Project for Biscayne Bay, Greater Miami, Florida

Drawing 1981. Two parts: 38 x 244 cm (15 x 96 in) and 106.6 x 244 cm (42 x 96 in)

Pencil, pastel, charcoal, pencil, engineering data and map

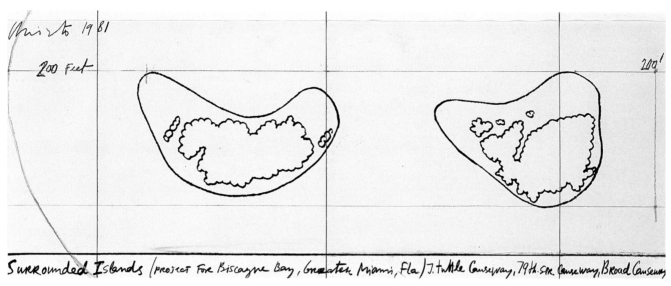

Christo 1981

200 Feet

200'

Surrounded Islands (project for Biscayne Bay, Greater Miami, Fla.) J. Tuttle Causeway, 79th str. Causeway, Broad Causeway

woven polypropylene fabric, covering the surface of the water, extending into the Bay 200 feet
200 Feet 650 Feet

the Floating Fabric, laced to a long Boom (diameter 6")

Surrounded Islands, Project for Biscayne Bay, Greater Miami, Florida
Collage 1981. Two parts: 28 x 71 cm (11 x 28 in) and 56 x 71 cm (22 x 28 in)
Pencil, fabric, pastel, charcoal, enamel paint, crayon and engineering drawing

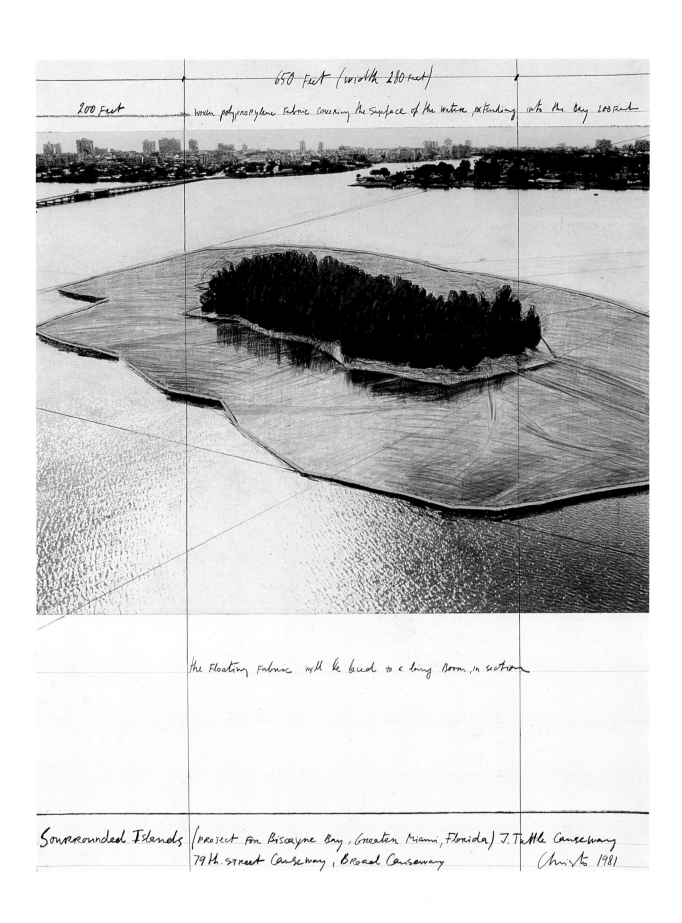

650 Feet (width 280 Feet)

200 Feet Woven polypropylene Fabric covering the Surface of the water extending into the bay 200 Feet

the Floating Fabric will be laced to a long Boom, in section

Sourrrounded Islands (PROJECT FOR Biscayne Bay, Greater Miami, Florida) J. Tuttle Causeway
79th. Street Causeway, Broad Causeway Christo 1981

Surrounded Islands, Project for Biscayne Bay, Greater Miami, Florida
Collage 1981: 71 x 56 cm (28 x 22 in)
Pencil, fabric, pastel, photostat, enamel paint and crayon

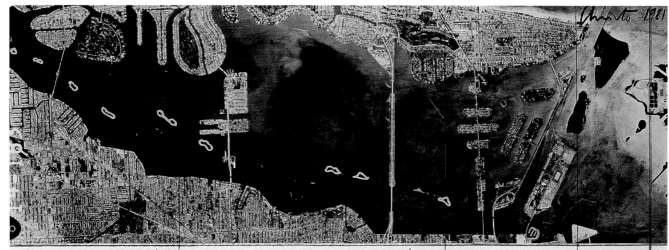

Surrounded Islands /Project For Biscayne Bay, Greater Miami, Florida / J. Tuttle Causeway, 79th. st. Causeway, Broad Causeway

woven polypropylene fabric, covering the surface of the water, extending into the Bay 200 Feet Length 2000 Feet
Width 275 Feet

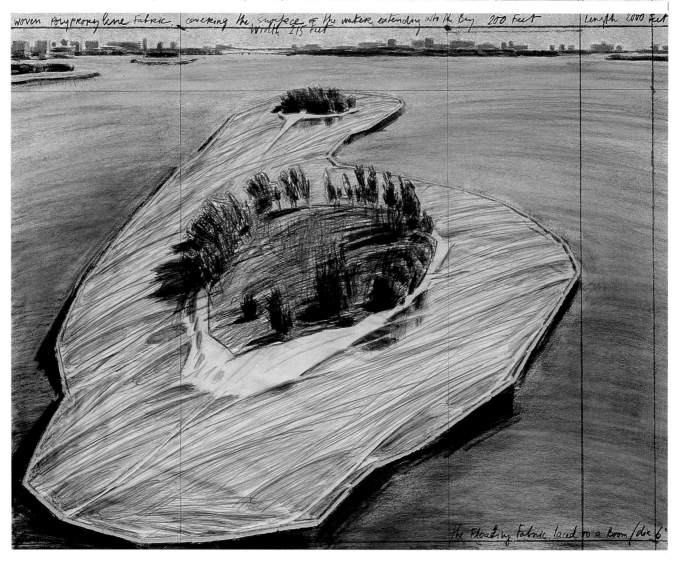

the floating fabric laced to a Boom / dia 6"

Surrounded Islands, Project for Biscayne Bay, Greater Miami, Florida

Collage 1981. Two parts: 28 x 71 cm (11 x 28 in) and 56 x 71 cm (22 x 28 in)

Pencil, fabric, pastel, charcoal, enamel paint, crayon and aerial photograph

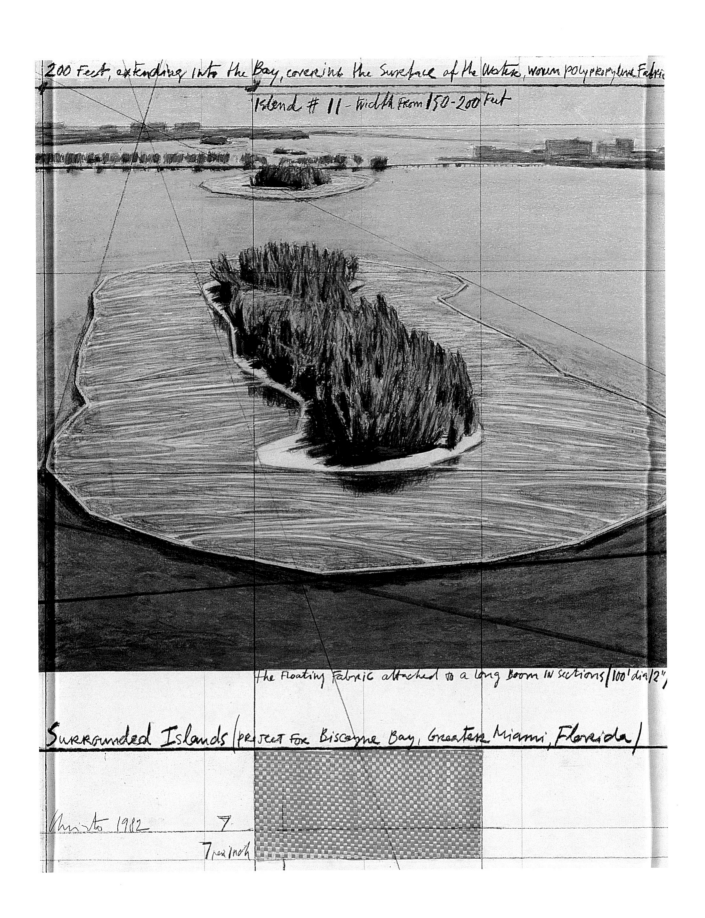

Surrounded Islands, Project for Biscayne Bay, Greater Miami, Florida
Collage 1982: 71 x 56 cm (28 x 22 in)
Pencil, fabric, pastel, charcoal, crayon, enamel paint and fabric sample

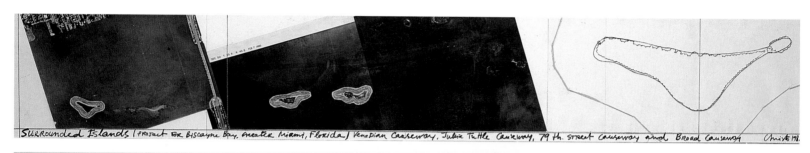

Surrounded Islands (Project for Biscayne Bay, Greater Miami, Florida) Venetian Causeway, Julia Tuttle Causeway, 79th Street Causeway and Broad Causeway Christo 198.

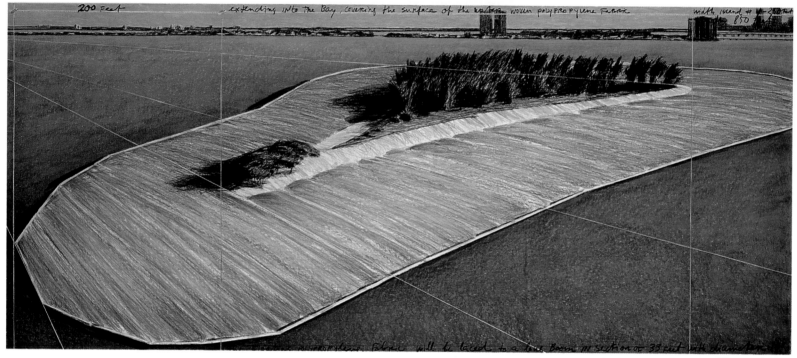

Surrounded Islands, Project for Biscayne Bay, Greater Miami, Florida

Drawing 1982. Two parts: 38 x 244 cm (15 x 96 in) and 106.6 x 244 cm (42 x 96 in)

Pencil, pastel, charcoal, crayon, enamel paint, aerial photographs and technical data

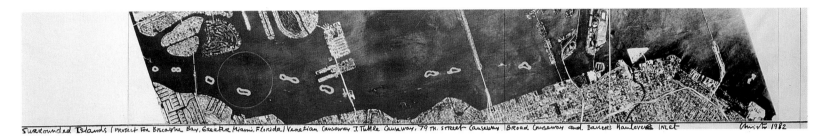

Surrounded Islands (Project for Biscayne Bay, Greater Miami, Florida) Venetian Causeway, J.Tuttle Causeway, 79th. street Causeway, Broad Causeway and Bakers Haulovers Inlet Christo 1982

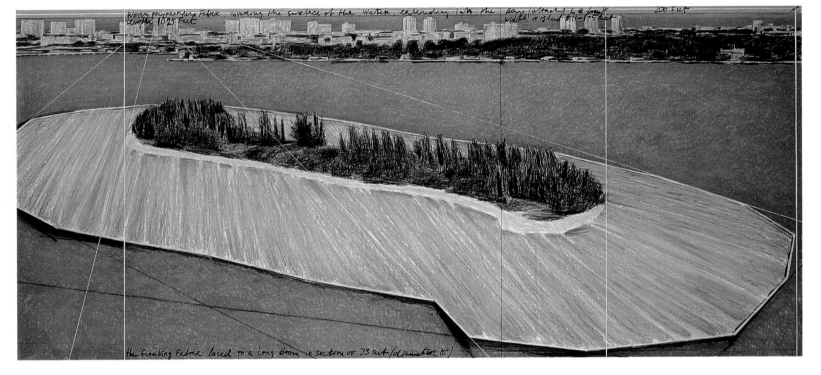

Woven Polypropylene Fabric, covering the surface of the Water, extending into the Bay (attached to a boom) width of island 11-175 feet 200 feet
length 1025 feet

the Floating Fabric laced to a long Boom in sections of 33 feet (diameter 10')

Surrounded Islands, Project for Biscayne Bay, Greater Miami, Florida

Drawing 1982. Two parts: 38 x 244 cm (15 x 96 in) and 106.6 x 244 cm (42 x 96 in)

Pencil, pastel, charcoal, enamel paint and aerial photograph

The Pont Neuf, Wrapped, Paris, 1975–85

40,000 square metres (440,000 square feet) of woven polyamide fabric and 13,000 metres (42,900 feet) of rope

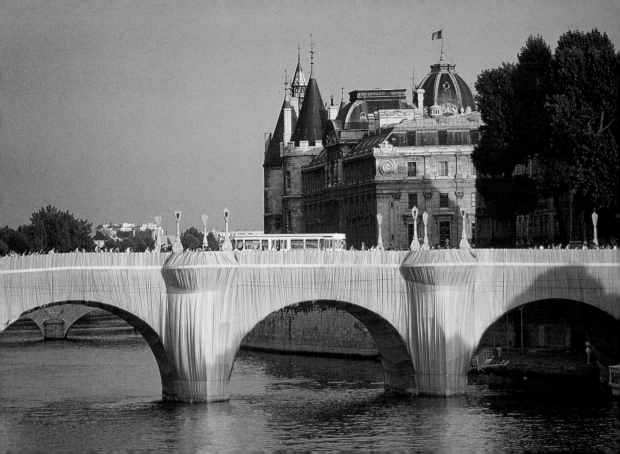

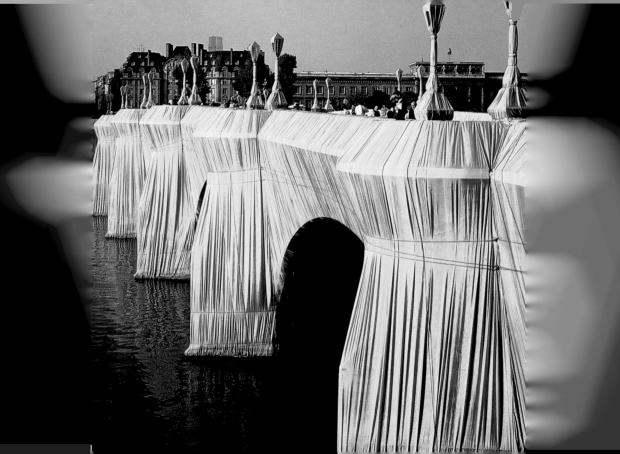

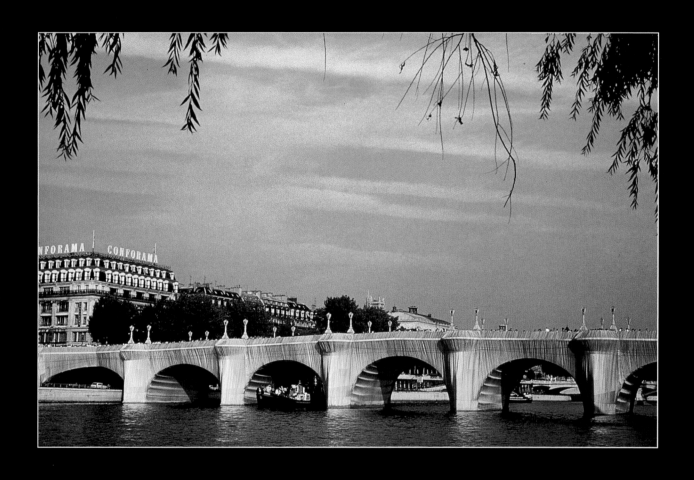

Christo and Jeanne-Claude:
The Pont Neuf, Wrapped, Paris, 1975–85

Press Release

On September 22, 1985, a group of 300 professional workers completed the temporary work of art "The Pont Neuf Wrapped".
They had deployed 40,000 square meters (440,000 square feet) of woven polyamide fabric, silky in appearance and golden sandstone in color, covering:

– The sides and vaults of the twelve arches, without hindering river traffic.
– The parapets down to the ground.
– The sidewalks and curbs (pedestrians walked on the fabric)
– All the street lamps on both sides of the bridge.
– The vertical part of the embankment of the western tip of the Ile de la Cité.
– The esplanade of the "Vert-Galant":

The fabric was restrained by 13,000 meters (42,900 feet) of rope and secured by 12.1 tons of steel chains encircling the base of each tower, 1 meter (3 feet) underwater.

The "Charpentiers de Paris" headed by Gérard Moulin, with french sub-contractors, were assisted by the USA engineers who have worked on Christo and Jeanne-Claude's previous projects, under the direction of Theodore Dougherty: Vahé Aprahamian, August L. Huber, James Fuller, John Thomson and Dimiter Zagoroff.
Johannes Schaub, the project's director had submitted the work method and detailed plans and received approval for the project from the authorities of the City of Paris, the Departement of the Seine and the State.

600 monitors, in crews of 40, were working around the clock maintaining the project and giving information, until the removal of the project on October 7.

All expenses for The Pont Neuf Wrapped were borne by the artists as in their other projects through the sale of preparatory drawings and collages as well as earlier works.

Begun under Henri III, the Pont-Neuf was completed in July 1606, during the reign of Henry IV. No other bridge in Paris offers such topographical and visual variety, today as in the past. From 1578 to 1890, the Pont Neuf under-went continual changes and additions of the most extravagant sort, such as the construction of shops on the bridge under Soufflot, the building, demolition, rebuilding and once again demolition of the massive rococco structure which housed the Samaritaine's water pump.
Wrapping the Pont-Neuf continues this tradition of successive metamorphoses by a new sculptural dimension and transforms it, for fourteen days, into a work of art.

Ropes held down the fabric to the bridge's surface and maintained the principal shapes, accentuating relief while emphasizing proportions and details of the Pont-Neuf which joins the left and right banks and the Ile de la Cité, the heart of Paris for over two thousand years.

Jeanne-Claude and Christo on the night shift during the installation of 'The Pont Neuf, Wrapped', September 1985.

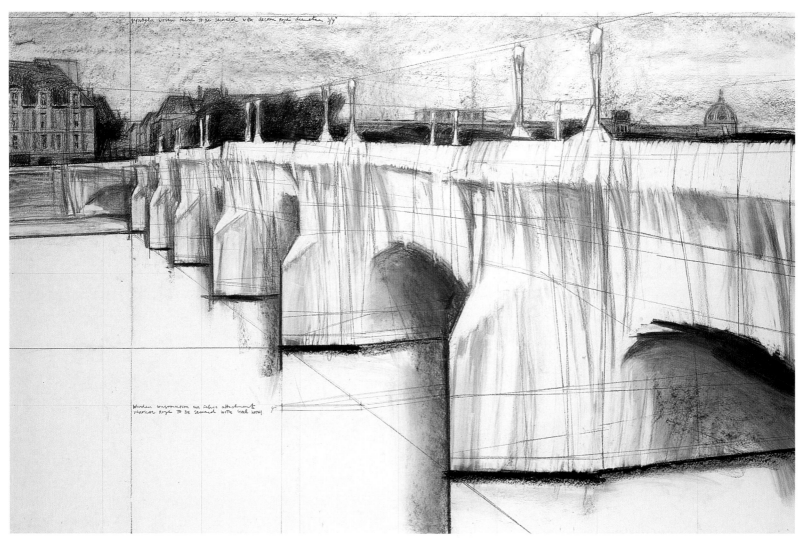

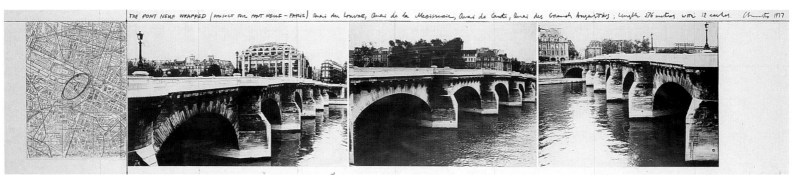

above The Pont Neuf, Wrapped, Project for Paris
Drawing 1977. Two parts: 106.6 x 165 cm (42 x 65 in) and 38 x 165 cm (15 x 65 in)
Pencil, charcoal, pastel, crayon, photographs and map

opposite The Pont Neuf, Wrapped, Project for Paris
Collage 1978: 71 x 56 cm (28 x 22 in)
Pencil, fabric, twine, pastel, charcoal, crayon and photostat

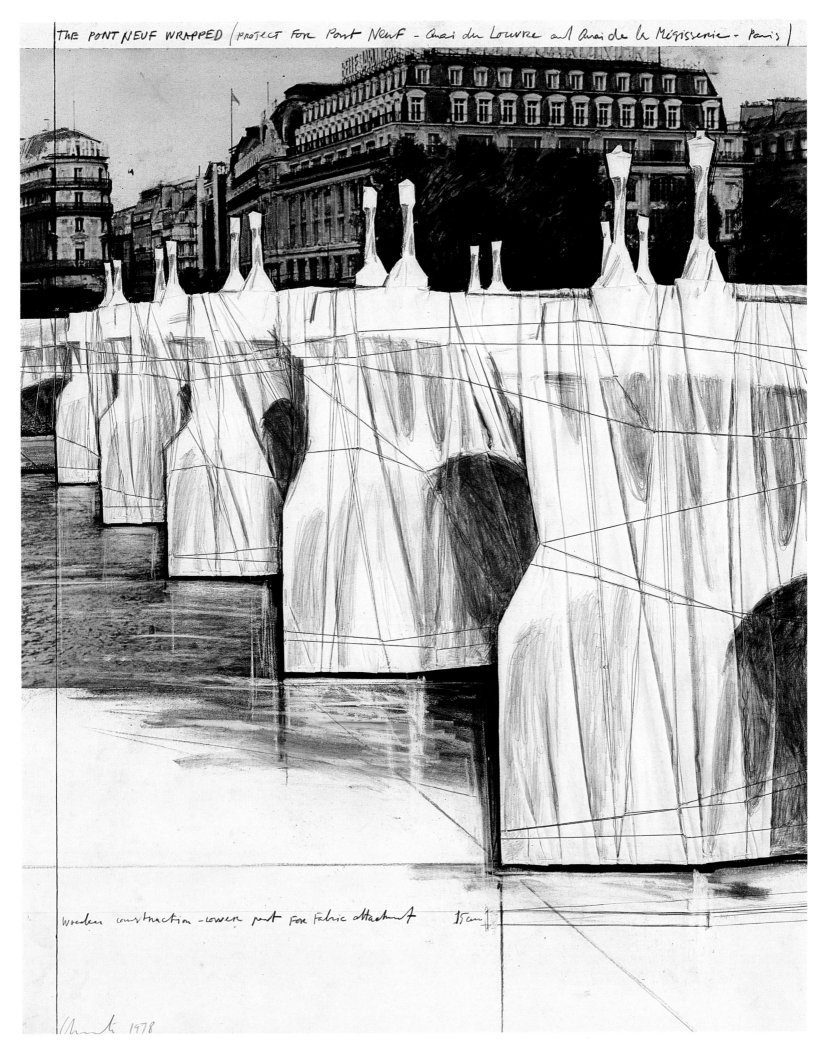

THE PONT NEUF WRAPPED (PROJECT FOR Pont Neuf - Quai du Louvre and Quai de la Mégisserie - Paris)

Wooden construction - lower part for fabric attachment 15cm

THE PONT NEUF WRAPPED (PROJECT FOR Pont Neuf - Quai du Louvre and Quai de la Mégisserie - Paris)

Christo 1978

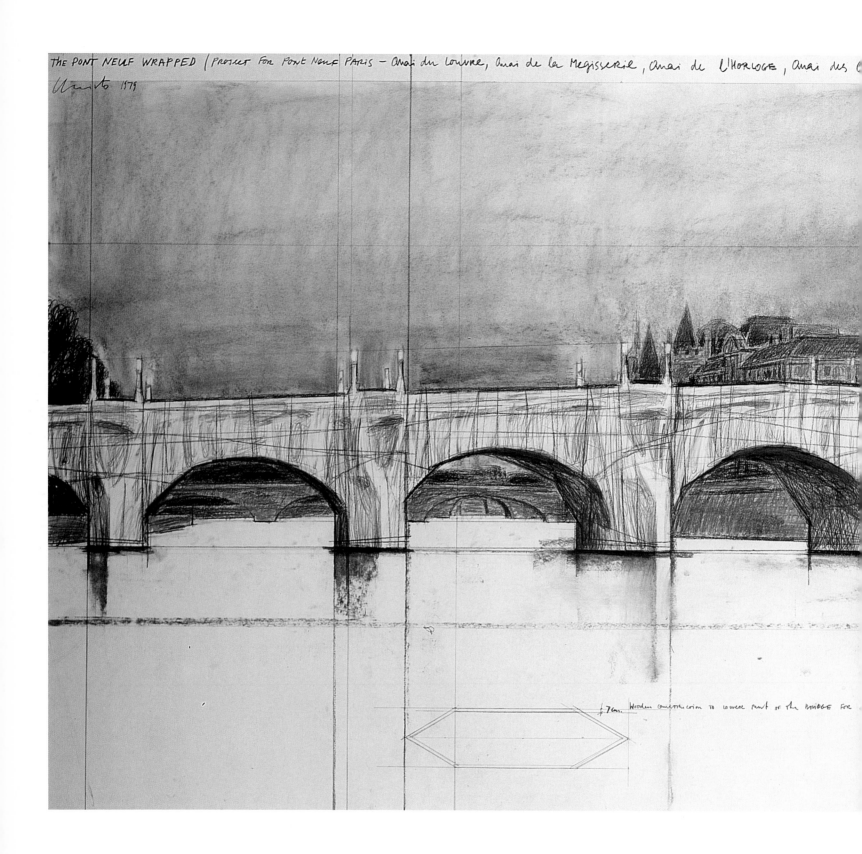

THE PONT NEUF WRAPPED / PROJECT FOR PONT NEUF PARIS — Quai du Louvre, Quai de la Mégisserie, Quai de L'Horloge, Quai des ...

Christo 1979

The Pont Neuf, Wrapped, Project for Paris
Drawing 1979: 106.6 x 244 cm (42 x 96 in)
Pencil, charcoal, pastel and crayon

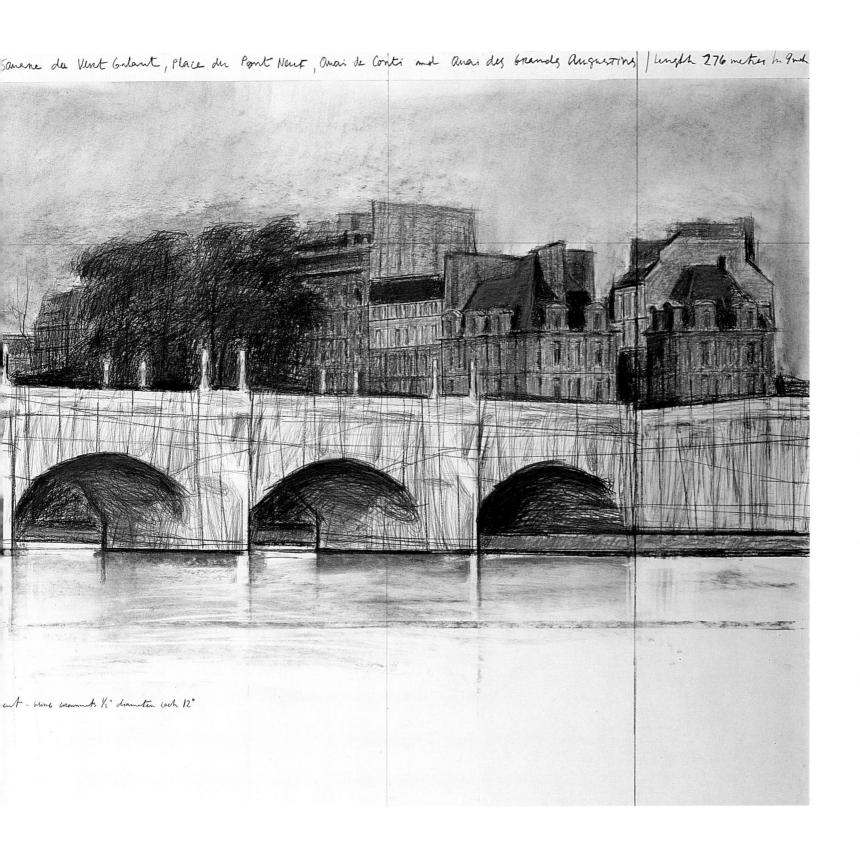

Squarre des Vert Galant, Place du Pont Neuf, Quai de Conti and Quai des Grands Augustins / Length 276 meters h. 9 m.th

ent - using grommets ½" diameter each 12"

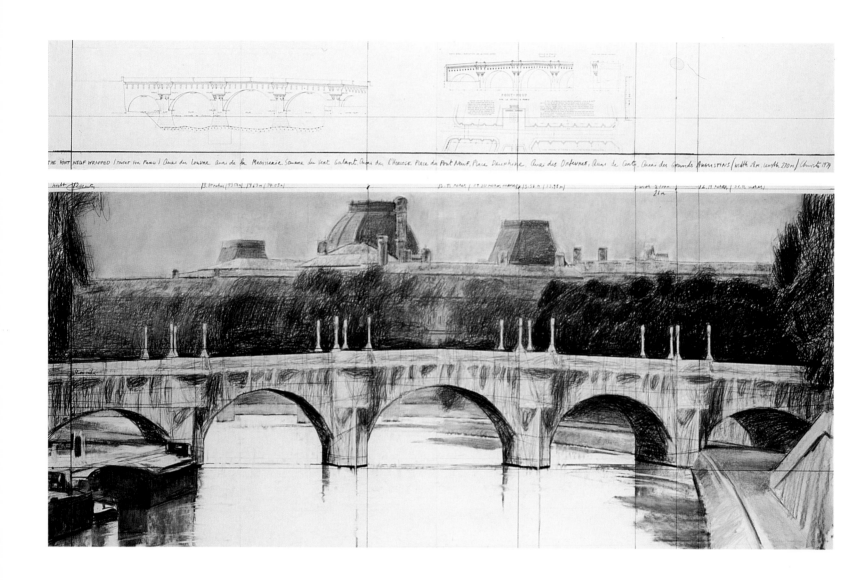

The Pont Neuf, Wrapped, Project for Paris

Drawing 1979. Two parts: 38 x 244 cm (15 x 96 in) and 106.6 x 244 cm (42 x 96 in)

Pencil, charcoal, pastel, crayon and technical data

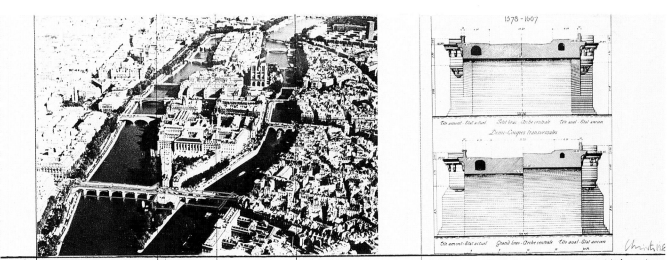

1578 - 1607

THE PONT NEUF, WRAPPED (Project For Paris) Quai du Louvre, Quai de la Megisserie, Place du Pont Neuf, Q. de Conti, Quai des Gds Augustins

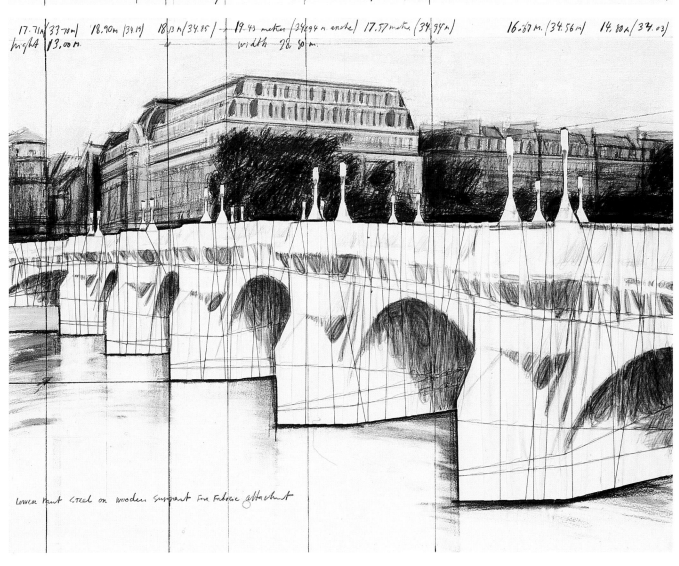

17.71M (33.70M) 18.90M (34.15) 18.13M (34.85) 19.45 meter (34.94 n arche) 17.57 meter (34.94 m) 16.67 M. (34.56M) 14.80M (34.03)
hight 13.00 m. width 28.80 m.

Lower Part attach on wooden support For Fabric attachment

The Pont Neuf, Wrapped, Project for Paris
Collage 1980. Two parts: 28 x 71 cm (11 x 28 in) and 56 x 71 cm (22 x 28 in)
Pencil, fabric, twine, pastel, charcoal, technical data and aerial photograph

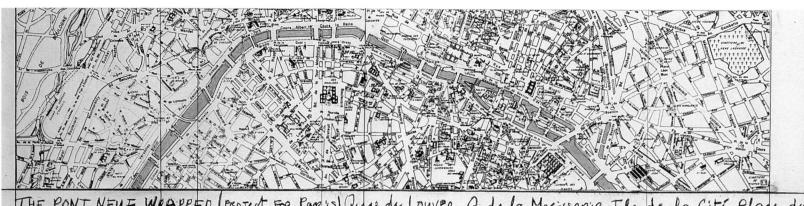

THE PONT NEUF, WRAPPED (Project for Paris) Quai du Louvre, Q. de la Megisserie, Île de la Cité, Place du

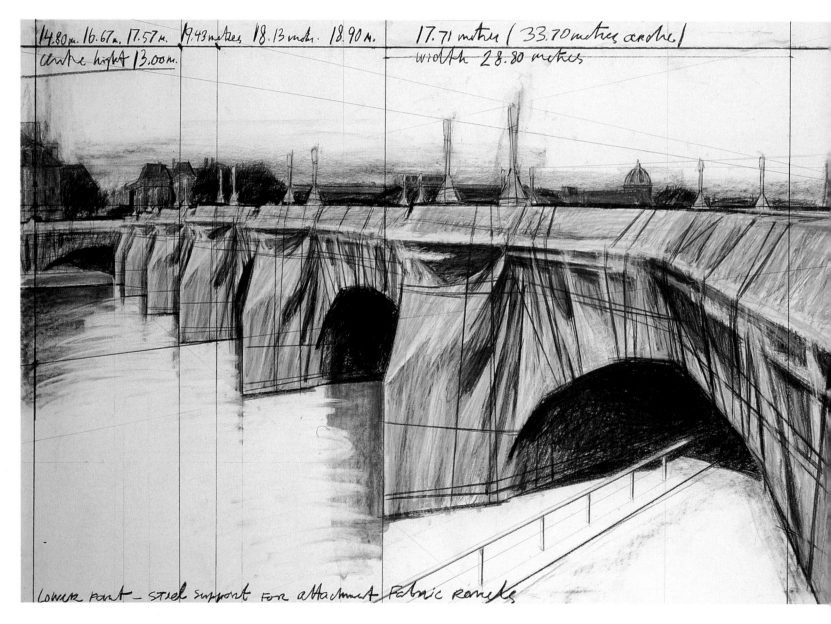

14.80 m. 16.67 m. 17.57 m. 19.43 metres 18.13 mtrs. 18.90 m. 17.71 metres (33.70 metres arche)

centre hight 13.00 m. width 28.80 metres

Lower part — steel support for attachment fabric ropes

Christo 1982

wf. Quai de Conti, Quai des Grandes Augustins

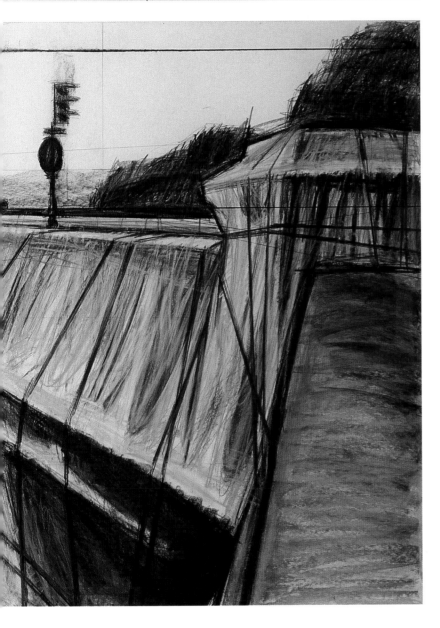

The Pont Neuf, Wrapped, Project for Paris
Drawing 1982. Two parts: 38 x 244 cm (15 x 96 in) and 106.6 x 244 cm (42 x 96 in)
Pencil, pastel, charcoal, crayon and map

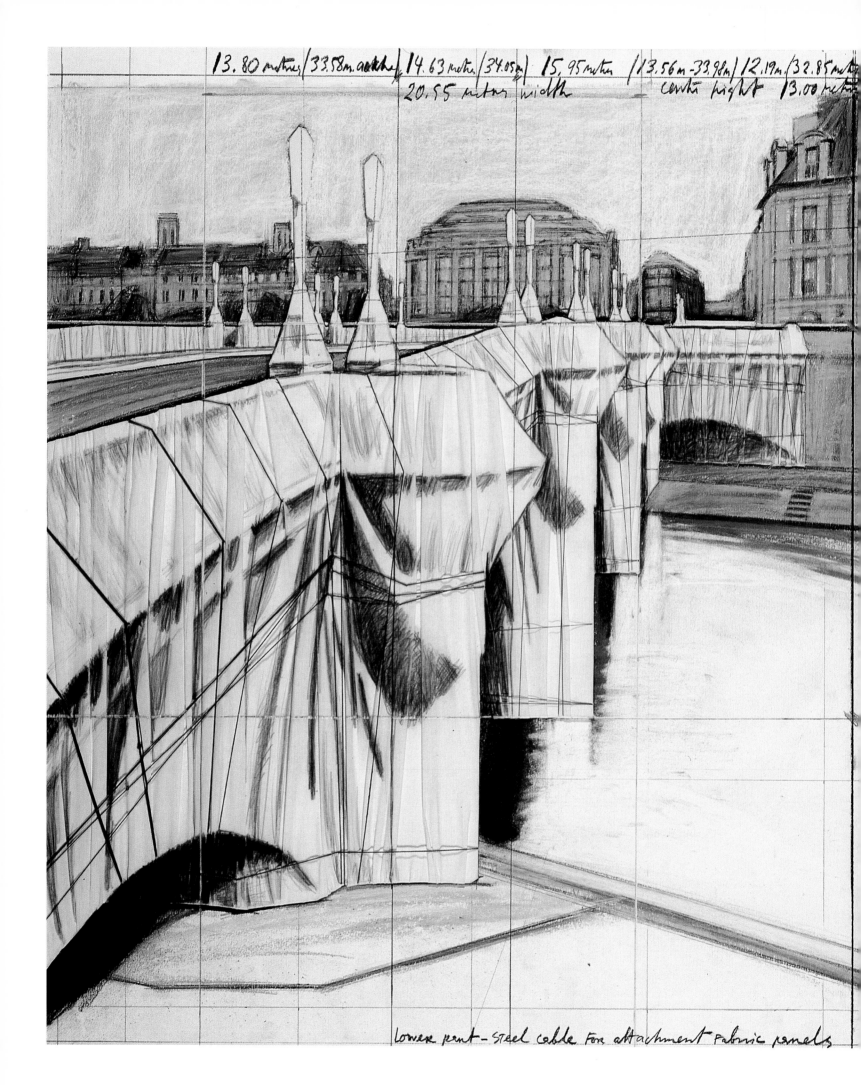

13.80 metres /33.58m. acce 14.63 metres /34.05m/ 15,95 metres /13.56m-33.98m/ 12.19m /32.85m

20.55 metres width centre hight 13.00 m

lower part - steel cable for attachment Fabric panels

142

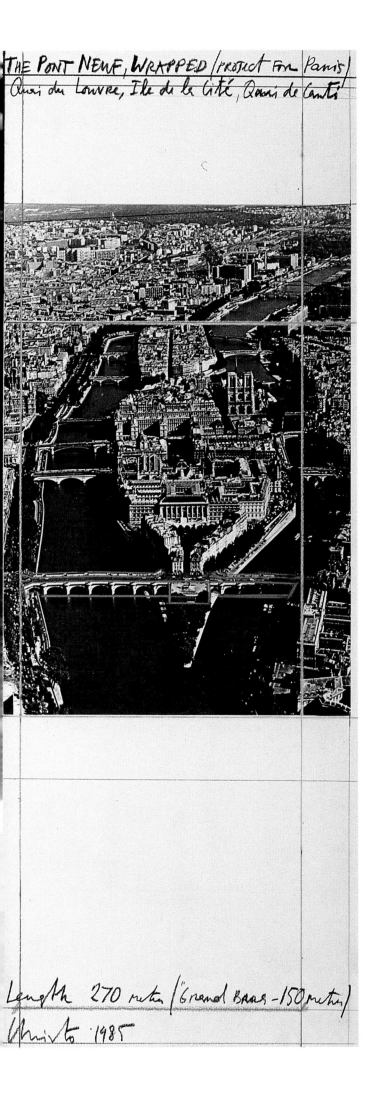

THE PONT NEUF, WRAPPED (PROJECT FOR Paris)
Quai du Louvre, Ile de la Cité, Quai de Conti

Length 270 meters ("Grand BRAS - 150 meters)

Christo 1985

The Pont Neuf, Wrapped, Project for Paris

Collage 1985. Two parts: 77.5 x 66.7 cm (30 1/2 x 26 1/4 in) and 77.5 x 30.5 cm (30 1/2 x 12 in)

Pencil, fabric, twine, charcoal, crayon, pastel and aerial photograph

143

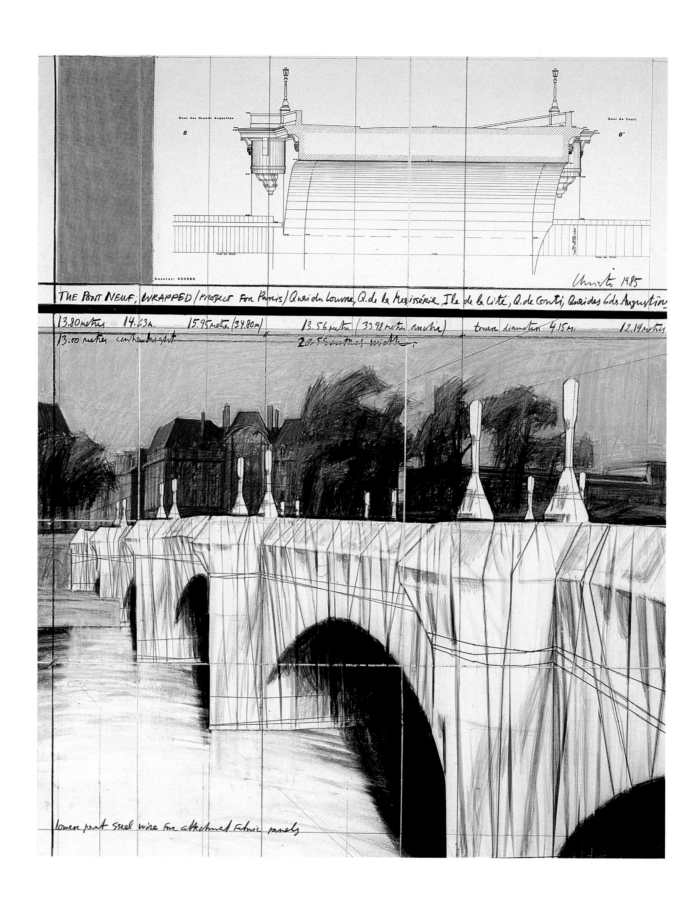

The Pont Neuf, Wrapped, Project for Paris

Collage 1985. Two parts: 30.5 x 77.5 cm (12 x 30 1/2 in) and 66.7 x 77.5 cm (26 1/4 x 30 1/2 in)

Pencil, fabric, twine, charcoal, crayon, pastel, aerial photograph and technical data

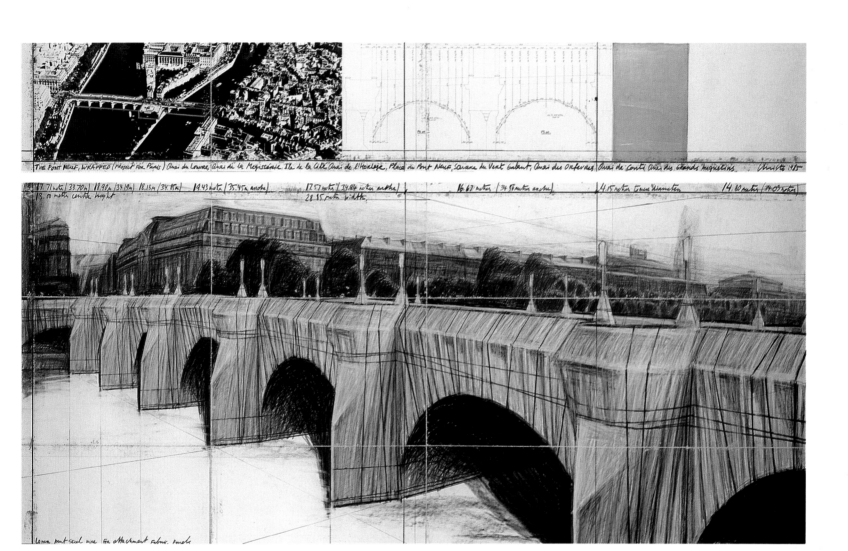

The Pont Neuf, Wrapped, Project for Paris

Drawing 1985. Two parts: 38 x 244 cm (15 x 96 in) and 106.6 x 244 cm (42 x 96 in)

Pencil, pastel, charcoal, crayon, fabric sample, aerial photographs and technical data

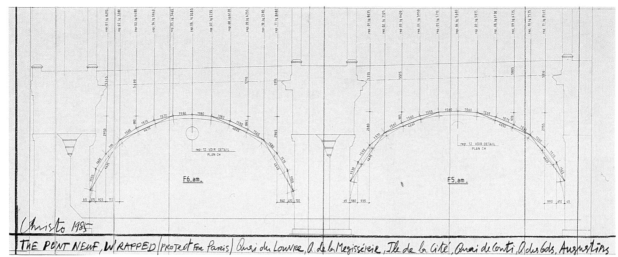

Christo 1985

THE PONT NEUF, WRAPPED (PROJECT FOR PARIS) Quai du Louvre, Q. de la Mégisserie, Ile de la Cité, Quai de Conti, Q. des Gds. Augustins

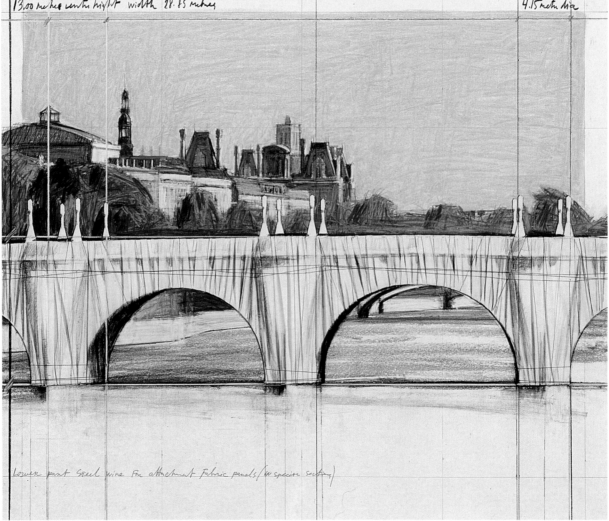

18.90 meters (34.19 m) 18.13 meters (34.85 meter arche) 19.43 meters (35.45 meter arche) 17.57 meters

13.00 meters center height width 28.85 meters 4.15 meter high

Lower part steel wire for attachment fabric panels (in specific section)

The Pont Neuf, Wrapped, Project for Paris

Collage 1985. Two parts: 30.5 x 77.5 cm (12 x 30^1/$_2$ in) and 66.7 x 77.5 cm (26^1/$_4$ x 30^1/$_2$ in)

Pencil, fabric, twine, pastel, charcoal, crayon and technical data

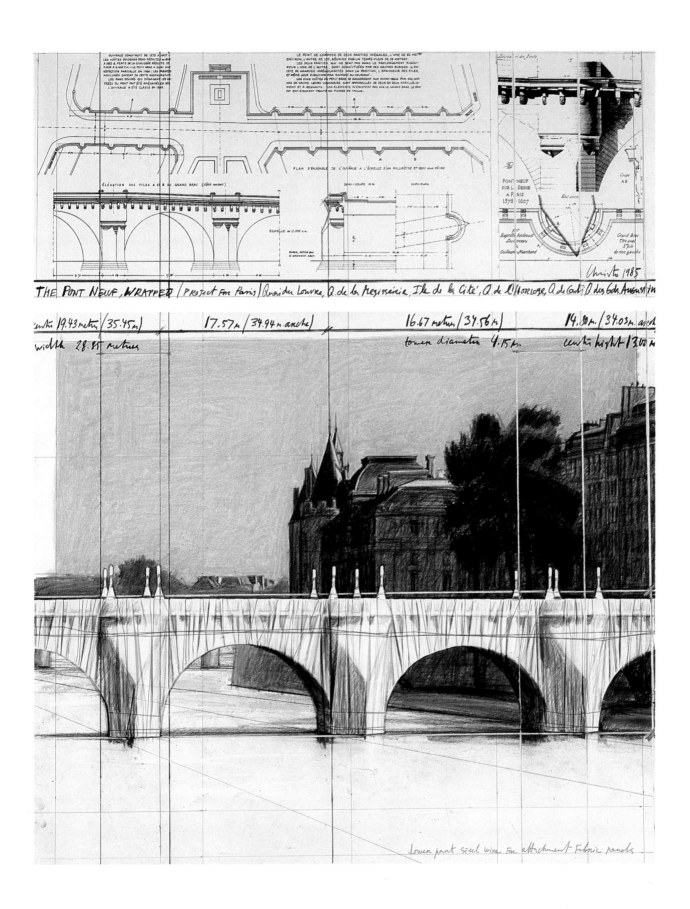

The Pont Neuf, Wrapped, Project for Paris

Collage 1985. Two parts: 30.5 x 77.5 cm (12 x 30 1/2 in) and 66.7 x 77.5 cm. (26 1/4 x 30 1/2 in)

Pencil, fabric, twine, charcoal, pastel, crayon and technical data

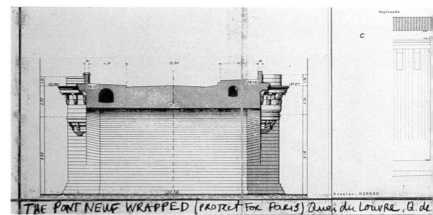

THE PONT NEUF WRAPPED (PROJECT FOR PARIS) Quai du Louvre, Q. de

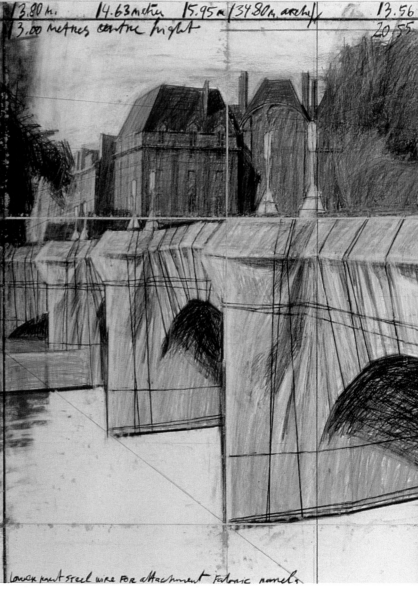

The Pont Neuf, Wrapped, Project for Paris

Drawing 1985. Two parts: 38 x 244 cm (15 x 96 in) and 106.6 x 244 cm (42 x 96 in)

Pencil, charcoal, pastel, crayon and technical data

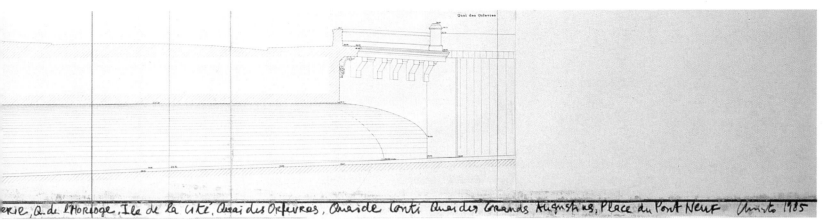

erie, Q. de l'Horloge, Île de la Cité, Quai des Orfevres, Quai de Conti Quai des Grands Augustins, Place du Pont Neuf Christo 1985

3.98 m. arche 4.15 m. tower diminution 12.19 meters (32.85 m. overage)
dH

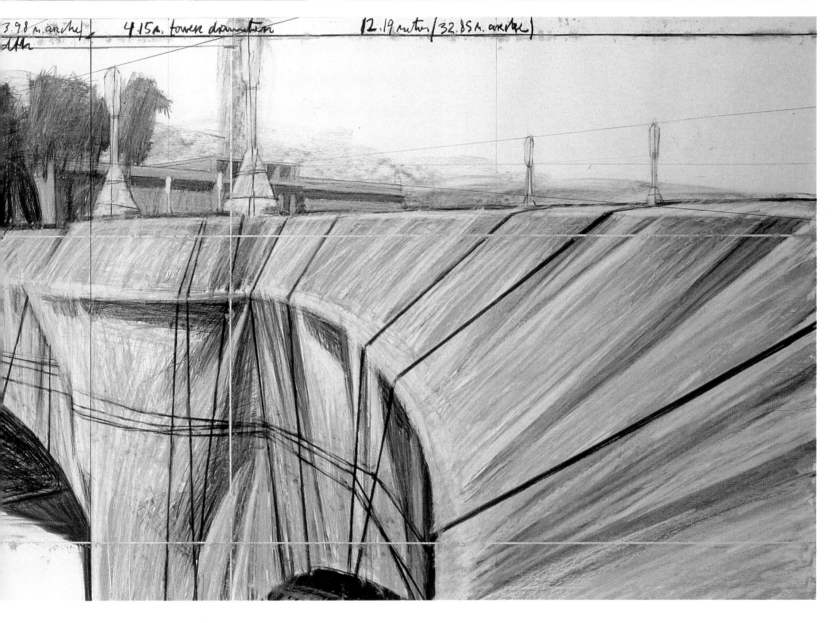

149

The Umbrellas, Japan and USA, 1984–91

1340 blue umbrellas in Ibaraki, Japan; 1760 yellow umbrellas in California, USA

Height: 19 feet 8 inches, diameter: 28 feet 6 inches

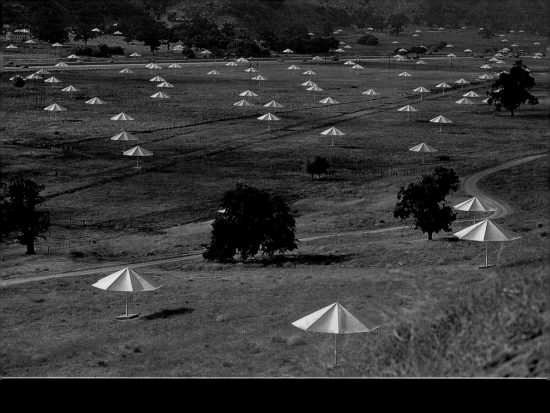

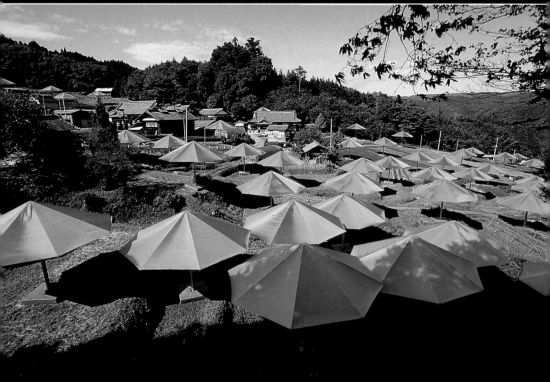

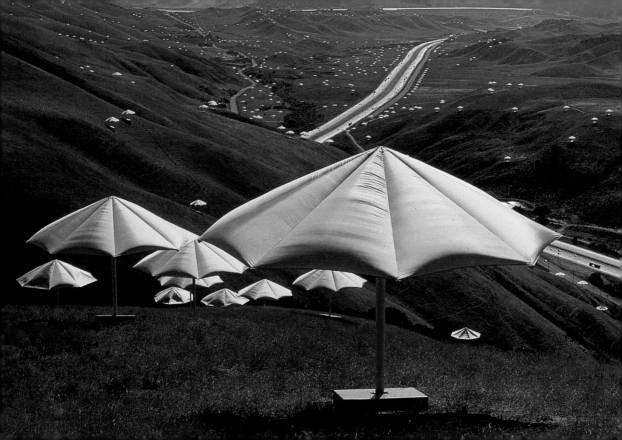

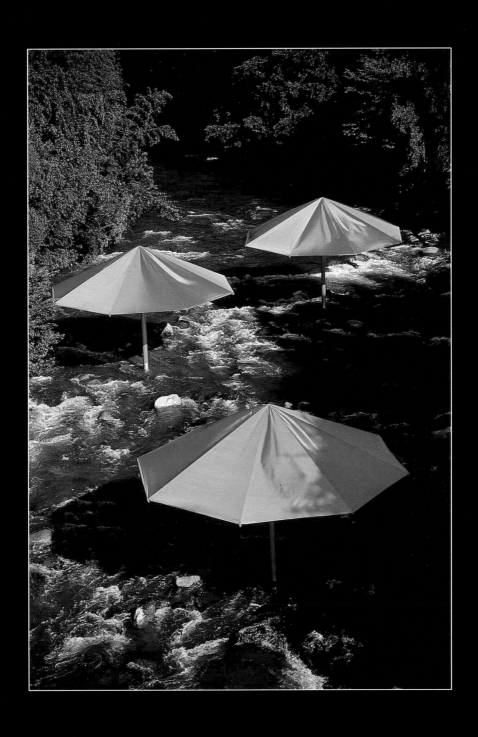

**Christo and Jeanne-Claude:
The Umbrellas, Japan–USA, 1984–91**

Press Release

At sunrise, on October 9th, 1991, Christo and Jeanne-Claude's 1,880 workers began to open the 3,100 Umbrellas in Ibaraki and California, in the presence of the artists.

This Japan–USA temporary work of art reflected the similarities and differences in the ways of life and the use of the land in two inland valleys, one 19 kilometers long (12 miles) in Japan, and the other 29 kilometers long (18 miles) in the USA.

In Japan, the valley is located north of Hitachiota and south of Satomi, 120 kilometers (75 miles) north of Tokyo, around Route 349 and the Sato River, in the Prefecture of Ibaraki, on the properties of 459 private landowners and governmental agencies.

In the U.S.A., the valley is located 96 kilometers (60 miles) north of Los Angeles, along Interstate 5 and the Tejon Pass, between south of Gorman and Grapevine, on the properties of Tejon Ranch, 25 private landowners as well as governmental agencies.

Eleven manufacturers in Japan, USA, Germany and Canada prepared the various elements of the Umbrellas: fabric, aluminum super-structure, steel frame bases, anchors, wooden base supports, bags and molded base covers. All 3,100 Umbrellas were assembled in Bakersfield, California, from where the 1,340 blue Umbrellas were shipped to Japan.

Starting in December 1990, with a total work force of 500, Muto Construction Co. Ltd. in Ibaraki, and A.L. Huber & Son in California installed the earth anchors and steel bases. The sitting platform/base covers were placed during August and September 1991.

From September 19 to October 7, 1991, an additional construction work force began transporting the Umbrellas to their assigned bases, bolted them to the receiving sleeves, and elevated the Umbrellas to an upright closed position. On October 4, students, agricultural workers, and friends, 960 in USA and 920 in Japan, joined the work force to complete the installation of the Umbrellas.

The Christos' 26 million dollar temporary work of art was entirely financed by the artists through The Umbrellas, Joint Project for Japan and U.S.A. Corporation (Jeanne-Claude Christo-Javacheff, president). Previous projects by the artists have all been financed in a similar manner through the sale of the studies, preparatory drawings, collages, scale models, early works, and original lithographs. The artists do not accept any sponsorship.

The removal started on October 27 and the land restored to its original condition. The Umbrellas have been taken apart and all elements recycled.

The Umbrellas, free standing dynamic modules, reflected the availability of land in each valley, creating an invitational inner space, as houses without walls, or temporary settlements and related to the ephemeral character of the work of art. In the precious and limited space of Japan, the Umbrellas were positioned intimately, close together and sometimes following the geometry of the rice fields. In the luxuriant vegetation enriched by water year round, the Umbrellas were blue. In the California vastness of uncultivated grazing land, the configuration of the Umbrellas was whimsical and spreading in every direction. The brown hills are covered by blond grass, and in that dry landscape, the Umbrellas were yellow.

From October 9th, 1991 for a period of eighteen days, The Umbrellas have been seen, approached, and enjoyed by the public, either by car from a distance and closer as they bordered the roads, or by walking under The Umbrellas in their luminous shadows.

Govermental Agencies

Tokyo
Ministry of Construction.
Building Center.
Ministry of Foreign Affairs.

Ibaraki Prefecture
The Governor's Office.
Planning Department.
Public Works Department.

Hitachiota-Shi
The Mayor's Office.
Planning Division.
Tokyo Electric Power,
Hitachiota office.
Nippon Telegraph and Telephone,
Hitachiota office.

Hitachi-Shi
The Mayor's Office.
Planning Division.
Hitachi Huto Co., Ltd. Hitachi Port

Satomi-Mura
The Mayor's Office.
Planning Division.

Omiya-Machi
River Kuji Fisherman's Union.

Washington, D.C.
U.S. Department of the Interior,
Bureau of Land Management.
U.S. Department of Transportation,
Federal Aviation Administration.
U.S. House of Representatives.
U.S. Customs Service.

State of California
The Governor's Office.
Department of Transportation
(Caltrans), District 6 and District 7.
Department of Parks and Recreation.
California Highway Patrol.
Board of Equalization.
California Legislature,
Assembly and Senate.
Assembly Standing Committee
on Revenue and Taxation.
Assembly Standing Committee
on Ways and Means.
Senate Standing Committee
on Revenue and Taxation.
Senate Standing Committee
on Appropriations.
Joint Committee on the Arts.
California Arts Council.

Los Angeles County
Los Angeles County Board of
Supervisors.
Chief Administrative Officer.
Department of Public Works.
Department of Regional Planning.
Fire Department.
Sheriff Department.

Kent County
Kern County Board of Supervisors.
Department of Planning and
Development Services.
Public Works (Roads).
Fire Department.
Sheriff Department.

Facts

Umbrellas

How many in Japan (blue):	1340	
How many in USA (yellow):	1760	
Height including base:	19ft 8 $^1/_4$"	6 meters
Diameter of Umbrellas:	28ft 5 inches	8.66 m
Weight of Umbrellas without base:	448 pounds	203.2 kg
Fabric area supported by Umbrella:	638.17ft^2	59.3m^2

Aluminum

Diameter of Pole:	8.625 inches	21.9 cm
Length of Ribs:	15ft 7$^3/_4$"	4.77 m
Size of Ribs:	3.75" x 2.25"	9.5 x 5.7 cm
Length of Strut:	7ft 5$^{11}/_{32}$"	2.27 m
Diameter of Strut:	3 inches	7.6 cm

Bases

How many steel-bases in USA: 1625
How many concrete-bases in USA: 135
How many steel-bases in Japan: 1205
How many concrete-bases in Japan: 35
How many river-bases in Japan: 100

Totals for both Japan and U.S.A.:

Paint:	2,000 gallons	7,600 liters
Total length Poles:	10.97 miles	17.7 km
Total number of Ribs:	24,800	
Total length Ribs:	73.5 miles	118.3 km
Total number of Struts:	24,800	
Total length Struts:	35 miles	56.3 km
Total fabric purchased:	4,413,347 ft^2	410,000 m^2

Total number of pieces per Umbrella: 470
Total number of pieces per steel-base with anchors: 64
Total number of all pieces: 1,655,400

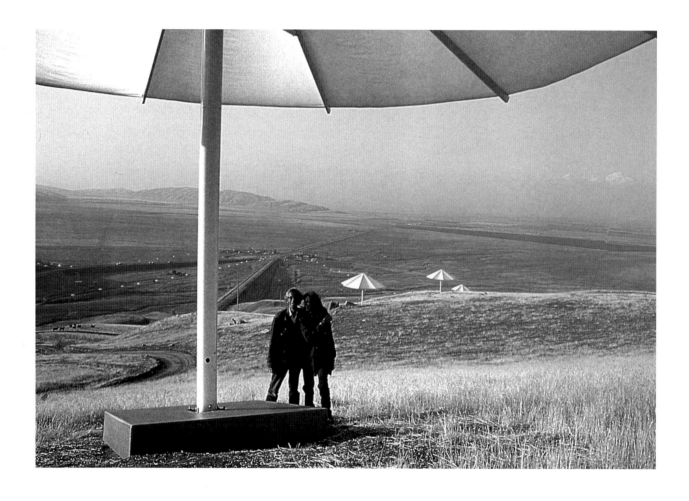

Christo and Jeanne-Claude in California, October 1991: in the background is
the village of Grapevine, at the northern part of 'The Umbrellas'.

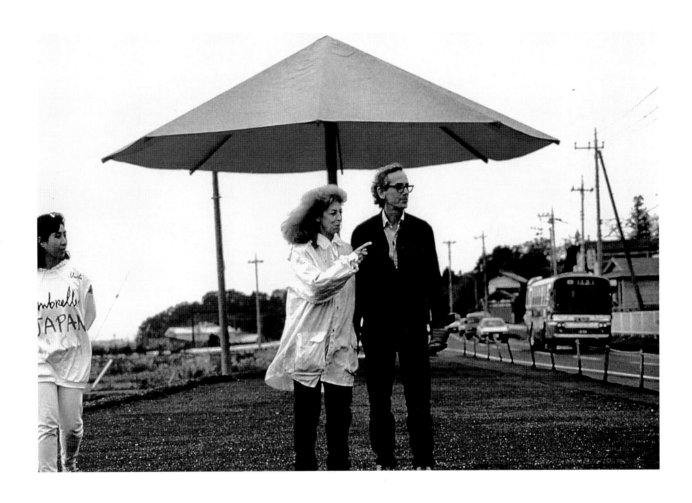

Interpreter Setsuko Shibata, Jeanne-Claude and Christo in Ibaraki, Japan,
in front of Umbrella number one, October 1991.

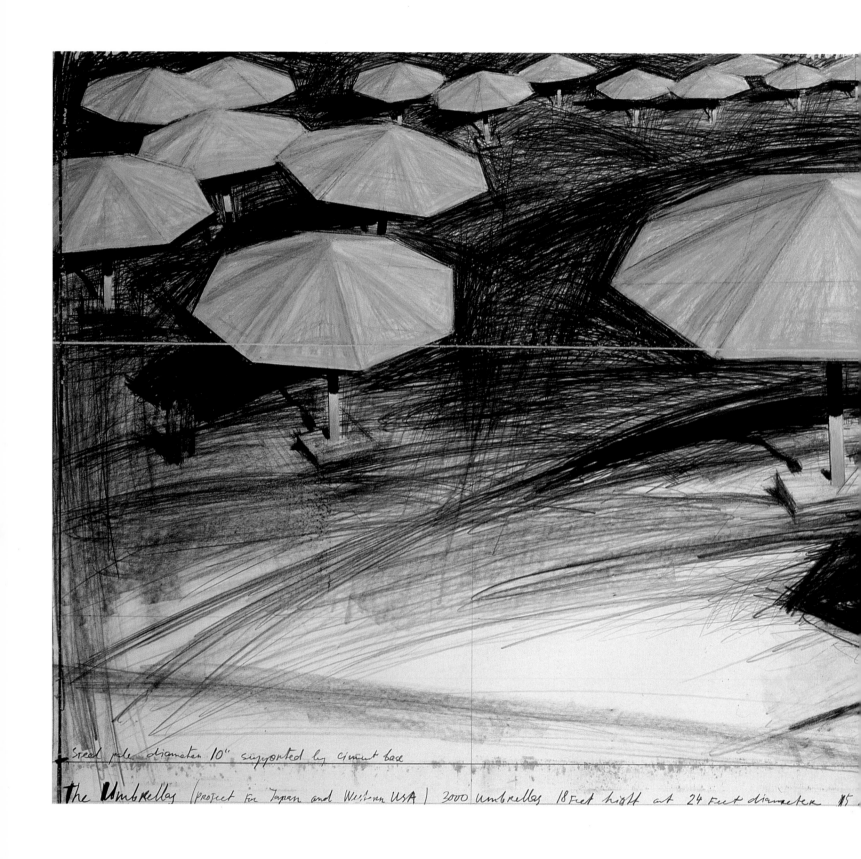

Steel pole diameter 10" supported by cement base

the Umbrellas (project for Japan and Western USA) 3000 umbrellas 18 feet hight at 24 feet diameter #5

The Umbrellas, Project for Japan and Western USA
Drawing 1985: 106.6 x 244 cm (42 x 96 in)
Pencil, charcoal, crayon and pastel

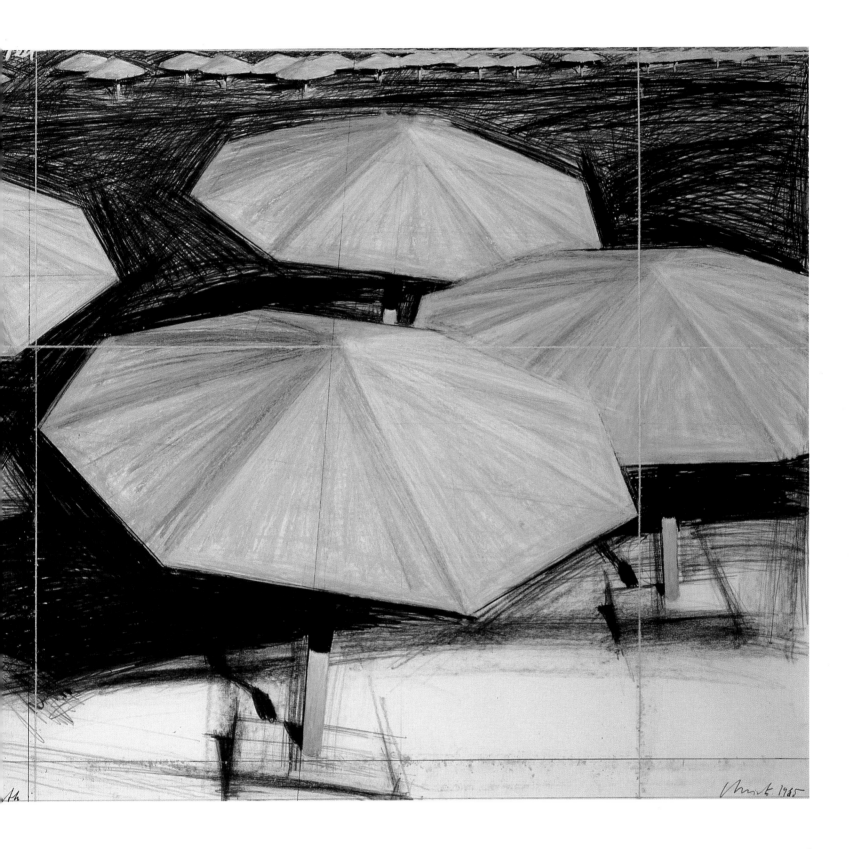

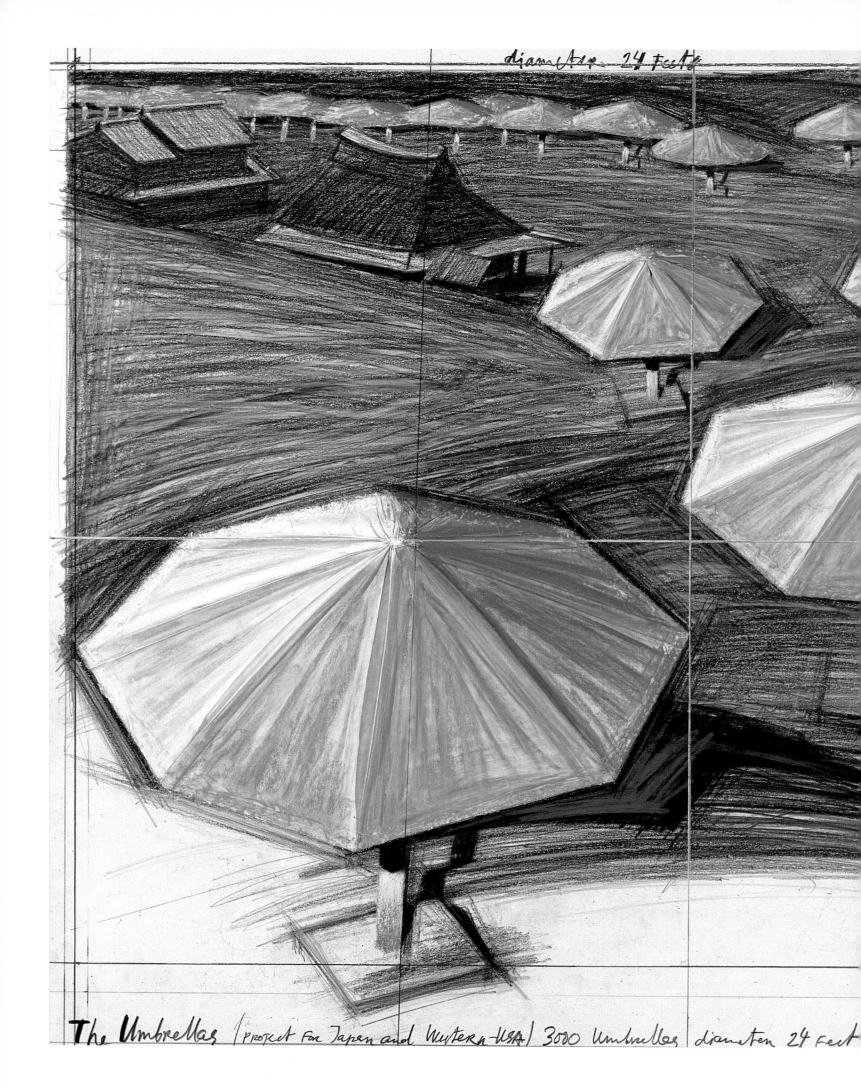

diameter 24 feet

The Umbrellas (project for Japan and Western USA) 3000 Umbrellas diameter 24 feet

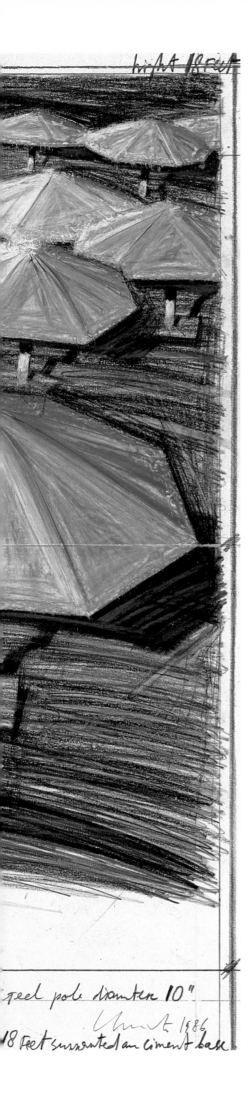

The Umbrellas, Project for Japan and Western USA
Collage 1986: 66.7 x 77.5 cm (26 1/4 x 30 1/2 in)
Pencil, fabric, pastel, charcoal and crayon

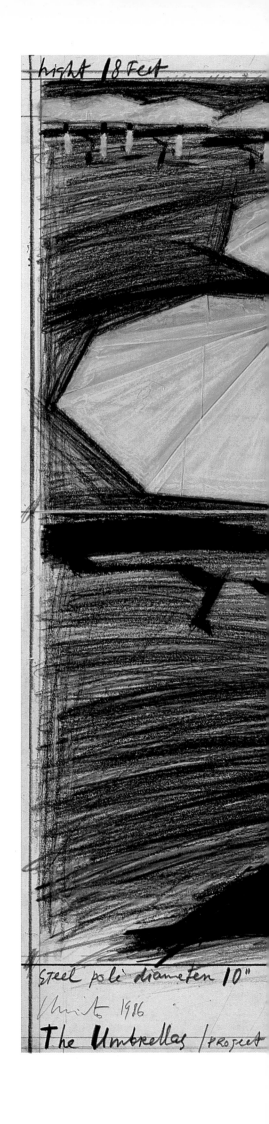

The Umbrellas, Project for Japan and Western USA
Collage 1986: 66.7 x 77.5 cm (26 1/4 x 30 1/2 in)
Pencil, fabric, charcoal, pastel and crayon

diameter 24 Feet

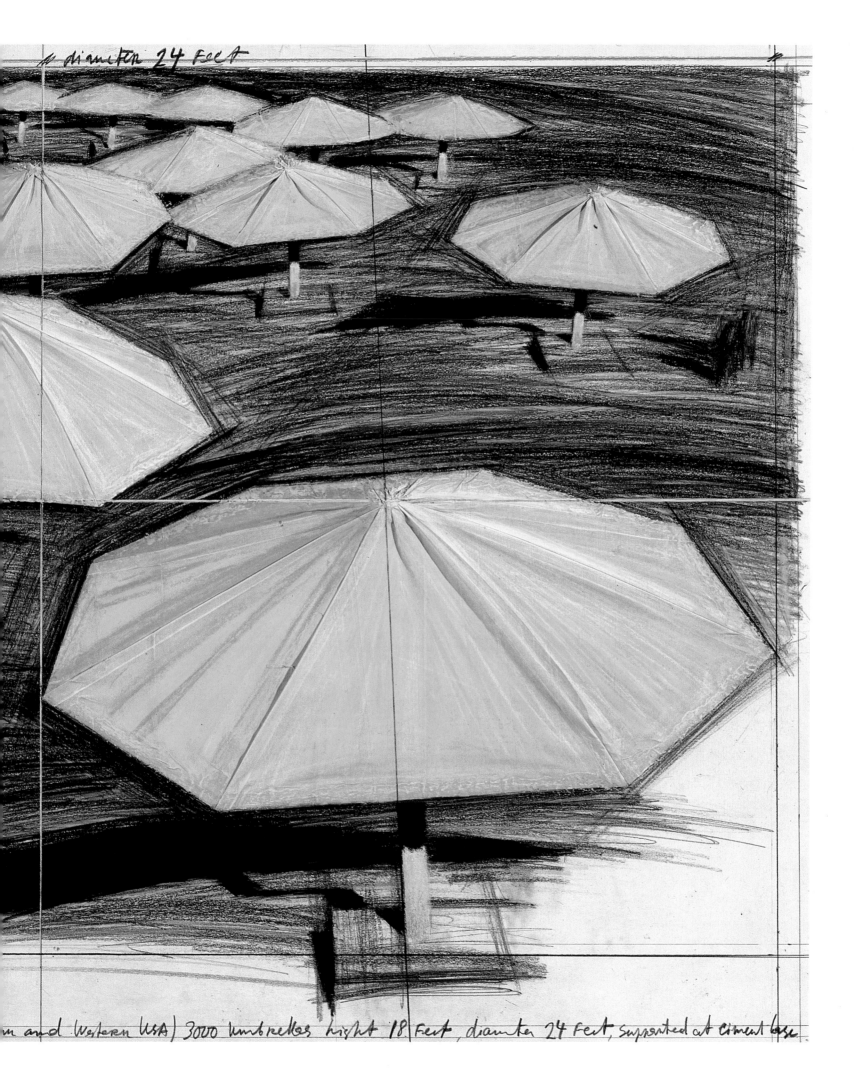

m and Western USA) 3000 umbrellas hight 18 Feet, diameter 24 Feet, supported at ciment base

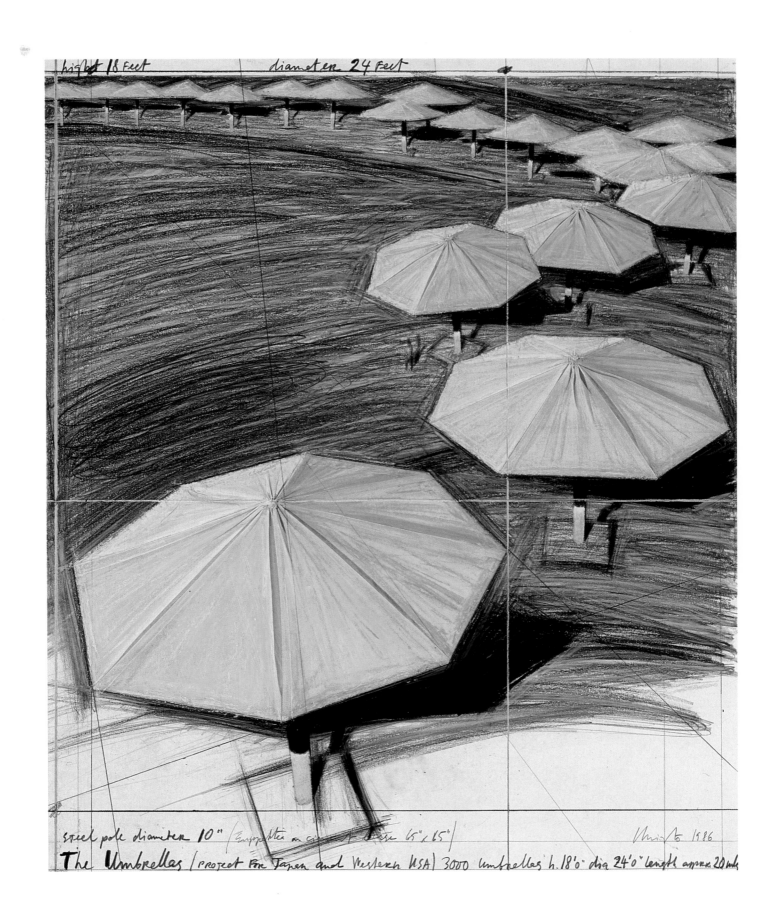

high 18 Feet diameter 24 Feet

steel pole diameter 10" (Empopolitie on c_____ _____ 65" x 65") Christo 1986

The Umbrellas (Project For Japan and Western USA) 3000 Umbrellas h. 18'0" dia 24'0" length approx 20 mls

The Umbrellas, Project for Japan and Western USA
Collage 1986: 77.5 x 66.7 cm (30 1/2 x 26 1/4 in)
Pencil, fabric, pastel, charcoal and crayon

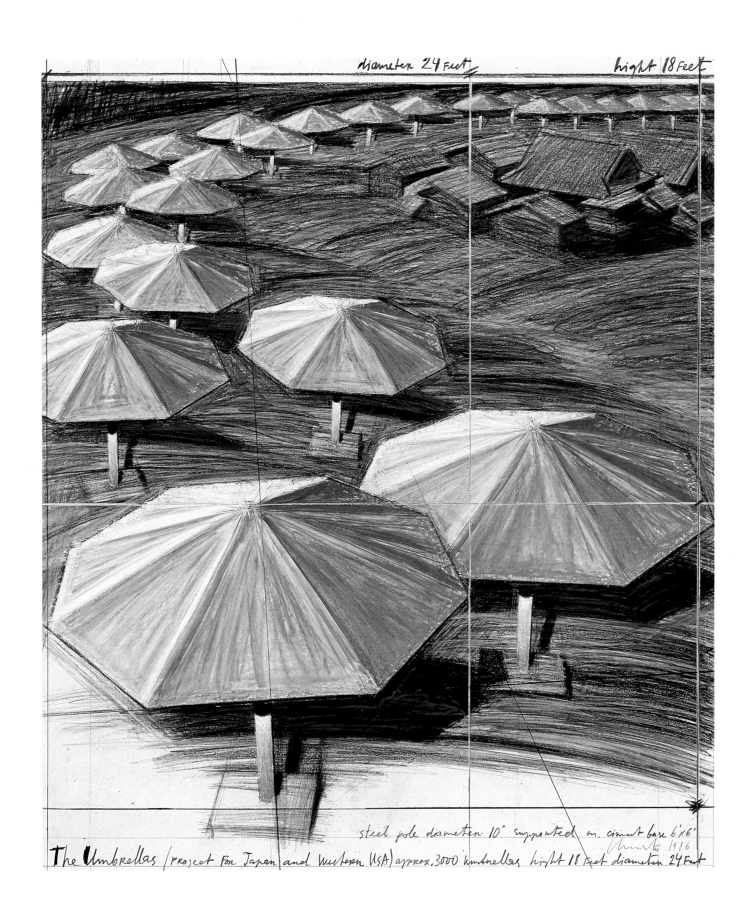

diameter 24 Feet hight 18 Feet

steel pole diameter 10" supported on cinent base 6'x6'
Christo 1986

The Umbrellas (Project For Japan and Western USA) approx. 3000 umbrellas hight 18 Feet diameter 24 Feet

The Umbrellas, Project for Japan and Western USA
Collage 1986: 77.5 x 66.7 cm (30 1/2 x 26 1/4 in)
Pencil, fabric, charcoal, pastel and crayon

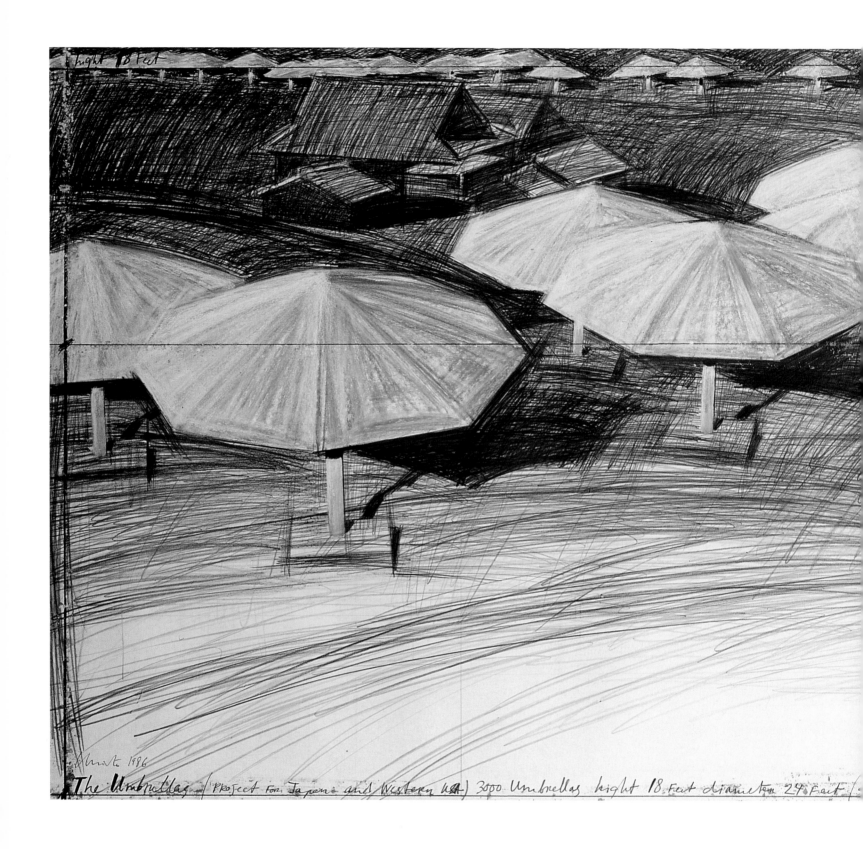

The Umbrellas, Project for Japan and Western USA
Drawing 1986: 106.6 x 244 cm (42 x 96 in)
Pencil, charcoal, pastel and crayon

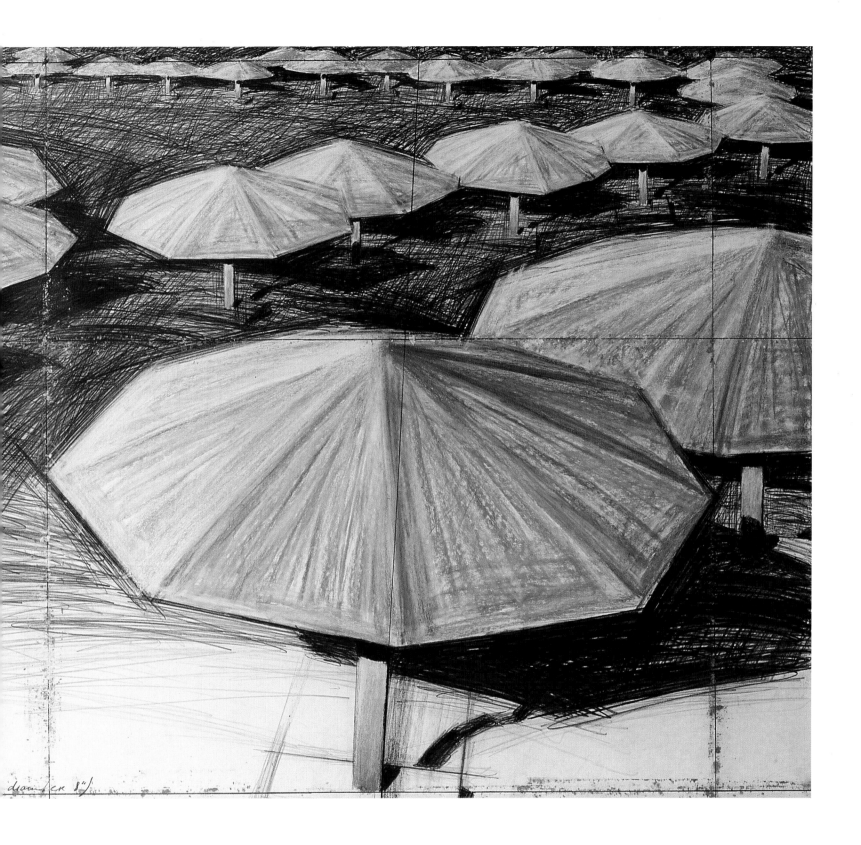

diameter 8'

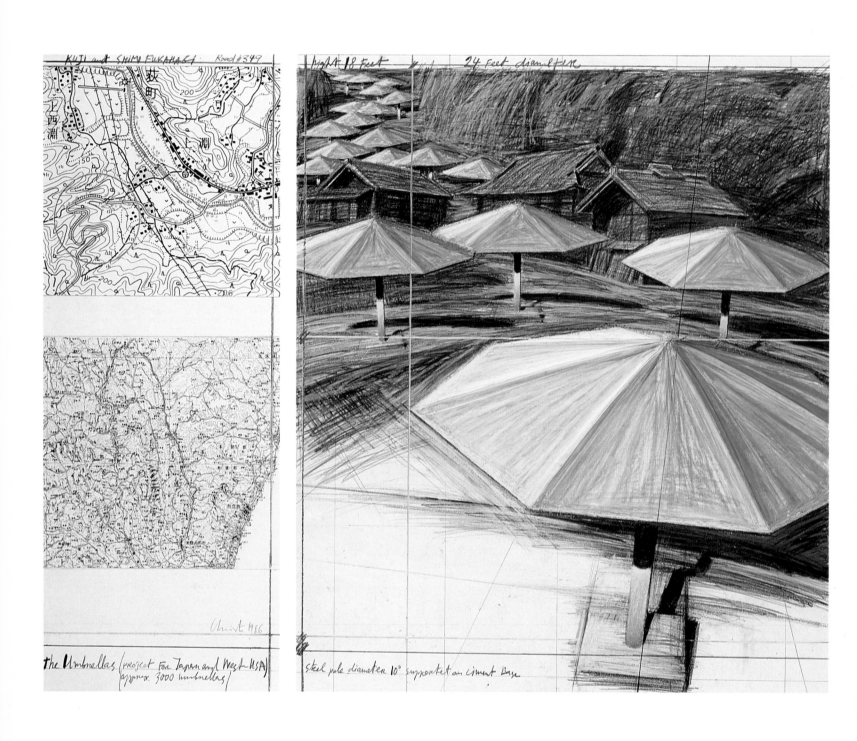

The Umbrellas, Project for Japan and Western USA
Collage 1986: 66.7 x 77.5 cm (26 1/4 x 30 1/2 in)
Pencil, fabric, pastel, charcoal, crayon, enamel paint and maps

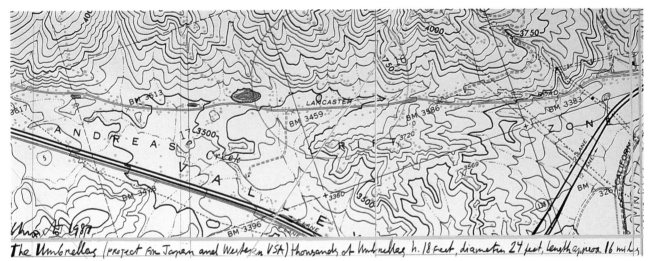

The Umbrellas (project for Japan and Western USA) thousands of Umbrellas h. 18 feet, diameter 24 feet, length approx. 16 miles

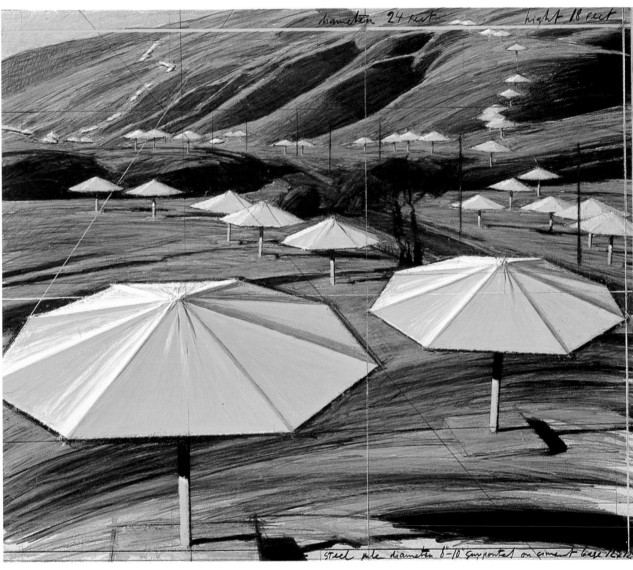

diameter 24 feet hight 18 feet

steel pole diameter 8"-10" supported on cement base 12×12

The Umbrellas, Project for Japan and Western USA

Collage 1986. Two parts: 30.5 x 77.5 cm (12 x 30 1/2 in) and 66.7 x 77.5 cm (26 1/3 x 30 1/2 in)

Pencil, fabric, charcoal, crayon, pastel, ballpoint pen, enamel paint and map

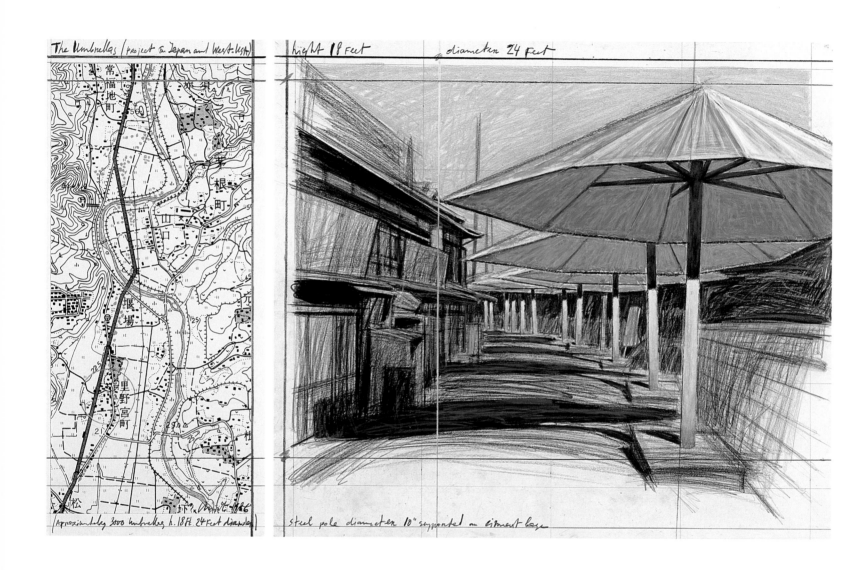

The Umbrellas, Project for Japan and Western USA

Collage 1986. Two parts: 66.7 x 30.5 cm (26 1/4 x 12 in) and 66.7 x 77.5 cm (26 1/4 x 30 1/2 in)

Pencil, fabric, charcoal, crayon, pastel, ballpoint pen, enamel paint and map

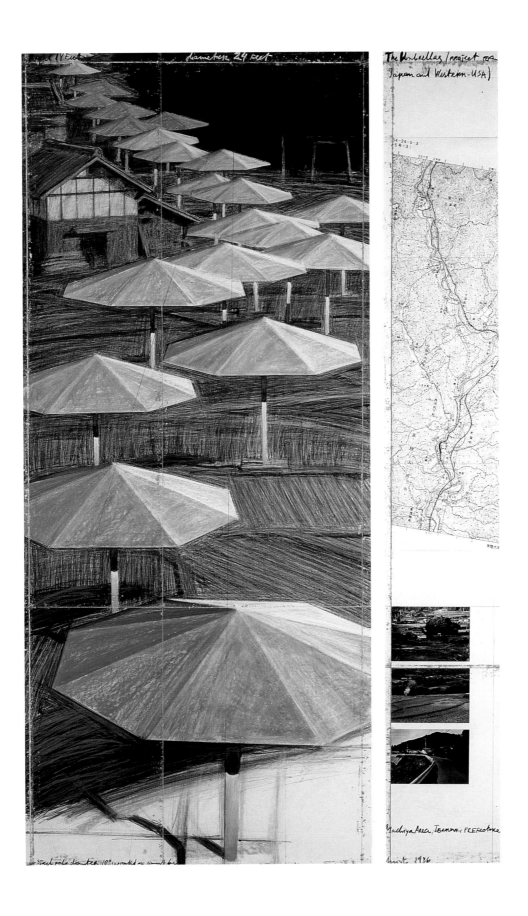

The Umbrellas, Project for Japan and Western USA

Drawing 1986. Two parts: 244 x 106.6 cm (96 x 42 in) and 244 x 38 cm (96 x 15 in)

Pencil, charcoal, crayon, photographs, pastel, enamel paint and map

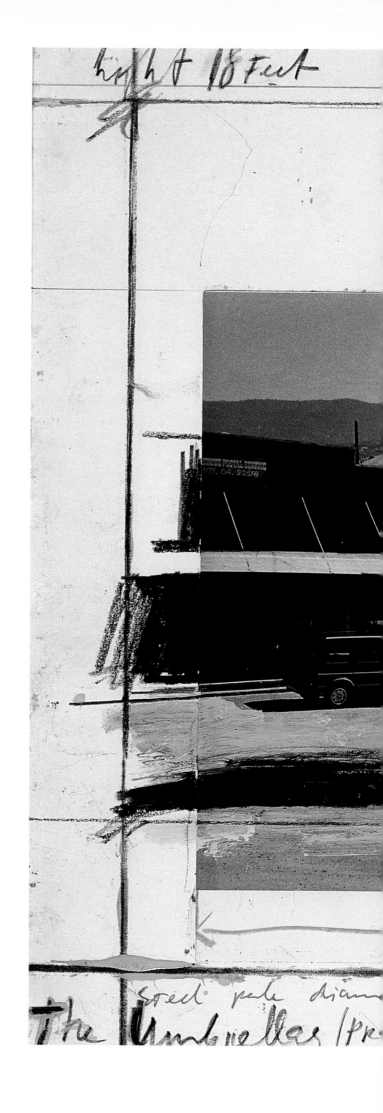

The Umbrellas, Project for Japan and Western USA
Collage 1986: 28 x 35.5 cm (11 x 14 in)
Pencil, enamel paint, photograph by Jeanne-Claude, crayon, charcoal and ballpoint pen

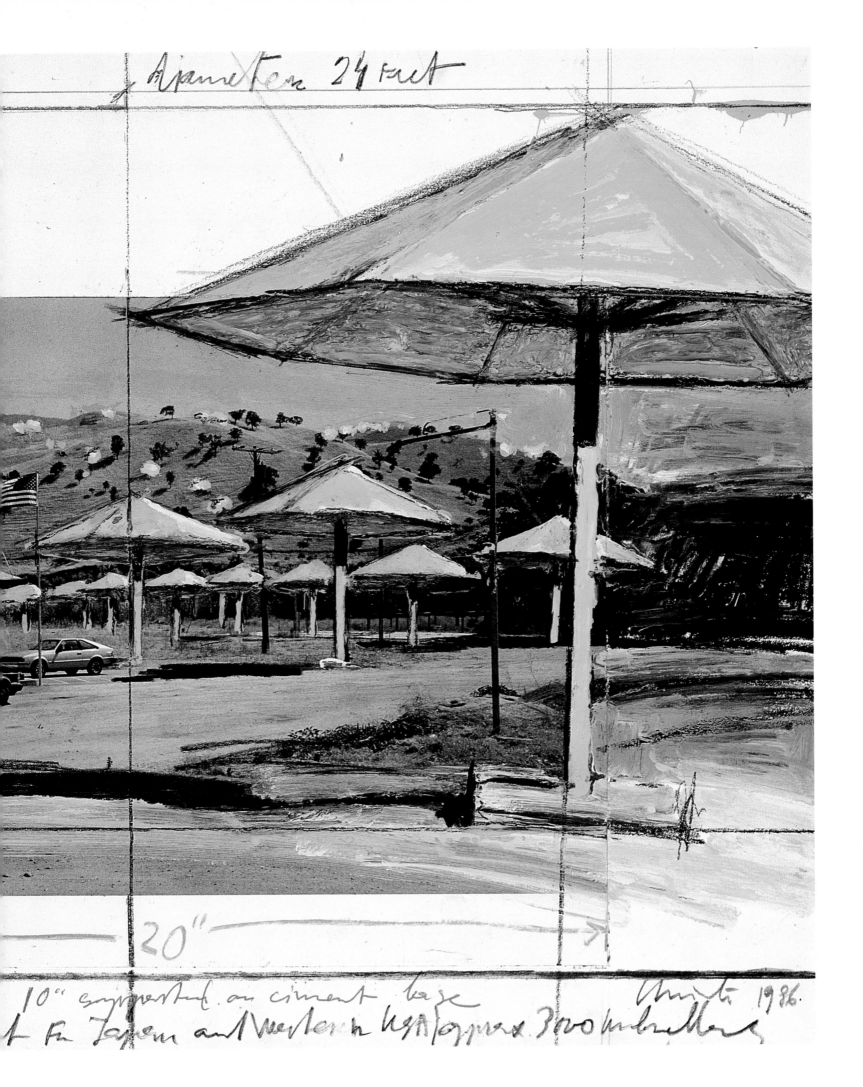

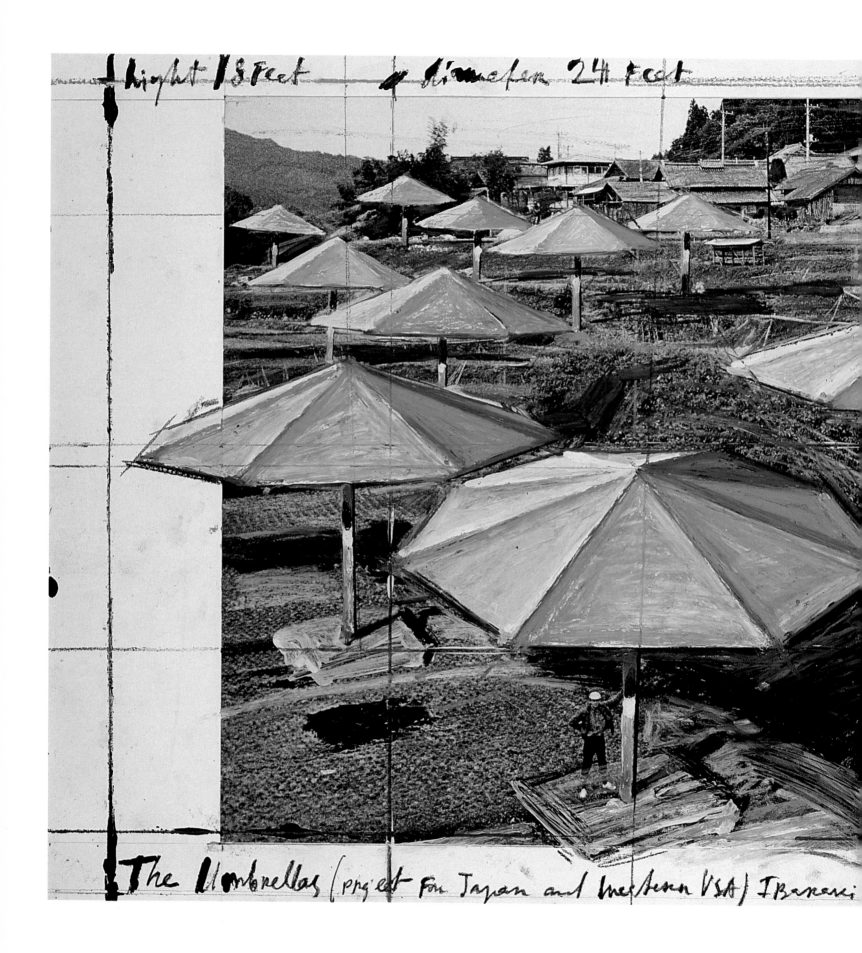

The Umbrellas (project for Japan and Western USA) Ibaraki

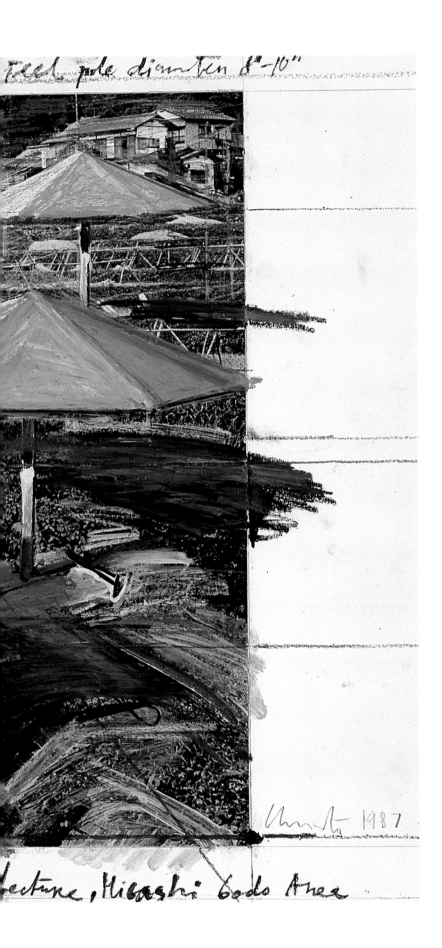

Feel pole diameter 8"-10"

Christo 1987

Lecture, Higashi Godo Area

The Umbrellas, Project for Japan and Western USA
Collage 1987: 35.5 x 56 cm (14 x 22 in)
Pencil, enamel paint, photograph, crayon and charcoal

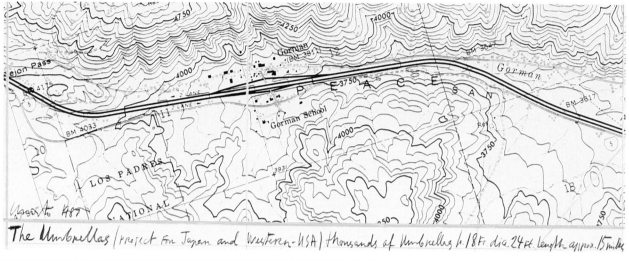

The Umbrellas / Project For Japan and Western-USA) thousands of Umbrellas, h. 18 Ft. dia. 24 Ft. length appox. 15 miles

height 18 Feet diameter 24 Feet

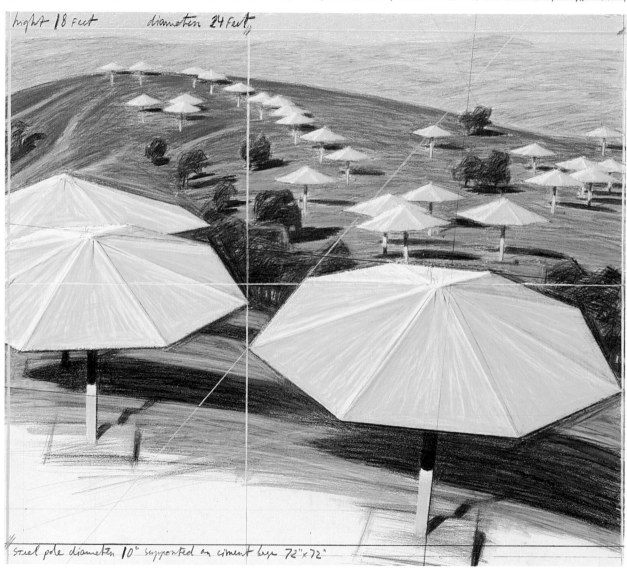

Steel pole diameter 10" supported on cement base 72" x 72"

The Umbrellas, Project for Japan and Western USA
Collage 1987. Two parts: 30.5 x 77.5 cm (12 x 30 1/2 in) and 66.7 x 77.5 cm (26 1/4 x 30 1/2 in)
Pencil, fabric, pastel, crayon, enamel paint and map

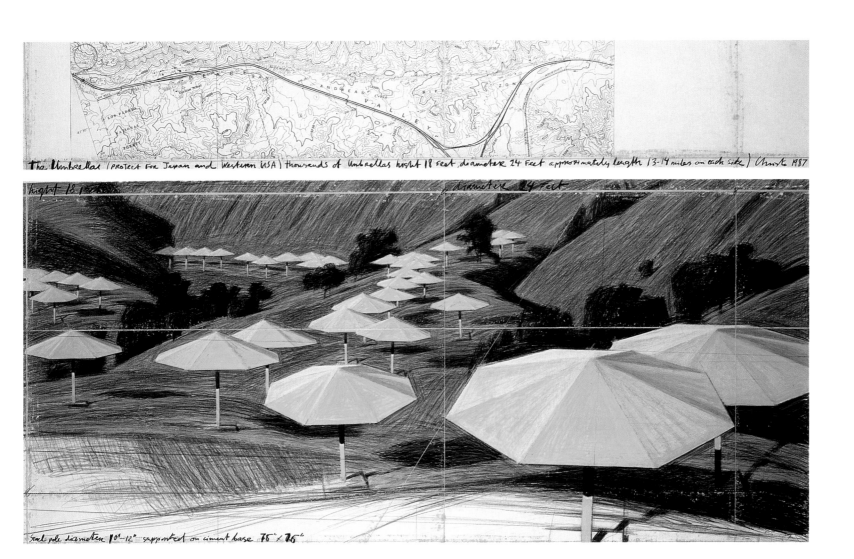

The Umbrellas, Project for Japan and Western USA

Drawing 1987. Two parts: 38 x 244 cm (15 x 96 in) and 107 x 244 cm (42 x 96 in)

Pencil, pastel, charcoal, crayon, enamel paint and map

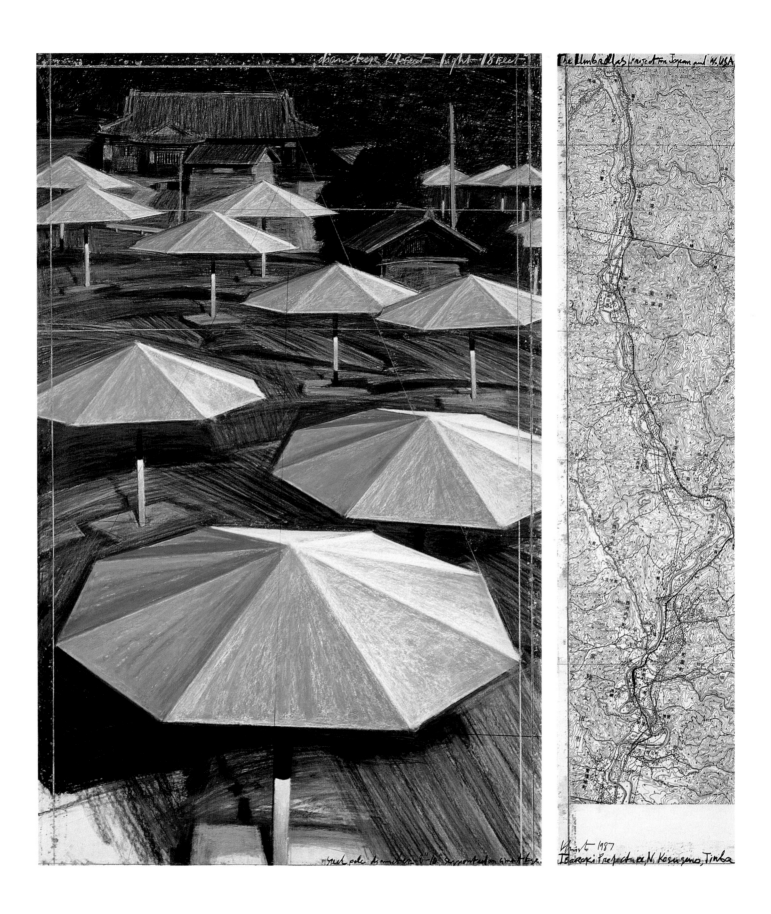

The Umbrellas, Project for Japan and Western USA

Drawing 1987. Two parts: 165 x 106.6 cm (65 x 42 in) and 165 x 38 cm (65 x 15 in)

Pencil, charcoal, pastel, crayon, ballpoint pen, enamel paint and map

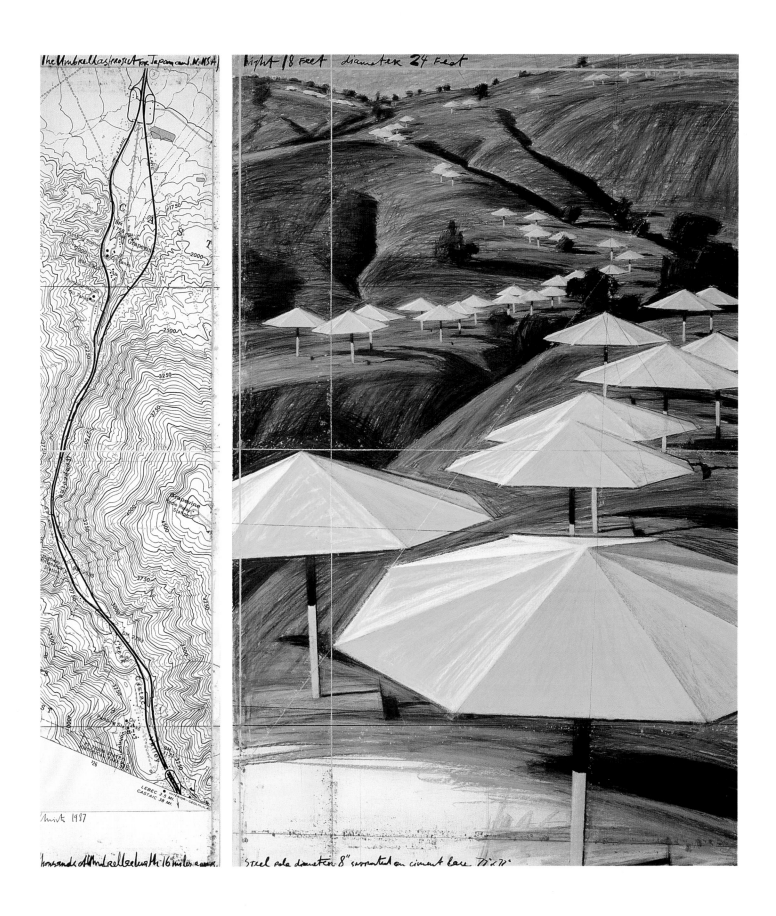

The Umbrellas, Project for Japan and Western USA

Drawing 1987. Two parts: 165 x 38 cm (65 x 15 in) and 165 x 106.6 cm (65 x 42 in)

Pencil, charcoal, crayon, pastel, enamel paint and map

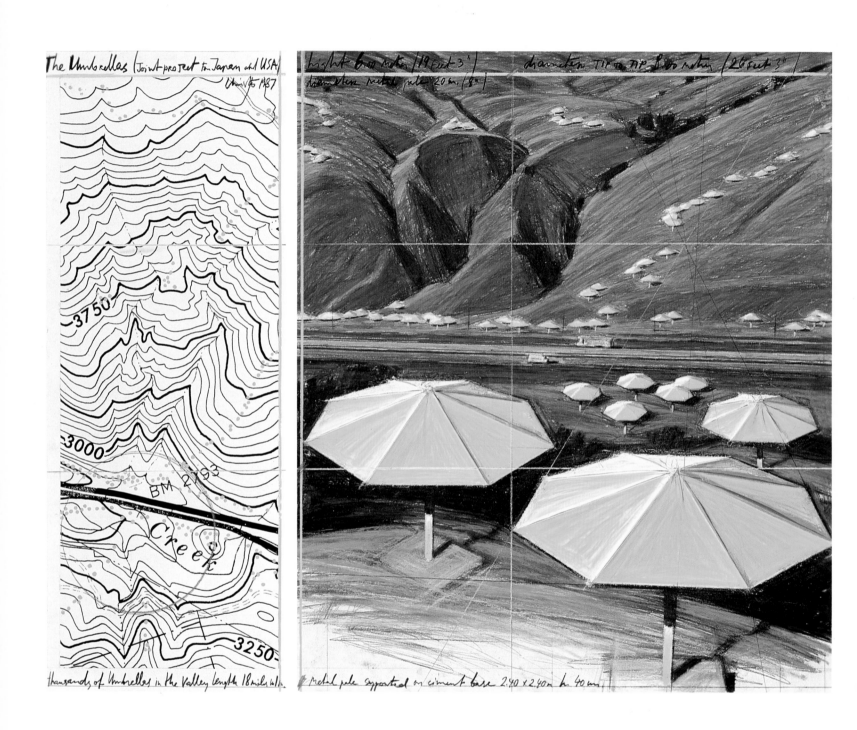

The Umbrellas, Joint Project for Japan and Western USA

Collage 1987. Two parts: 77.5 x 30.5 cm (30 1/$_2$ x 12 in) and 77.5 x 66.7 cm (30 1/$_2$ x 26 1/$_4$ in)

Pencil, fabric, pastel, charcoal, crayon, enamel paint and topographic map

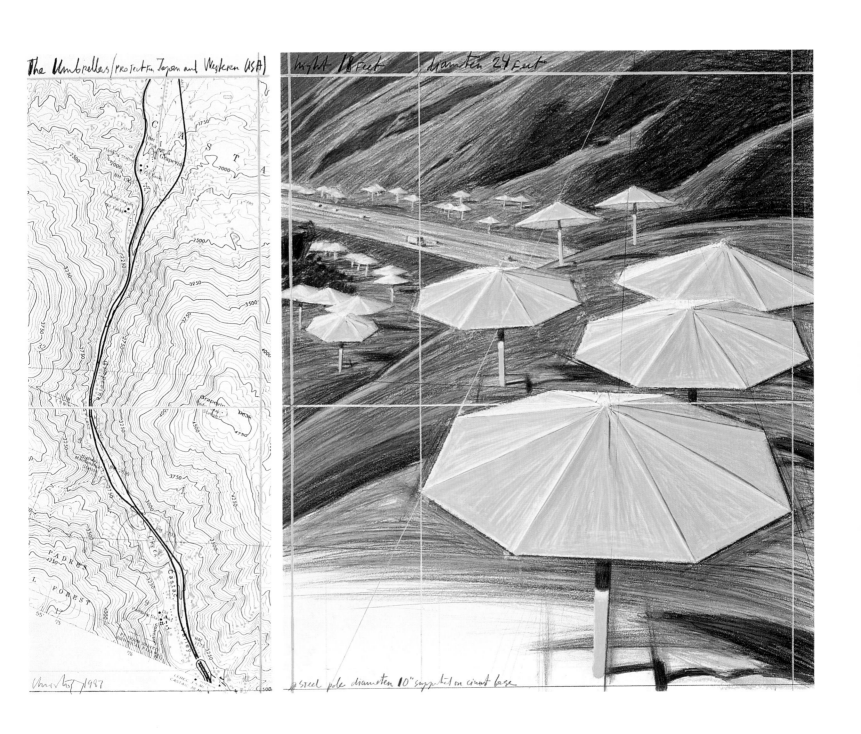

The Umbrellas, Project for Japan and Western USA

Collage 1987. Two parts: 77.5 x 30.5 cm (30 ½ x 12 in) and 77.5 x 66.7 cm (30 ½ x 26 ¼ in)

Pencil, fabric, pastel, crayons, enamel paint and map

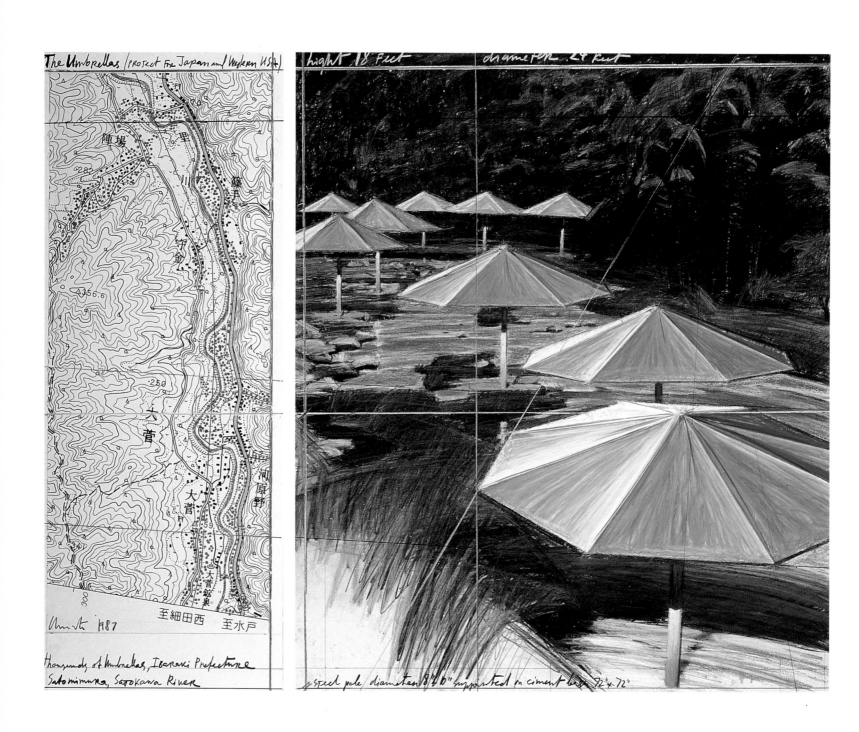

The Umbrellas, Project for Japan and Western USA

Collage 1987. Two parts: 77.5 x 30.5 cm (30 1/2 x 12 in) and 77.5 x 66.7 cm (30 1/2 x 26 1/4 in)

Pencil, fabric, charcoal, crayon, pastel, enamel paint and map

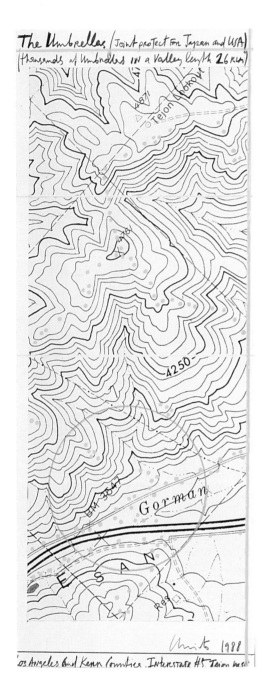

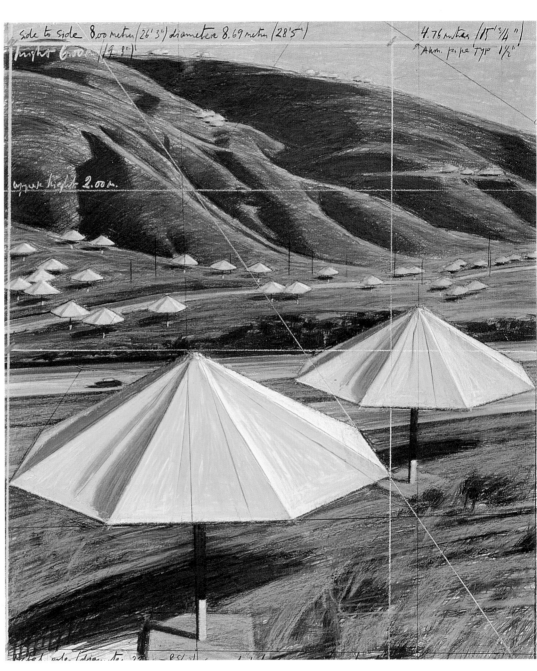

The Umbrellas, Joint Project for Japan and USA

Collage 1988. Two parts: 77.5 x 30.5 cm (30 1/2 x 12 in) and 77.5 x 66.7 cm (30 1/2 x 26 1/4 in)

Pencil, fabric, charcoal, pastel, crayon, enamel paint and map

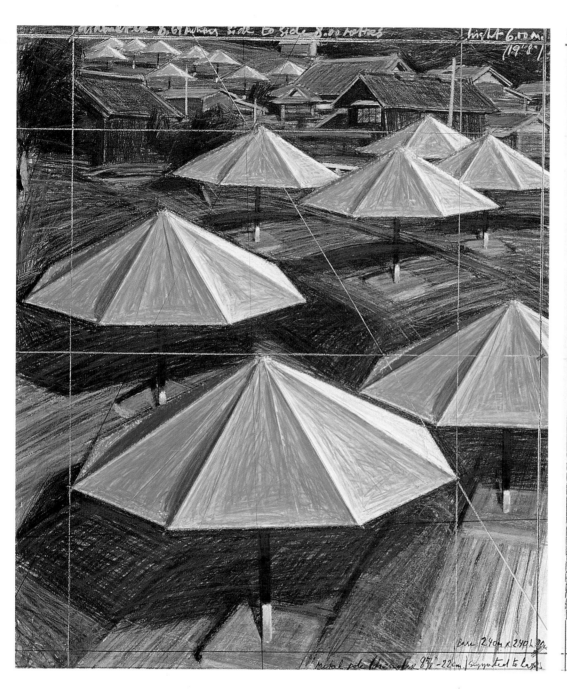
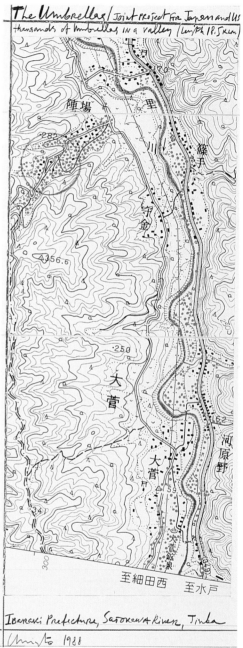

The Umbrellas, Joint Project for Japan and USA
Collage 1988. Two parts: 77.5 x 66.7 cm (30 1/2 x 26 1/4 in) and 77.5 x 30.5 cm (30 1/2 x 12 in)
Pencil, fabric, charcoal, pastel, crayon, enamel paint and map

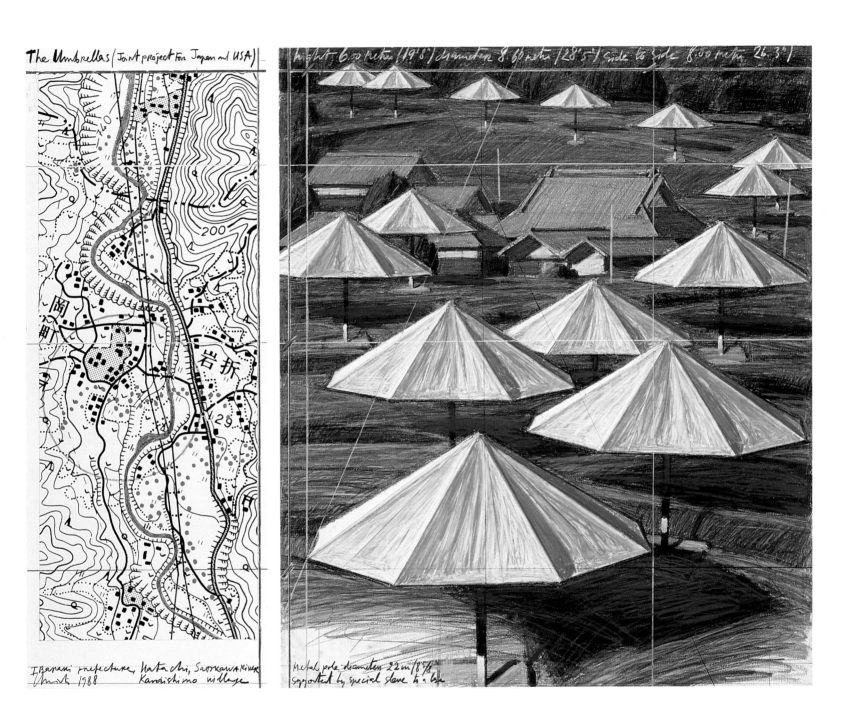

The Umbrellas, Joint Project for Japan and USA
Collage 1988. Two parts: 77.5 x 30.5 cm (30 1/2 x 12 in) and 77.5 x 66.7 cm (30 1/2 x 26 1/4 in)
Pencil, fabric, pastel, charcoal, crayon, enamel paint, ballpoint pen and map

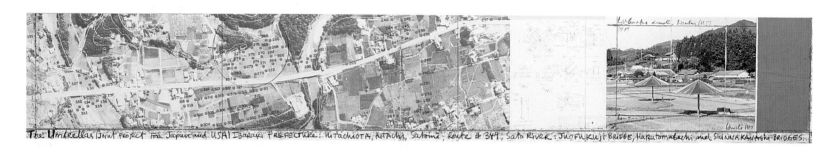

The Umbrellas (Joint Project for Japan and USA) Ibaraki PREFECTURE: HITACHIOTA, HITACHI, Satomi; Route # 349; Sato RIVER: JUOFUKUJI BRIDGE, Harutomabachi and SHINNAKAWASHI BRIDGES.

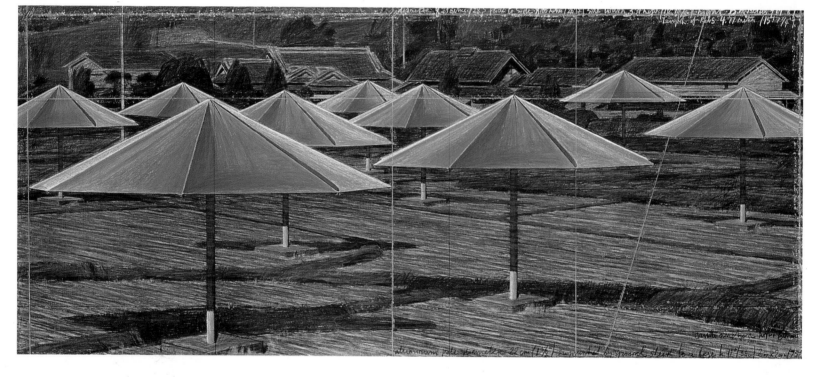

The Umbrellas, Joint Project for Japan and USA
Drawing 1990. Two parts: 38 x 244 cm (15 x 96 in) and 106.6 x 244 cm (42 x 96 in)
Pencil, crayon, photograph, pastel, charcoal, enamel paint, aerial photograph,
technical data and fabric sample